HOCKNEY ON 'ART'

conversations with Paul Joyce

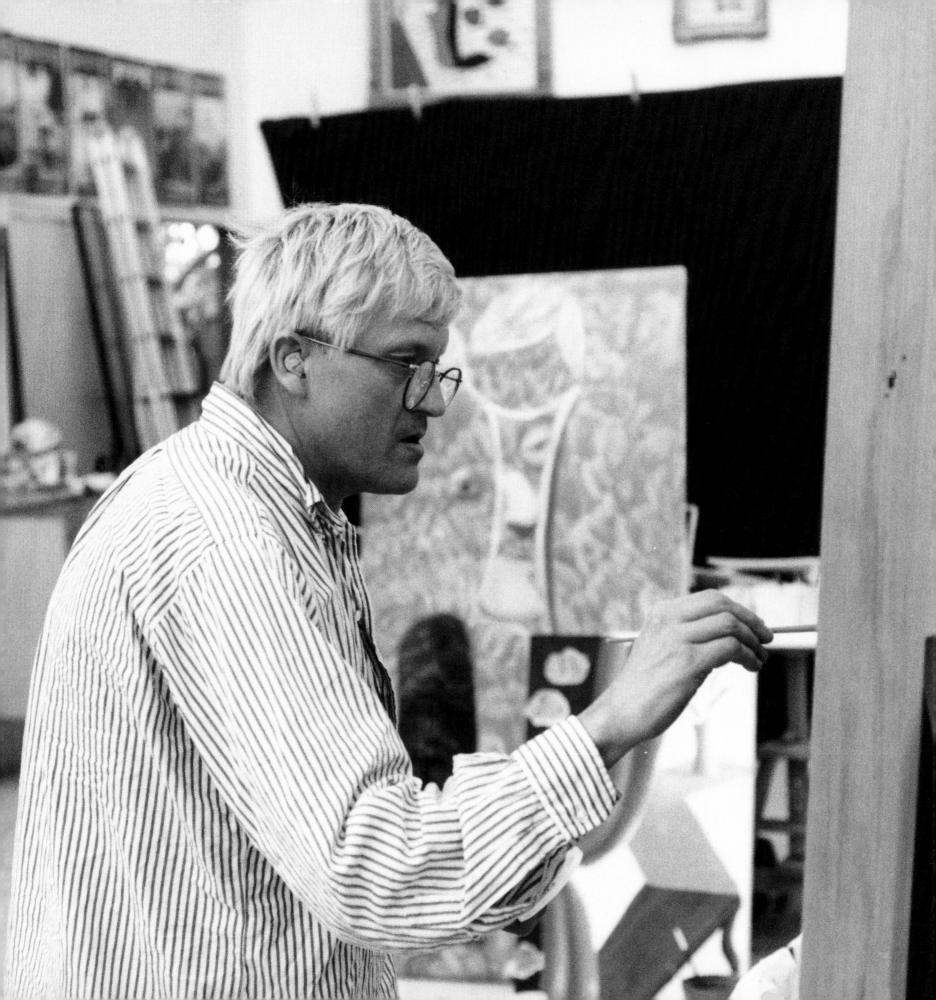

HOCKNEY ON 'ART'

conversations with Paul Joyce

Little, Brown and Company
Boston · New York · London

For Joan, Wendy, Nathan and Sam

A LITTLE, BROWN BOOK

First published in 1999 by Little, Brown and Company (UK).
Portions of this book first appeared in *Hockney on Photography* (Jonathan Cape, 1988).

Text by David Hockney and Paul Joyce © copyright 1999.
All illustrations © copyright David Hockney, unless otherwise attributed on page 264,
which constitutes an extension of this page.

A CIP catalogue record for this book is available from the British Library.

ISBN 0-316-64233-9

Designed by Brian Wall
Printed and bound in Italy by L.E.G.O. Spa

Little, Brown and Company (UK)
Brettenham House, Lancaster Place
London WC2E 7EN

My thanks to Wendy Brown, who transcribed and edited these texts with great understanding of the content as well as minute
attention to detail. To Alan Samson, editorial director of Little, Brown, who conspicuously failed to suppress his own editorial
abilities and guided this book through dangerous reefs as well as the occasional becalming. Most of all to David Hockney for his
support in allowing this text to come to light, and beyond that for his greatly valued friendship.

CONTENTS

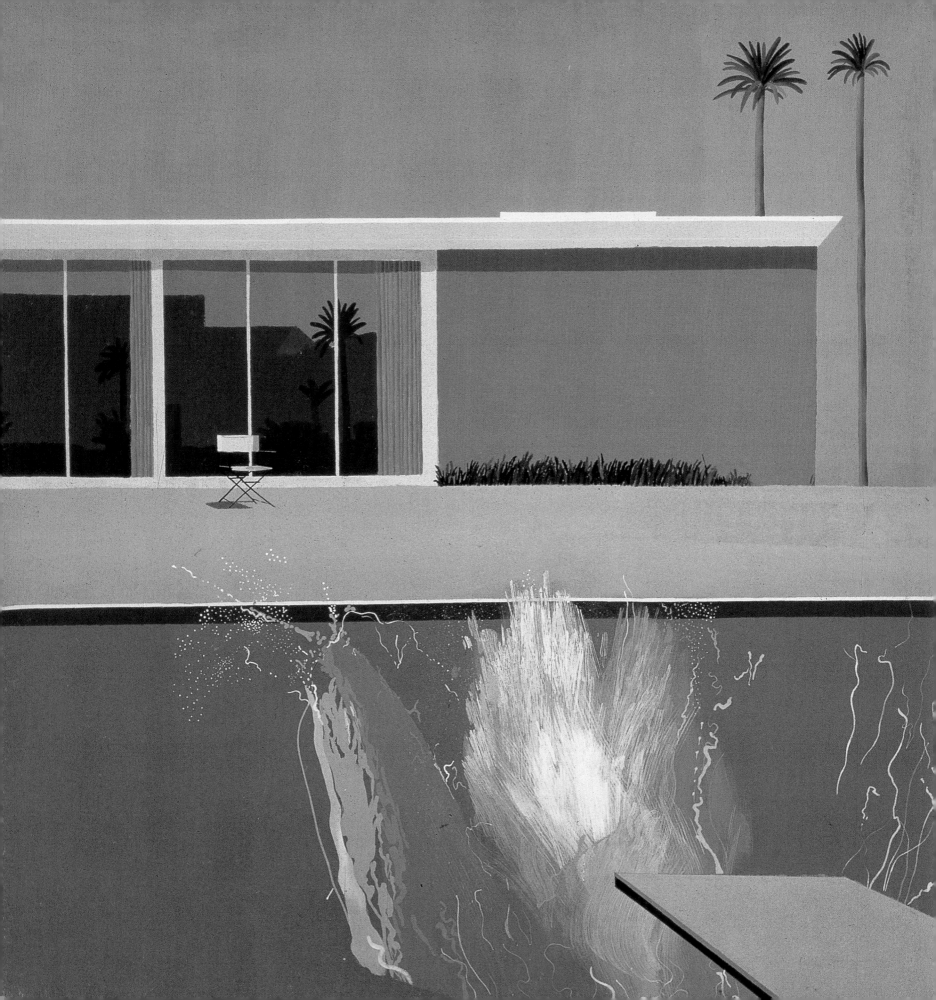

Introduction

David Hockney is perhaps the best known and arguably the greatest living English artist, as well as one of the most widely published. At any given time there is at least one major exhibition of his somewhere in the world. He has appropriated certain images and themes on a more or less permanent basis: pools, boys in showers, indelible pencil portraits of friends, Los Angelian views, American landscapes and luminous still lives. His range of work is acknowledged universally.

Hockney has practised photography for over thirty years. However, this aspect of his work has been consistently underrated. Hockney thinks of his photographic experiments as 'drawing with a camera'. I thought that by taking this aspect of his work as a starting point, I might penetrate his artistic consciousness. Frankly, I was interested in nothing less. How often does one have the opportunity of watching, travelling and talking with an artist at the height of his powers? For Hockney is a highly articulate man who spends a great deal of time alone, working and, above all else, pondering on matters artistic, political and social. His views are never held tentatively. He thinks through his position with great rigour, and defends it with tenacity allied with considerable powers of persuasion.

During the seventeen years that he and I have been talking, Hockney's photographic work has had a huge impact on advertising, and much of its superficial aspects have been subsumed into the commercial arena. His work with the camera holds a key to a completely new way of seeing, one in which conventional notions of perspective are turned upon their head. Here the concept of a camera being an extension of an artist's sketchpad assumes a pivotal significance. Every advance he made with the camera triggered a parallel development in some other aspect of his work. He has always said that if you show people another way, they will follow. In 1982 I was the only person connected with photography to pursue him in search of new insights about the medium. Most professional photographers chose to dismiss the work as merely provocative or playful, and the ideas as contentious or irrelevant. Some took the superficial aspects and appropriated them for their own purposes without understanding their real depth and power. Many see Hockney's massive photographic outpouring as a kind of theatrical gesture and, by implication, some quirk or flaw in an otherwise serious artist. Why bother with photography? It's not serious work. How can it be when anyone can do it?

We know that anyone can pick up a camera, and most people do at some time, but it takes an artist to use a camera as an artist to reinterpret the world. If anything, this is harder to achieve than a painterly image, for most photography has a tendency towards uniformity – a notion which David exploded over an intense five-year period. It was only after the dust had settled upon his 1985 piece, *Pearblossom Highway*, that it was clear a silent revolution had taken place.

In December 1997 there opened, at the Museum Ludwig in Cologne, a retrospective of

A Bigger Splash, 1967

7

Hockney's photographic outpourings which has been skilfully orchestrated by the show's curator, Dr Reinhold Misselbeck, to show precisely how relevant the photos are to Hockney's other work. Thus paintings, drawings and installations, such as *Snails Space*, are all on show together, each image leading us through cavernous rooms, one discipline dovetailing into another. This show will travel throughout Europe until the Millennium and will be within reach of millions of people. It was in part the importance of this show, as well as his later extraordinary paintings of the Grand Canyon, which prompted me to return to our recorded conversations and shape them into this current volume. Hockney always speaks in contexts broader than photography, encompassing the practical and intellectual problems facing an artist working at the end of a century which has brought greater changes than any other in the course of Western civilization. The core of this text moves beyond photography, as Hockney himself has done, emerging after seventeen years (rather to my surprise and much to my delight) as a broad treatise on the relationship of the artist to the world he inhabits.

One afternoon towards the end of June 1982 I walked into London's Knoedler Gallery in Cork Street to see an exhibition of Hockney photographs, for which I had not read a single review. I emerged blinking into the sunlight. This was one of those rare moments in life when one is confronted by such a fundamental change of vision that thereafter nothing is quite the same again.

All the work on display at the Knoedler Gallery in 1982, and the hundreds of photographic pieces Hockney has made since, have at their core one revolutionary ingredient: a moving consciousness at war with established notions of photographic 'realism'. Hockney smashed the rigid barrier – the fixed unblinking viewpoint – and became free to reconstruct the world as he sees it, not as any single camera lens might interpret it. This was the essence of the revelation which struck me seventeen years ago. No other artist has ever managed to place himself firmly within the world under scrutiny with the compassion, humour and precision of Hockney.

As soon as I got home that summer evening I wrote to Hockney, a stranger out of the blue. He called me the next day, saying that he knew someone would respond to his work. He was eager to talk. The following morning I loaded my Morris Minor with cameras and tripods and drove to Pembroke Studios. This was the beginning of our many years of conversations. The whole morning disappeared. The phone was simply left to ring. Other people with appointments sat around waiting. Nothing interrupted the flow of ideas. Hockney said he had thought about these things so intensely and deeply that he felt at times he was going mad. 'Not mad,' I replied. 'You're going sane!' During those three hours I saw a man radiating more energy than any artist I had ever met. I could imagine that when harnessed to his art such energy could be frightening. Indeed, he told me that Christopher Isherwood, when sitting for a photographic joiner portrait, had likened him to a mad scientist.

Hockney had been wrestling with conceptual problems presented by the photographic image for a very long time. He had been shooting pictures consistently for over twenty years, pasting chemist's prints into countless large albums, and tossing the negatives into old cases. A selection

of his early work had already formed the basis for an exhibition at the Centre Georges Pompidou (Beaubourg) in Paris and for a book, *David Hockney Photographs* (Petersburg Press, 1982). A glance at that book reveals that he was experimenting with multiple images and 'cut-ups' in the early 1970s. But it was not until he discovered the Polaroid SX-70 camera that he was able to put all the preparation time to such remarkable effect. The square format of the Polaroid image allowed him to arrange the individual shots in combinations both vertical and horizontal. Thus he was able to build up a formalized and rigorous grid which allowed him to extend pictures as far as he wished.

As Hockney explains, the 'trigger' for his first Polaroid 'joiners' (his term for these large composite photographs) was his inheritance of some unexposed packs of film. He simply picked up a camera and began to experiment. But it's clear that some such accidental stimulation would have happened sooner or later. His early work was never tentative. It appeared suddenly and so fully formed that Hockney himself was taken by surprise. He would get up in the middle of the night to study the joiners in progress, looking at them excitedly but with an objective eye, almost as if they had been done by someone else. The intensity of his daily work, combined with the sessions at night when he looked and learned, led to a massive concentration of effort and hundreds of new pieces.

For the first few months of photographing (approximately February – July 1982) Hockney's medium was predominantly Polaroid film and the results are different in character from the later photo-collages. Apart from the special colour quality of the Polaroid stock (due in part to the technical process whereby the development of the image takes place within the film sheet itself) all the Polaroid joiners were mounted with an equal white border around each image. By the time Hockney had picked up a conventional 35mm reflex camera he was ready to experiment with direct mounting without borders, so that the work became collage. He found this change from Polaroid to 35mm (and the smaller 120 format) both liberating and convenient. Films could be processed at the one-hour 'Fotomat' down the road and the shooting process could be executed much faster. He did not have to wait two to three minutes for each individual Polaroid to develop. But the main change was that when Hockney used 35mm he had to keep the whole picture in his head, effectively visualizing the end result. The Polaroid process allowed for a gradual build-up of images and permitted quite a measure of second thoughts and changes to the original concept during the three to six hours each work took to produce. Using conventional methods, the picture remained firmly in his head and in the camera until the films were processed, so he had to narrow the margin for error. This extraordinary discipline, combined with freedom from the Polaroid camera, led to an explosion of creative activity lasting not months but years.

The range of subject matter and the physical size of the works he showed me that morning at Pembroke Studios demonstrated just how exciting and deeply engaging he found this process to be. By overturning the established parameters of photography, he brought a new vision to bear on subjects as diverse as a simple car steering wheel or the Grand Canyon. I remember thinking: 'This

man could end up photographing the whole world!'

In 1985 Hockney produced his photographic masterpiece, Pearblossom Highway, and then publicly disavowed the medium. Privately we who knew him also knew that he would never abandon the camera. Rather he saw the camera within other pieces of equipment which excited his interest and artistic curiosity: fax machines, photocopiers, laser printers and computers. He also began using a large 8 by 10-inch plate camera as the basis for computer-generated prints which he was able to create – for the first time without expert assistance – within the confines of his Hollywood studio. Playful as always, he produced work which contained photographic elements alongside traditional painting techniques, then photographed the result to be reproduced via a computer on to archival watercolour paper. Were the results photographic, prints, or some new form hitherto unexplored? How should they be priced? Would they survive in archival terms?

During this period Hockney also worked as an opera designer on *Turandot, Die Frau Ohne Schatten* and *Tristan and Isolde*. These designs were intimately aligned with developments in his new painting; indeed it was probably inspiration from the music, particularly from Richard Strauss, which led Hockney into these absolutely unique private landscapes. All the while, the camera stayed with him. Some time later he began to experiment with video, mainly on the Hi-8 format. If it is true that the camera remains for Hockney a kind of pencil, then during this time he filled many notebooks.

The following conversations were recorded mainly on a pocket machine in locations which changed almost as frequently as the topics under discussion. Sometimes a session would merely clarify points raised previously and these have been incorporated into the body of the text. Most repetitions have been eliminated. It was clear as the informal interviews progressed that Hockney constantly goes back in his mind to things which have been preoccupying him. Usually when he returned to a topic he did so with new insights, and I hope the text reflects this organic process.

It is rare to be allowed to share the thought processes and working life of an artist like Hockney during his most creative period. It also happened to be a time of greatest sadness, for he lost a swathe of close friends alongside whom he fully expected to grow old. Nathan Kolodner, his New York gallery director, died in 1989; Henry Geldzahler, his oldest friend to whom he spoke on a daily basis, in 1994; and Jonathan Silver, who bought and revitalized Salts Mill, in 1997 – these three were the most treasured amongst dozens of others, many succumbing to AIDS during its most virulent years. The point arrived when David was frightened to pick up the telephone, fearing it would carry bad news. All this while his hearing was deteriorating to such a degree that he doubted he would ever be able to be involved in opera production again. However, his optimism about life and the natural world remains undimmed, as can be seen by his most recent paintings of the Grand Canyon. Hockney says that art can change people's lives. I've always hoped and believed that this was true. This book stands in praise of that belief.

Paul Joyce
London, 1999

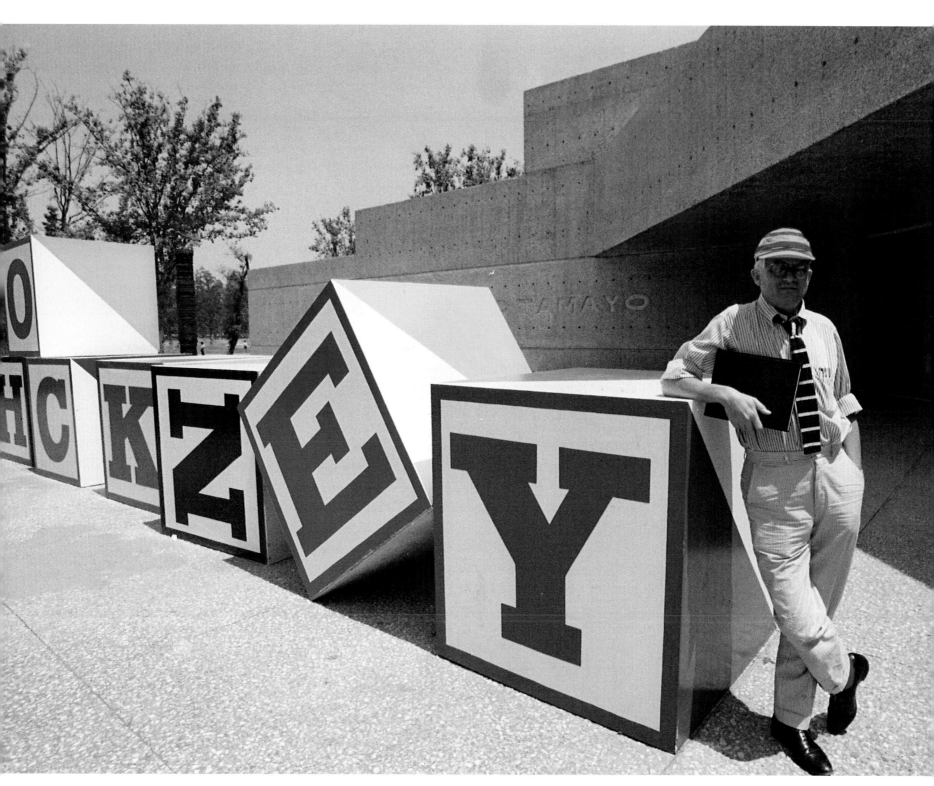

David Hockney outside the Museo Rufino Tamayo. Mexico City May 1984. Photo Paul Joyce

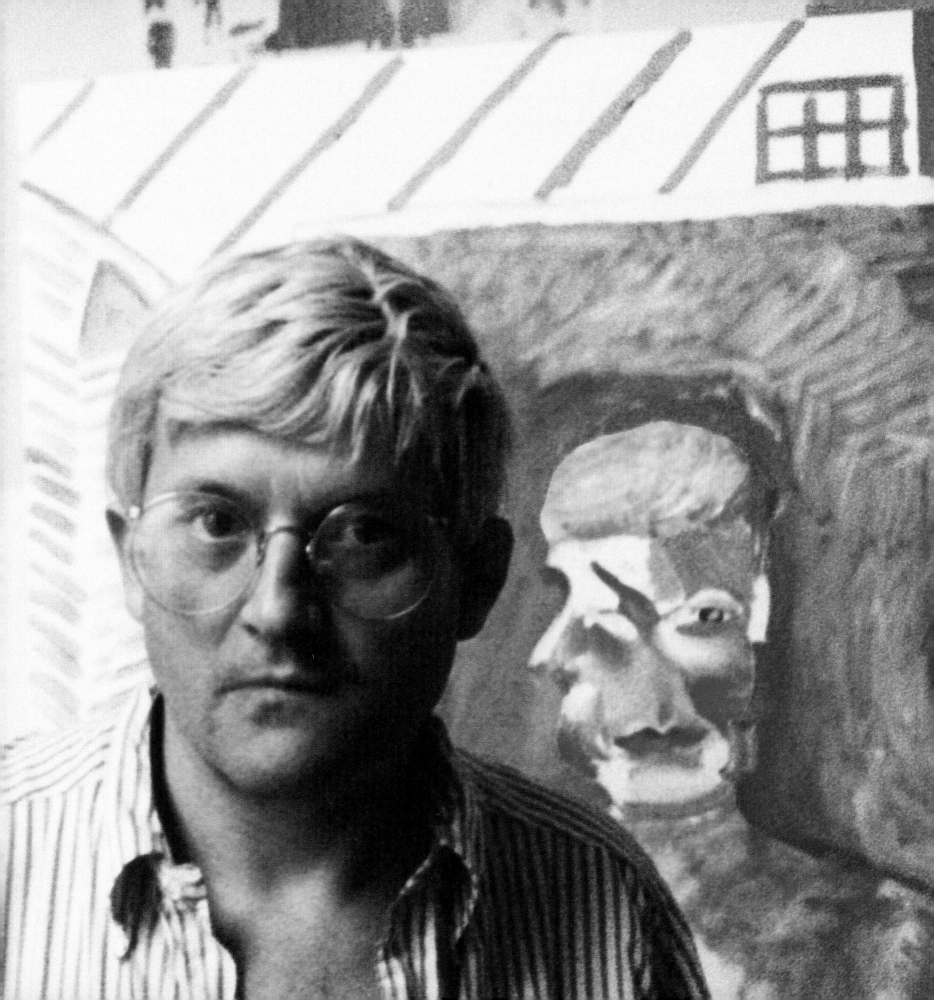

London, July 1982

When I arrived on the doorstep of Pembroke Studios, camera, tripod, notebooks and tape recorder dangling from every available human hook, it was to confront an already familiar yet completely unknown icon as the door opened on that famous mop of blond thatch. He held out a hand saying, 'Hello, I'm David Hockney . . .', and ushered me inside for his unique brew-up of Marks and Spencer's (strong) teabags. His studio contained a number of apparently abandoned paintings, one of which I later photographed him in front of: an oil study of his friend Ian Falconer combining a simultaneous front and profile view of the face. Over a neglected pot of treacle-textured tea, he embarked on a rapid fire conversation which just flooded out of him. He had clearly been both working on, and thinking intensely about, his Polaroid 'joiners' and simply had to share his observations and speculations. This was fine by me. I had just started the journey into a new and different way of seeing the world, and here was a willing, accommodating and incredibly perceptive guide. I had no idea then that we would still be engaged in such intense conversations almost two decades later.

PJ: You've always used photography as an adjunct to your painting, as a tool. But was there a time when you suddenly realized that your photographs had some real quality of their own?

DH: I had been taking photographs for years, and if I do anything, I do it seriously. I have thousands and thousands of photographs. They're all stuck in albums, just like anybody else's. I never edited them. I just stuck every one in. I always went to the chemist to have them processed, mostly as colour prints. I don't take photographs in the way that a professional photographer might do, taking, say, sixty of the same thing. I didn't file the negatives. They were just chucked in a box, but I did keep them.

When you look at my albums you can see that by 1971 the photos are much more carefully taken. They are more considered. I was standing still then and groping very slowly. You do gradually see an eye at work, and a sensibility, but that took time. With a lot of the early photographs I just pointed. Then I thought: 'The camera is only seeing what I see.' But if I didn't see anything in the first place, I couldn't photograph it. When I found that out it made me more interested. I realized that some of the photographs I'd intended to use for paintings didn't have to become paintings.

There was a point in the paintings when it looked as if I was becoming obsessed with verisimilitude, which is not interesting painting. It can be technically interesting, but great painting is not like that. And as I moved away in painting, I became conscious that a photograph was another thing completely. Some of them were strong enough as images to exist on their own. And so I did become more interested in the photograph as the photograph.

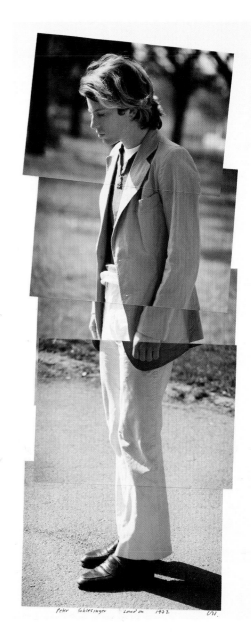

Above: **Peter Schlesinger, London 1972, photographed by Hockney.**
Opposite: **Paul Joyce's first portrait of Hockney, Pembroke Studios 1982, taken on a Pentax 110, a format favoured by Hockney for his early 'joiners'.**

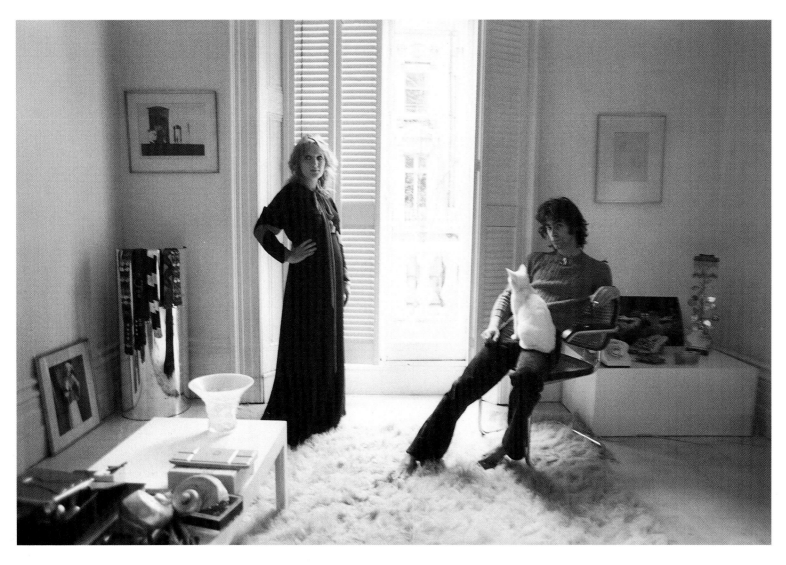

Mr and Mrs. Ossie Clark.
Photograph 1970

I'd still never shown any, partly because nobody had asked! Picture dealers such as [John] Kasmin [known as 'Kas', a long-time friend, who acted as Hockney's dealer for twenty-five years] had never shown any interest in my photographs, so I never bothered. Then in 1976 Ileana Sonnabend [art collector and publisher] published a portfolio of mine in Paris, called *Twenty Photographic Pictures*. Each photograph sold for three or four hundred dollars, which I thought was *quite* enough. Later the price went up, and I thought: 'It is crazy to pay all this money for photographs. You can just print some more; after all, you've got the negatives.' I couldn't understand it. If you make an etching, you have a limited edition. You just can't print that many: the plate would fall apart. There's a good reason for printing only a hundred or so, but photography isn't like this.

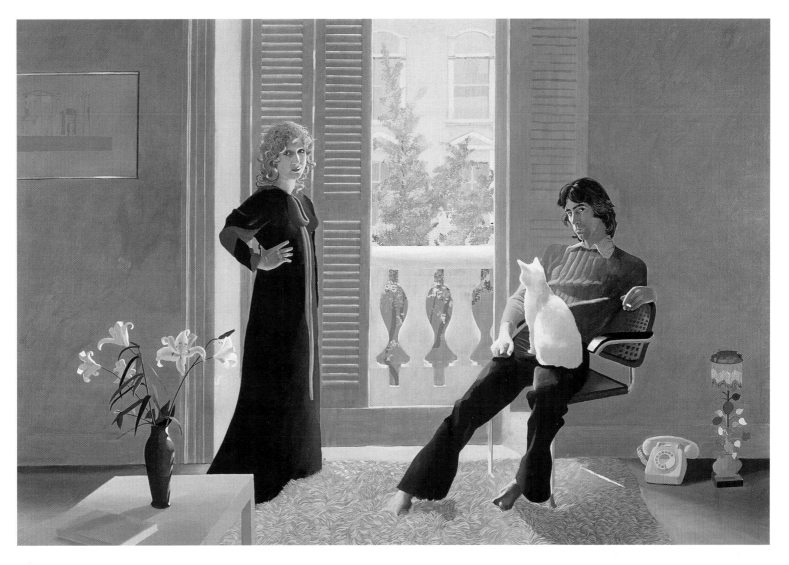

Mr and Mrs. Clark and Percy.
Acrylic on canvas 1970–1

PJ: What, specifically, started you off on the joiner photographs?

DH: I didn't plan the joiners, they just happened. There was a period in the late sixties when photographers were using wide-angle lenses a lot, and the photographs were awful. Everything was distorted in a way that you never see. That was what put me off – you just never see in this way. I knew there was something deeply wrong with it. I thought I'd rather join the pictures together. Even if they don't fit, it's more interesting, more honest, and it gives a feeling of space. For instance, if I'd used a wide-angle lens to photograph this giant room [Pembroke Studios], I don't think it would achieve the same feeling at all. Of course, when I began to join the photos together I was working blind, trying to remember the previous picture I had taken, where it had ended, and so on.

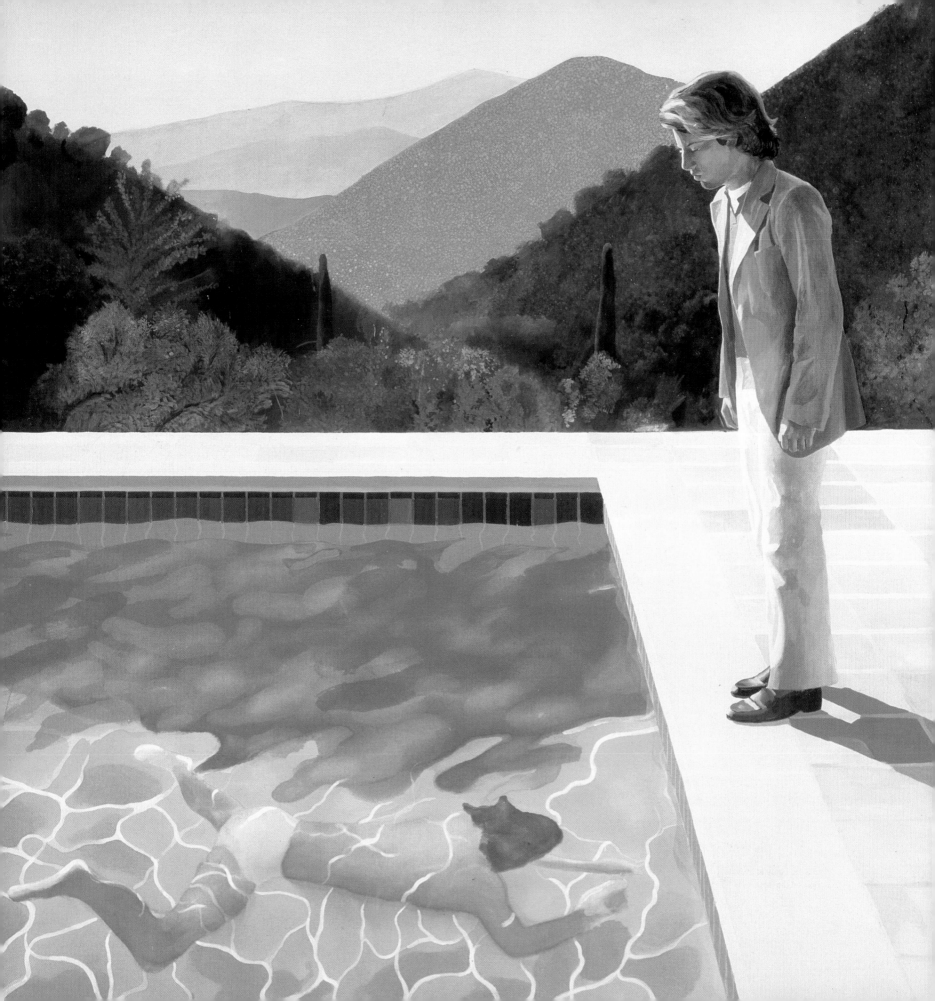

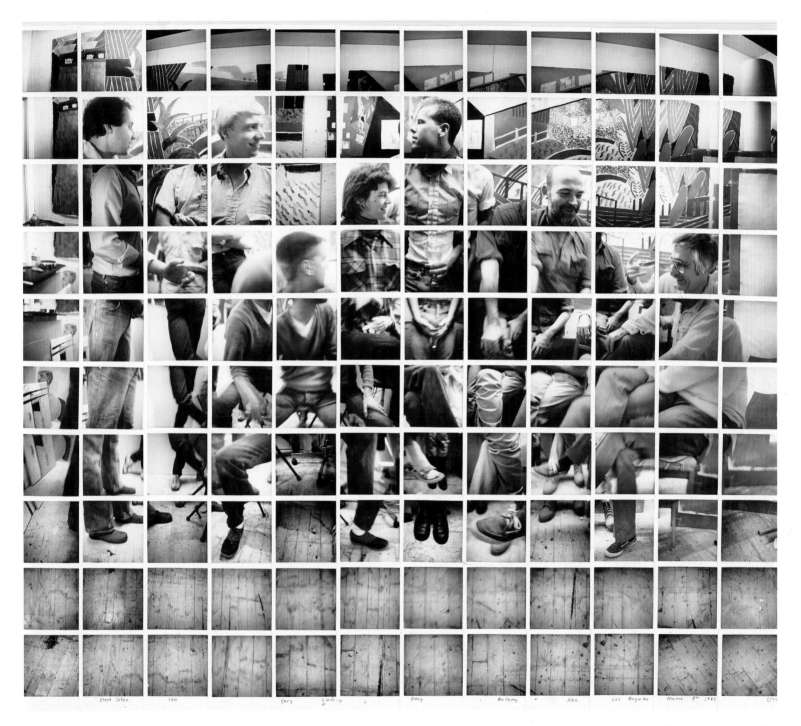

Opposite: **Study of an Artist (Pool with Two Figures) 1972.**
Acrylic on canvas

**Steve Cohen, Ian, Gary, Lindsay, Doug, Anthony, Ken.
Los Angeles, March 8th 1982.** Composite polaroid

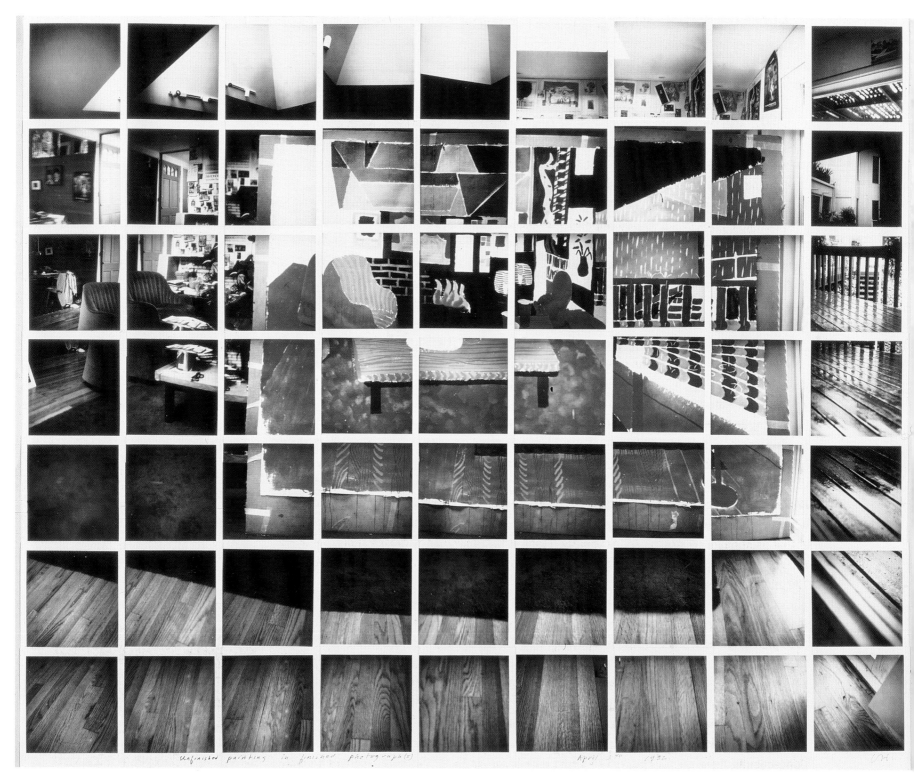

Unfinished Painting in Finished Photograph(s) April 2nd 1982.
Composite Polaroid 1982

I'd done a painting of the living room in Los Angeles. Both the living room and the terrace were combined into one picture. I just re-did it on Polaroid film, and glued it together. That was the first one! I pinned it to the wall, and I kept going back to it. Even in the middle of the night! It was different, somehow. It was a narrative, a story. You moved. The viewer's body moved through the house. But the main point was that I read it differently. It wasn't just a photograph. It was abstracted, stylized. The ideas were based on Cubism in the way that it filters things down to an essence. It was just eighteen pictures – nine, in two rows – and it worked so well that I couldn't believe what was happening when I looked at it. I saw all these different spaces, and I thought: 'My God! I've never seen *anything* like this in photography.'

Then I was at the camera night and day. I bought a thousand dollars of Polaroid film straight away! Within a week I'd done very complex things. I quickly discovered that I didn't have to match things up at all. In fact, I couldn't possibly match them, and it wasn't necessary. The joiners were much closer to the way that we actually look at things, closer to the truth of experience. Within a week they had developed amazingly. I then began on that huge one of a group of people [*Steve Cohen, Ian, Gary, Lindsay, Doug, Anthony, Ken, Los Angeles, March 8th 1982* (see page 17)]. It took about two hours to do, and when I'd finished I nearly collapsed. I was astounded because I knew it was alive, and normally a group photograph is the most static of all.

At that point I realized it was more than just a novelty. I decided to interrupt my painting for a while to pursue the joiners and expected to stop when I got bored. The problem was that I didn't get bored: it got more and more fascinating. It became harder as I pushed it, and even more interesting to me. I had to do a lot of calculations in my head and the amount of concentration needed was enormous. I couldn't break off. I ignored everybody else. I just forgot about them because I was so involved. Christopher Isherwood thought I was like a mad scientist!

I had begun a twenty-by-seven-foot painting of Santa Monica Boulevard (*Santa Monica Boulevard, Los Angeles 1978/80,* abandoned for no particular reason). I used to walk up and down it, and the main problem was that it was seen from one point of view, essentially. I had struggled at that painting for six months, trying to make it look as though you were walking along. But when I started the joiners, I realized I could now paint the Santa Monica Boulevard picture *another way*. The joiners told me how to do it.

PJ: It occurs to me that the one element you say is missing from photography is that of time. But even joining up three pictures, taken almost simultaneously, injects . . .

DH: Time. Yes. I realized that very quickly. It seemed that these pictures had added a new dimension to photography. I had wanted to put time into the photograph more obviously than just in the evidence that my hand pressed the shutter and there it was.

The big joiners of Kasmin, Stephen Spender and so on took about four hours to do. Consequently there are four hours of layered time locked in there. I've never seen an ordinary

European-style Dark Tent.
Wood engraving, 1877

Camera Obscura. Wood engraving, c. 1840

photograph with four hours of layered time. That's much longer than you would take to look at it! This is what it's overcome. For me the main problem in photography always came down to that. Any drawing or painting contains time because you know it took time to do. You know it wasn't made with a glance. If it's honest work, you know it must be a genuine scrutiny of the experience of seeing.

One extraordinary thing I discovered was that you can go on and on looking at these pictures, which is very unusual with photographs. However good the photograph, it doesn't haunt you in the way that a painting can. A good painting has real ambiguities which you never get to grips with, and that's what is so tantalizing. You keep looking back. A single-eyed photograph can't have that quality. When you look back, it's the same. But even though I'd made those joiners I still kept looking at them days later. Once you start looking at them, you're drawn in, and you cannot *not* look unless you turn away. There is a movement going on which keeps changing. It's a very complicated process. It's not just a number of photographs you look at. The combinations of pictures have much greater possibilities than that. To me this represents a complete reversal of the usual qualities of photography.

After three whole weeks working on the joiners I could hardly sleep: I used to get up in the middle of the night and sit and look at them to find out what I was doing. Everybody who came to see me was equally excited, so I knew it was working. After all, they usually wonder what I'm going on about! So I just went on and on, and finally after about three months the burst of energy wore out. That's a long time. Every artist gets energy with an inspiration, but the bursts usually don't last that long.

At the first show in New York one or two critics were impressed just with the amount of work. They knew I had been working for nearly three months, but all they were looking at was a third of my output during that time. And they didn't know it! The first reaction was from an art critic, who thought it was interesting, but just a novelty. A week later a photography critic [Andy Grunberg of *The New York Times*] wrote about it and he was much more interesting. He'd looked harder, and being a photographer he would have known about the thinking process involved.

From the moment the New York show opened they had a lot of people visiting, people who went out and said to others: 'You *must* go and see them.'

PJ: That's how I came to see the show. Wendy (Brown) came back and said: 'You've got to see it. It's the most interesting thing that's happened in photography for years.' So we got straight in the car. And I must have told half a dozen people, key people.

DH: . . . who would believe your word.

PJ: Absolutely. How often are you really excited about something? Is there some quality about the joiners which even you haven't come to terms with?

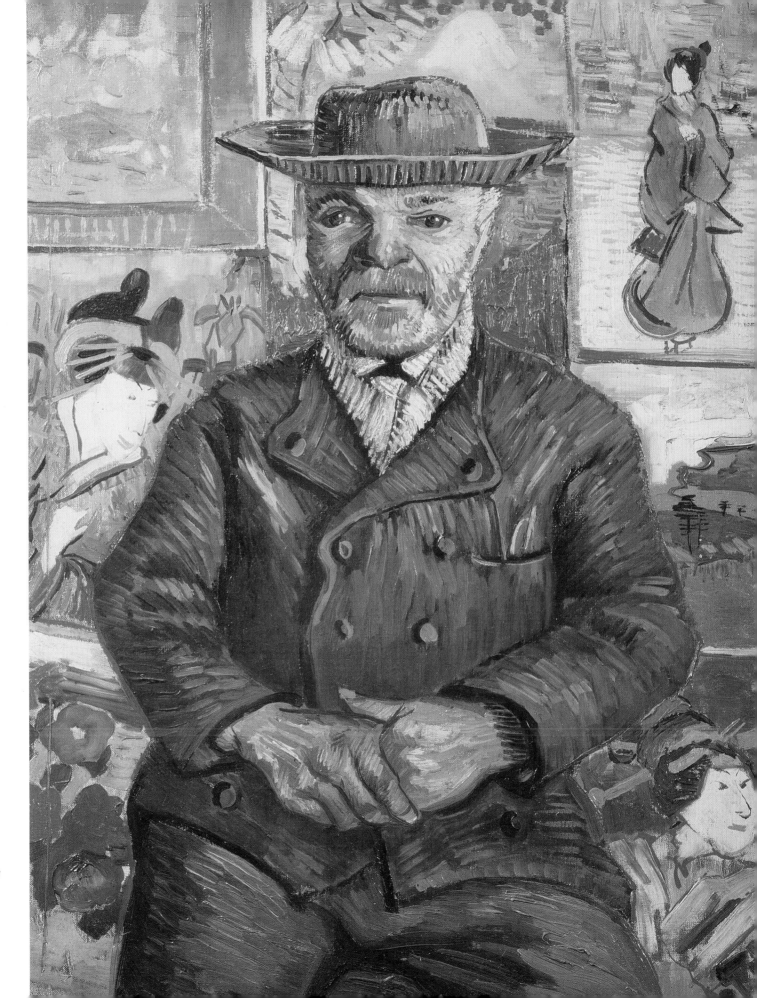

Le Père Tanguy by
Vincent van Gogh

Christopher Isherwood and Don Bachardy. Acrylic on canvas 1968

DH: Yes. Naturally I got excited enough to try and analyse things, as you do when you stop and sit down. It occurred to me that in Western art things always stop at the top, bottom and sides because of the camera's influence. The camera is quite a lot older than photography, and it has dominated Western art for at least three hundred and fifty years, since the invention of the *camera obscura*.* Canaletto and Vermeer, many artists used the *camera obscura* and naturally they were fascinated by what was happening.

With the invention of the *camera obscura*, easel-painting really flourished. Previously, the idea of painting was always on much bigger areas, such as walls or ceilings, and the edges were far away. Painting was not about edges. But with this idea of the window, the camera leads inevitably to an interest in verisimilitude. By the nineteenth century a lot of artists realized there was something wrong with this. It was not quite truthful.

And in Europe certain artists started to escape from the one-point perspective of Western art when they noticed Oriental art, and Japanese art in particular, which is based on Chinese art. The Japanese and the Chinese did not have the camera until the nineteenth century. I assume they didn't because there's no evidence of their art being one-eyed. Renaissance artists were always looking with one eye, looking through a hole. Oriental artists had different ideas. They could depict a landscape as a scroll which opens out. Manet and Van Gogh saw some Japanese prints which must have looked unbelievable to them in the nineteenth century. Marvellous and simple. Here was an art that dealt with essences, not with verisimilitude, which is about surfaces. They were fascinated and it influenced them. Manet's forms became simpler and bolder. They accused Manet of being like a child, which is just what they called Picasso. We can't see it now.

But the bigger break comes with Cubism. Cubism is an unfortunate name and it wasn't given for any real reasons. Essentially, it's a different way of looking, and it's about reality and perception. In the art world Cubism has been greatly misinterpreted as being about abstraction, which it's not. The late theorizers of Cubism never say it's about abstraction. They know it's about perceiving the physical. Cubism is about how we see what we see. What the cubists did was difficult but any intelligent person instantly responded to it. Within ten years Cubism had enormous influence, and within twenty years it had influenced everything, showing a way to do things more simply. However obscure it was in the beginning, whether there was a mass audience was not the point. It had reached just enough people to filter down the ideas.

One of the problems of Cubism, as Clement Greenberg pointed out, was that cubists had difficulty with the corners of their paintings. He said, 'They make round pictures.' Now it's dawned on me why they had difficulty with the corners. I've discovered why through doing this photography. In the picture that has four edges, the edges are the most interesting, the sides particularly, because the top is the sky, infinity or a roof, and the bottom is you, your feet, your body. But we don't see that way at all. I realized that with this photography I was making things closer to the truth of the way we see them. We see everything in focus, everything, but we don't see it all at once; that's the point. We take time. The camera, the one-eyed camera, can be arranged

so that it sees a lot in focus, but it's difficult if there's something very close to it and there's something else thirty feet away.

It is possible to do this technically. If I look at your face I can also see this tape recorder. It's not blurred; nothing is blurred. If I move my eyes and look at the tape recorder I can see a great deal more, but now your face is different. It isn't blurred, though, nothing is ever blurred, unless there is something wrong with your eyes, and then you would wear spectacles. Blurred things are unnatural; we don't see that way, nobody does. In photographs you often get blur, and therefore in time they'll come to be seen as slightly primitive images, I'm sure. Again, you're dealing with this urge for verisimilitude – a natural urge because it does seem that there's a truth there. I realized that although it looks as if the cubists were abstracting, what they were really trying to do was to ask: 'What is it I see when I look at your face, and how do I deal with it?'

At one time I said I was going to take pictures with peripheral vision, but you can't do that. You'd drive yourself insane! But in painting, of course, you can, and this may be the area where vision merges with other senses – memory, for instance – and gets very complicated. These ideas encouraged me to look again at cubist pictures, which I began to see in a different light. I was more and more fascinated. Cubism, which is a great idea about reality, has not influenced realist painting much outside Picasso and Braque. I think that is because Picasso is such a giant artist. It's difficult to deal with these giant human beings; we tend to skirt around them. In painting today it's as though Picasso hadn't been there. But this giant was there and we must deal with him. The influence of Picasso was superficial in the sense that people hadn't grasped fully what he was doing. They did know it was interesting, but they could only deal with the superficial aspects of what had happened. Therefore Picassoesque painting emerged.

It was then I realized that I was attempting two-eyed photography, and that while I was taking the photographs I was spending a great deal of time looking, but not through the camera. Ordinarily the photographer spends the time looking through the camera because he needs that frame. I began to realize that I was making pictures in a very strange way, in that when I began I did not know where the edge was going to be. Now, in any drawing or painting you know where the edge is because you begin on a piece of paper, or canvas – anything with four edges. No matter what you do on it the four sides make it into something, so a few marks can, for instance, suggest a landscape. Oddly enough this is not like a window, even though it looks literal enough, because your eye is moving in and out all the time as it does naturally. I may be perfectly still but my eye is moving around the room and wherever it moves everything is in focus. I suddenly realized I'm moving! And that, unlike an ordinary photograph, the composition of the finished picture with the joiners was not as important in terms of making you look. In an ordinary photograph, a one-eyed photograph, composition in many ways is everything, and the only thing that can transcend this is a face. If you have a face depicted, the features and the things that it tells you are more interesting than what is happening at the side. Something strongly erotic would have this effect too. Otherwise, it's the edges that are making you look, and lines from there often lead you into the

picture – that's what the photographer uses. The painter uses these devices as well to make you look here or there.

I'm convinced now that there is no such thing as objective vision. We choose all the time to look at what we see. We realize that we are always attracted to certain things. In any picture, if there is a figure big enough, we are forced to look at it, but if there is a face, then we cannot *not* look at it. And if there are strong eyes in a painting or photograph, we are drawn to them. The other thing we are drawn and attracted to is light – until it reaches the point where it is too strong, and then we are repelled and have to turn away. Apart from these things, there are other reasons for looking. What do we see? How do we see?

I notice that people who come in here to see me are mostly people who are interested in visual art. They are curious people who look around a lot. I tend to do that. I notice things. Each person notices different things, but everybody sees people first. You look at people, or you deliberately don't look. If you don't look, it's a very conscious choice. If you are a painter, you look at the paint, and if you are a book dealer, you look at the books, and so on and so on. Different people choose different things depending on their interests and ideas. All vision must be like this in some way: some things attract us while other things repel. The moment that you leave Cubism, everything becomes based on a fixed point. My joke is that all ordinary photographs are taken by a one-eyed frozen man! But the joiners are to do with movement. I'm moving around when I'm taking them. It's not possible to use a tripod, not the way I'm working.

PJ: Well, you'd be there for three days, wouldn't you?

DH: Oh, yes! Unbelievable! You'd go mad. You just couldn't do it.

PJ: You say that you have reached the end of your three months of intense work on this, but do you see yourself pursuing it?

DH: Well, yes, but I want to put these ideas back into painting. It might take me months of hard work, but I could discover another kind of Cubism. Cubism isn't a style: it's an attitude. By treating it as a style, people simply imitated Picasso. If you use your own experience, eventually you will come up with something different. His example is too good, too complicated to avoid. If you look at it more than superficially, you realize what was going on. This work has made me do that. I knew the joiners were related to drawing because you have to know where to put things. You have to know about drawing.

PJ: I see what you mean about the graphic problems. Is the centre your starting point? Do you move from there outwards? The structuring must present you with complex problems.

Don and Christopher, Los Angeles, 6th March 1982.
Composite Polaroid

DH: I move from faces outwards. In the portrait of Don and Christopher (*Christopher Isherwood and Don Bachardy* painting 1968), I started with the faces, but I move and change about. Don was looking at me, but I noticed that he kept looking at Christopher. This is about the second double portrait that I did as a joiner. Even though things got out of scale, you're aware that he's watching Christopher, aren't you?

PJ: Yes, you are. And in your famous portrait of him [*Don and Christopher, Los Angeles, 6th March 1982* Polaroid collage], it's the reverse! These photographs really show that we look at people in a series of glances: look at them, then away, look back, and so on.

DH: Yes, and I think that's why these have a dimension that hasn't been seen before. This is scrutiny, and it took time.

In December 1983 Hockney delivered his first lecture on photography in England at the Victoria and Albert Museum. The lecture was, on the whole, well received, but other photographers (such as David Bailey, who left the auditorium with embarrassing speed) failed to engage Hockney in the kind of provocative questioning he had hoped to stimulate. The audience was respectful and attentive, and there was not a spare seat in the room.

His photographic show at the Hayward Gallery in London (9 November 1983–5 February 1984) was drawing record crowds. We met briefly during the few days he was in London, and agreed to continue our conversations. David's pleasure at the public reaction to the show was somewhat blunted by the negative response to his work from the photographic establishment.

During the winter, we spoke frequently on the telephone, and it was clear that his passionate engagement with photography continued unabated. He constantly expressed surprise that his ideas for the joiners were not being taken up. I pointed out that photographers would have difficulty in embracing a technique which seemed to undermine their own practices and which required an ability to draw. David kept hoping for a more positive response.

** Camera obscura, literally a darkened room. Leonardo da Vinci describes the principle of the camera obscura as light entering a minute hole in the wall of a darkened room that projects an inverted image of whatever is outside on the opposite wall. As early as 1550, it was discovered that a lens in this hole sharpened and brightened the image on the wall. The camera obscura shrank from the size of a room to the size of converted sedan chairs during the seventeenth and eighteenth centuries to a portable two-foot box. A lens in one end of the box cast an image that would be seen outside the camera. Beaumont Newhall writes that these 'perfected models' became 'standard equipment for artists' [The History of Photography, Secker & Warburg, 1972].*

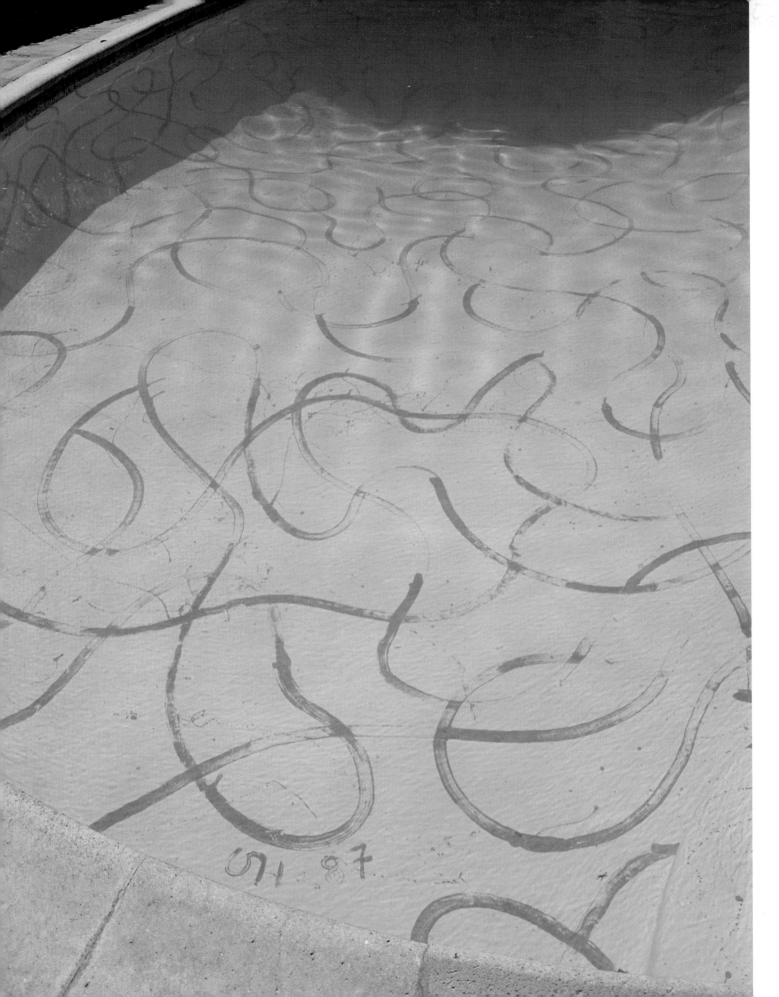

Hockney's swimming pool. Photo by Paul Joyce

Los Angeles, May 1984

In May 1984 I flew to Los Angeles to research a film on the actor and director Dennis Hopper, who made his reputation with Easy Rider *in 1968. The very day I arrived, Hopper was taken into hospital. (He emerged triumphantly two months later and his career has been on an upward curve ever since.) During this forced interruption I was able to visit David at his home off Mulholland Drive almost daily for the next three weeks, which made for a special intensity in our dialogue. Although he had recently constructed an enormous studio in his garden by razing a tennis court, the whole house is effectively his workspace. Space is one of the reasons Hockney has now committed himself fully to Los Angeles. Much of his work in progress was brought down to the living room, which has a magnificent terrace running the length of the house, overlooking the famous pool. Here it was studied, tried out in frames, and pinned to the wall. We sat surrounded by David's work and discussed problems of seeing and representation.*

PJ: Can we talk about the differences between Western and Eastern notions of perspective? If a conventional Western perspective freezes the moment, it must surely stop the flow of time.

DH: It must do. In the Chinese book which I found so fascinating (George Rowley, *Principles of Chinese Painting* Princeton University Press, 1959), it says that perspective must be read laterally. On a flat surface, it is just about all the eye can do, but the surface tells you things: it gives you illusions. Perspective makes you think of deep space on a flat surface. But the trouble with perspective is that it has no movement at all. The one vanishing point exists only for a fraction of a second to us. The moment your eye moves slightly, it's gone, and it's somewhere else. In a painting, the hand is moving, the mark is being made: these things themselves run through time.

Why is it that people are always interested and impressed by what they call 'hand-done' work? The camera is only a machine, but a drawing made by a human machine fascinates them much more than anything photographic. It's an interesting fact that the perspective in painting matters less than it does in the photograph which by the nature of the lens is forced to have perspective. I did make one photograph without perspective [*Walking in the Zen Garden at the Ryoanji Temple,*

Hockney's Hollywood home. The picture of the off-angle paintings on the wall (below) was taken on the morning of the Los Angeles earthquake, January 17th 1994. Photos by Paul Joyce

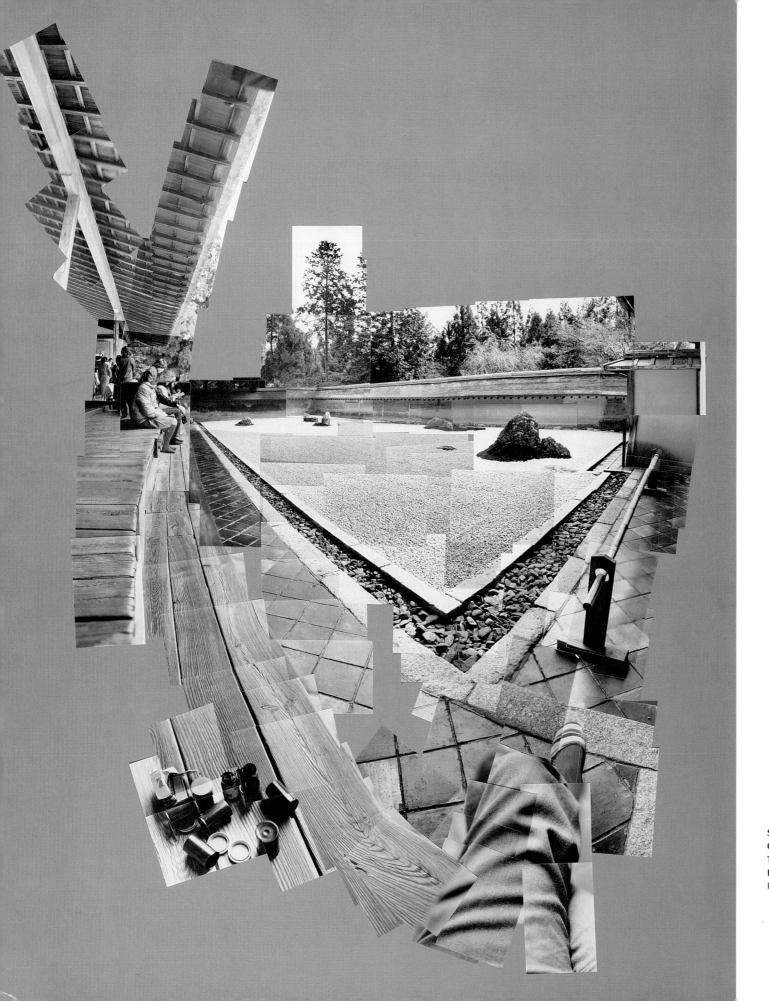

Sitting in the Rock Garden at the Ryoanji Temple, Kyoto, February 19th 1983.
Photographic collage

Kyoto, February 21st, 1983 (see page 56)] but you literally have to move in order to do that. The joiners have many perspectives within one general one. You sit still, so you have the feeling of a general perspective, but the moment your head moves there are many more.

PJ: Such as in your picture of the Ryoanji Gardens?*?

DH: Yes . . . I'm positive now that what we see depends also on our memory. The Renaissance idea of fixing space persists – posing for a photograph is a Renaissance idea! When you pose for the picture you stop, and you imitate this stopped time. The only moment we do this is for an artist or a photograph. Usually we move. When I took the picture at Ryoanji, I planned it. After all, the garden as we know it is a rectangle. Because it's on a different plane, at ninety degrees to us, we can know it to be a rectangle only by moving along it. If you visit the garden, and you are not photographing it, you would walk along the edge of it, sit down, contemplate, do whatever you are supposed to do. After you had left, if someone asked you what shape it was, you would say it was a rectangle. Now, if you had seen it from one point, as in the other photograph I took, you would think it was a triangle. So we come back to a weird question: when is the present? When did the past end and the present occur, and when does the future start?

Unfortunately, for the purpose of illustrating things, science is still geared to the conventions of Renaissance art. Consequently, we have machines to depict things – the camera itself, of course. The only way scientists can make depictions is by using a computer, but it is still essentially from a fixed point of view. The computer itself can't see: it can only be programmed.

PJ: I wonder whether you are going almost beyond art itself, or art as we know it, into an area of representation which we haven't even thought about?

DH: Don't you think it's possible? It must be possible, because we become more and more aware. We do make advances. But at times I feel I must be going mad; it's all so strange. On the other hand, something new is very strange to us at the beginning.

The experience of art is more real in painting than in photography. The moment is longer, and we can feel that moment. In a photograph we can't. Perhaps this is why there are so few good photographs. The good ones that do exist are almost accidental, one fraction of a second that looks as though it's longer than it is. We don't know what an isolated fraction of a second is. We can't isolate a second in our lives, can we? The photograph must be a much more primitive picture than a painting is. But, if you asked the average person which looks more real, they would say the photograph. I'm convinced it can't be true.

PJ: This goes back to what you were saying earlier, that the photograph has influenced the way we look at things. If we are presented with a photograph, we say: 'Well, that's life.' Movies have

influenced our way of seeing as much as still photographs, and they are not life at all. They show a world confected, glamorized, changed.

DH: I do think it's true that all depictions must be stylized, what we would call stylized. There is no way they can't be. After all, they are not the reality. They are put on a flat surface as stylizations of some kind.

Listen to what Leo Steinberg [*Other Criteria* Oxford University Press, 1975] has to say about Picasso:

Surveying Picasso's lifelong commitment to the theme of woman as solid reality – a commitment relaxed only during the cubist episode – one arrives at a disturbing conclusion. That Picasso, the great flattener of twentieth-century painting, has had to cope in himself with the most uncompromising three-dimensional imagination that ever possessed a great painter. And that he flattened the language of painting in the years just before World War I because the traditional means of 3D rendering inherited from the past were for him too one-sided, too lamely content with the exclusive aspect. In other words – not 3D enough.

Amazing, isn't it! Picasso shows you both front and back, and this must be about memory because . . .

PJ: You must retain one when you are looking at the other. Of course, when we walk round an object, such as a jacket that's on a peg, we are also dealing with what we expect it to be like. We have seen a jacket before and our imagination and our memory are stimulated by something already seen and known.

DH: Yes, once you've seen something, it remains in your memory. And as time passed, a few seconds ago, that time has already accumulated in your memory.

The rendering of that figure has become so apt and effortless that it belies the burden of the attempt. It accords with Picasso's oft-quoted remark – ' I don' t seek, I find.' But such euphoric statements must be read against the more frequent kind: ' One never stops seeking because one never finds anything.' Or: ' I never do a painting as a work of art. All of them are researches. I search constantly, and there is a logical sequence in all this research. It' s an experiment in time.'

I'd never read that before, but it must be, of course, because if you're putting a front and back together to make it one, they work as one. Only thirty years ago many people, intelligent people, attacked Picasso's drawing, saying it was distorted and horrible. It isn't distorted, actually. There's no distortion. He taught us to see a great deal more, at least he did me. But thirty years ago they

Opposite:
Seated Nude 1909–10
by Pablo Picasso

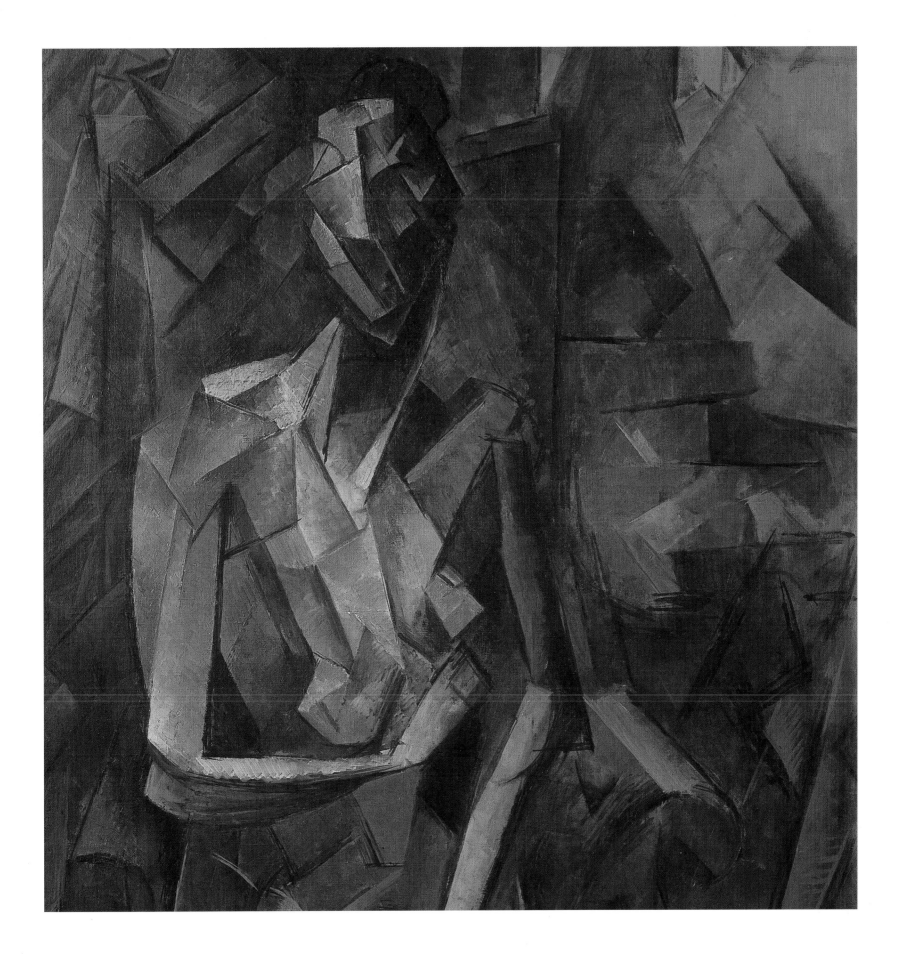

all said: *people just don't look like that*. They said that because they could only take in one moment – a fixed perspective moment. But after throwing it up in 1904 or so, Picasso then spent nearly seventy years, working every day, pursuing the problems of depiction in a way that nobody else has. Picasso's work is there: we have to learn from it. I think that art that doesn't take in his work is just a waste, although it may be pleasurable. I know his work is important, even though it may be hard to grasp.

PJ: How do you grasp time? You can't. For me there's only one other artist who comes close to Picasso and that's Rembrandt. He builds time into his self-portraits so that the man appears to age visibly as we look at the paintings.

DH: Of course, of course, and as you go on the memories are accumulating in your head all the time. They tell us that brain cells are dying, but things do go in and stay there, piling up. As Picasso grew older and older he became more and more energetic, and more and more things happened in his work. When you begin to understand what he was doing, you are hardly surprised he couldn't stop – the work was much too interesting. There is nothing else like it: no other artist got anywhere near it. Strangely enough, people didn't see it! I never doubted Picasso, I never doubted his integrity, and I never believed for one moment that he churned out stuff which was all the same. When people say this, they prove that they don't understand his work.

I don't think money meant anything to Picasso, or fame or vanity, for that matter. Even the vanity of an artist which, after all, is a strong feeling. Picasso was on his own. Nobody else has really got away from that vision we think we see. And that vision has become more pervasive in the years since Cubism. Photographs now surround us. They go through everybody's letter box daily inside newspapers. In 1904 there were fewer photographs around, but now they are everywhere.

It's interesting that now the Chinese would not make a scroll if they wanted to depict their leader making a visit to the South, and the picture wouldn't be as good. It wouldn't tell you as much. People don't believe me, but I have seen the evidence. It's a bit mind-blowing, and it goes way outside technology, which is very refreshing!

PJ: The main difference between Picasso and yourself, I think, is that you can lead people who are not artists to see much more clearly, whereas Picasso was dealing with a very esoteric area which needs an artist to decipher it. Your work can be appreciated easily by people who aren't trained artists.

DH: Picasso was seen as a very esoteric artist in the end because what he was doing was revolutionary and difficult. It had to be done in a certain way. Also, he didn't write or talk to people; he was a painter, essentially.

Picasso died when he was, what, ninety-one? Up until the last year of his life he was still painting in his studio. He wasn't very tall, probably under five feet six inches, and there he'd stand,

completely naked, in his studio, with his dogs. Imagine that little puckered bum! But what was he painting so ferociously? Huge canvases of female genitalia – the lot! Explicit, overt, sexual images. Now, just think what would have happened if he'd been in an old people's home. What would the nurses have said? 'There's a filthy old man upstairs, bollock naked, painting disgusting pictures of women's fannies and things. He'll have to go!'

Many people do say to me: 'Oh, you start talking about Picasso, David, and you make it so clear.' Well, that's only because they hear me talking with the excitement of an artist, rather than as a writer or a scholar. I get excited because I'm absorbing ideas which will eventually come out in my work. I'm so convinced of this way of seeing now: I know it will make things richer for everybody.

PJ: You were saying earlier that you thought photography was not the beginning of something, but rather the end . . .

DH: That is clear to me now. And I explained this to Colin Ford [then Keeper, National Museum of Photography, Film and Television, Bradford. Currently he is Director, National Museum and Gallery of Wales, Cardiff]. He said it was all very interesting but, after all, he had this photographic museum and all these old photographs! 'Well,' I said, 'I'm not suggesting you throw them away! They are interesting, they are documents, and if you have a museum, then put them in.' But it is the end of something and not the beginning. I'm not suggesting photography is nothing. But it is the end because it is the end of a way of seeing that was developed five hundred years ago.

The more you think it out the more obvious it becomes. Perspective is a theoretical abstraction that was worked out in the fifteenth century. It suddenly altered pictures. It gave a strong illusion of depth. It lost something and gained something. At first the gain was thrilling, but slowly, very slowly, we became aware of what had been lost. That loss was the depiction of the passing of time. We thought this way of looking was so true that when the photograph came along it seemed to confirm perspective. Of course, it was going to confirm perspective because it was exactly the same way of looking, from one central point with one eye fixed in time.

We know perspective is not real. We know the lines don't meet. We know that if you move along them all is parallel. Clearly the photograph belongs to the Renaissance picture. Cubism is the only thing that's broken the grip of the old perspective. When you look at Cubism, you realize how primitive it is, but, obviously, it can move on. The fact that all those years passed and we didn't quite grasp what was going on is neither here nor there. In many ways it doesn't matter.

I tried to break the old perspective with the joiners and, even then, sometimes they succeed and sometimes they don't. The important thing is that those experiments with photography led me back to the hand. In fragmenting perspective I had then to piece it together. You need the hand to piece it together because, essentially, you are drawing. It's not then the little mechanical instrument you are using. If you're drawing there are many choices, many ways to put the joiners together. Other

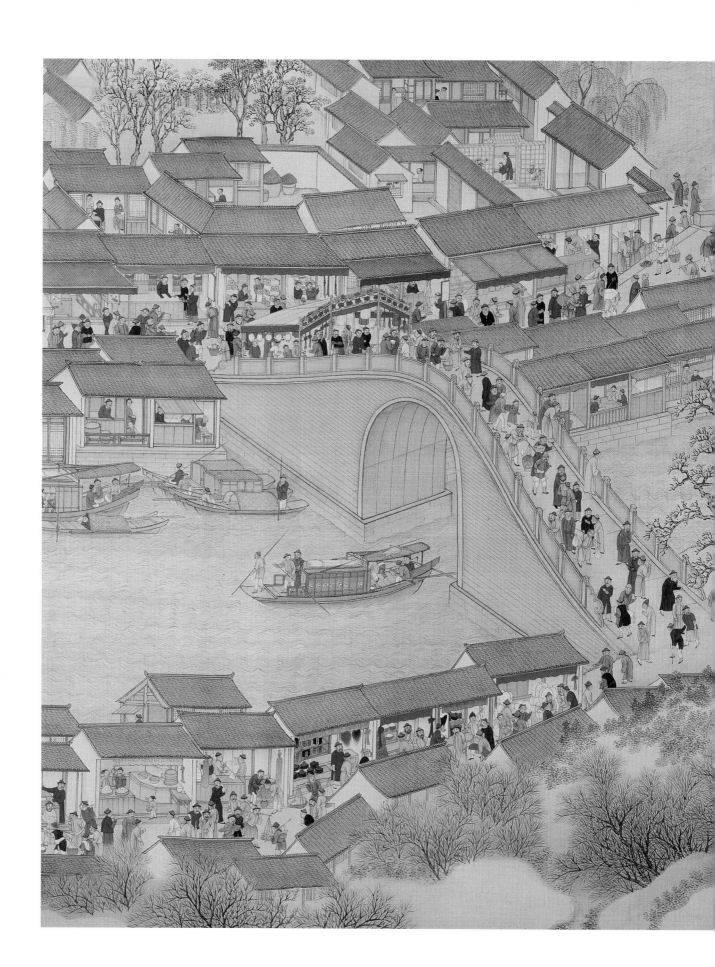

From Wu-hsi to Suchou,
the seventh Nan-hsün-t'u
handscroll 1691–8 by Wang Hui

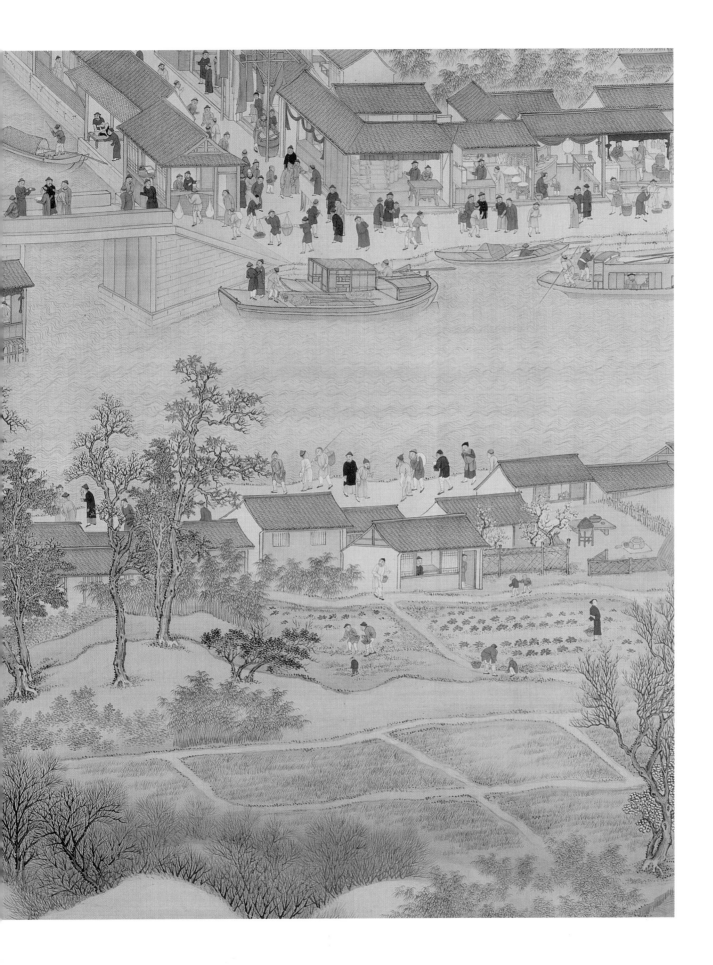

people put them together very simply because they can't draw. It comes down to that.

Picasso, however, moved on. He didn't go back to the previous ways of showing time passing, such as the Chinese scroll. And apart from Picasso, the Chinese scrolls are the most sophisticated images I've ever seen. Stunning! How vivid the experience was! It was one of the most thrilling days I've ever had.

We were on the floor [of The Sydney Moss Gallery in London], going along the scroll, and the man there began to tell me about certain special courtiers who wore little red hats. And I said: 'Yes, we passed the shop that was selling them a few feet back along the scroll there!' Now, you couldn't say that about a Canaletto. You don't make a tour of an ordinary painting in that way. You don't go into it. Essentially you're still a spectator outside it. With the scrolls, you are in there, as though you had passed the shop back there on the street, a little shop with hats piled up. It's unbelievably vivid! And it's interesting that you'd use language like that; you'd say: 'Yes, I passed the shop', because you literally had passed it and gone on to something else. How many pictures can you talk about like that? Even in a movie, the photographer has to actually show you things, but here, you choose to stop somewhere, and that act shows you that it's a vastly different way of making a picture. I don't think Picasso ever saw the scrolls. Very few people have seen them. You have to ask to see them in the British Museum in London, or in the Metropolitan Museum in New York.

The National Gallery has now bought a cubist painting. It's quite different from all the other pictures in the gallery.

PJ: In fact, the National Portrait Gallery, just around the corner, has a huge collection of photographs, and they fit very well with the paintings.

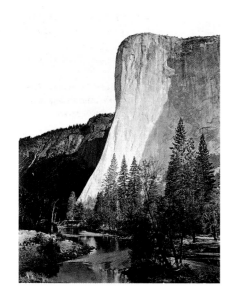

El Capitan, Yosemite, by C. E. Watkins, 1866

DH: They do fit well because most photographic portraits have been posed in exactly the same way.

PJ: And, unfortunately, most photographic portraits are superior to most painted portraits now, simply because there are so few good artists.

DH: And most of the pap painters use photographs, you can tell. They've got all the faults of the photographic portrait and all the faults of the lousy hand and brush, which makes it worse! There's the guy who does Prince Charles . . .

PJ: Orchid, or someone, Organ . . .

DH: That's it, Bryan Organ. Terrible, absolutely terrible.

PJ: I don't understand why those people are commissioned to paint portraits.

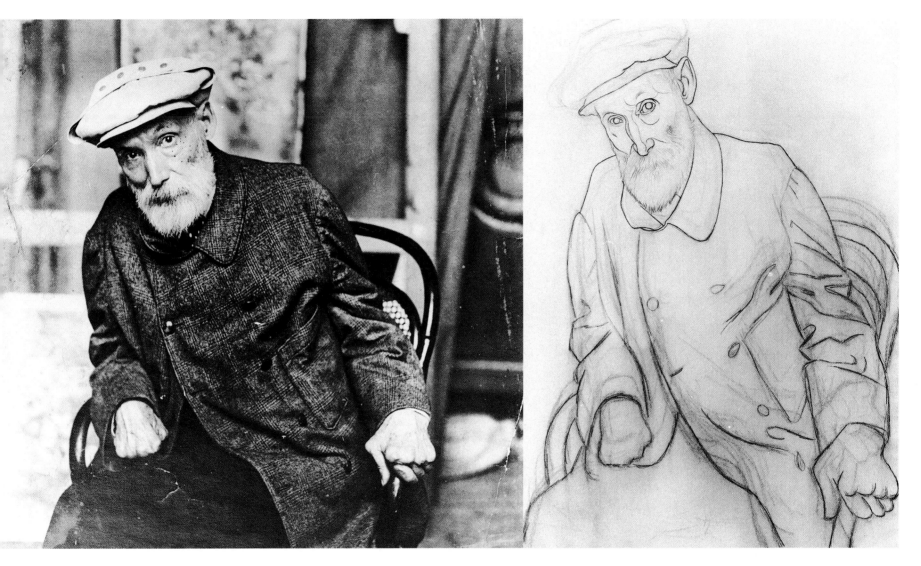

**Portrait of Auguste Renoir
(after the photograph)**
by Pablo Picasso

DH: Because nobody thinks about it. Tradition tells them that the painted portrait should be better. Some painted portraits are superb – Rembrandt's, for instance. But Organ is nowhere near Rembrandt, so photographs would be better. Nobody will admit that, though. You can't expect somebody at Buckingham Palace to start thinking this out. Their way of thinking about portraiture is completely fixed. I try to talk to people but they never come back. I say things, hoping that they are outrageous. I did a little essay for a show called *The Artist's Eye* [National Gallery, 1 July – 31 August 1981] once, and in it I made the provocative suggestion that photography was only good for reproducing drawings and paintings, but nobody took it up.

PJ: The whole essay is provocative. I'm a very traditional photographer, but I recognize that this is

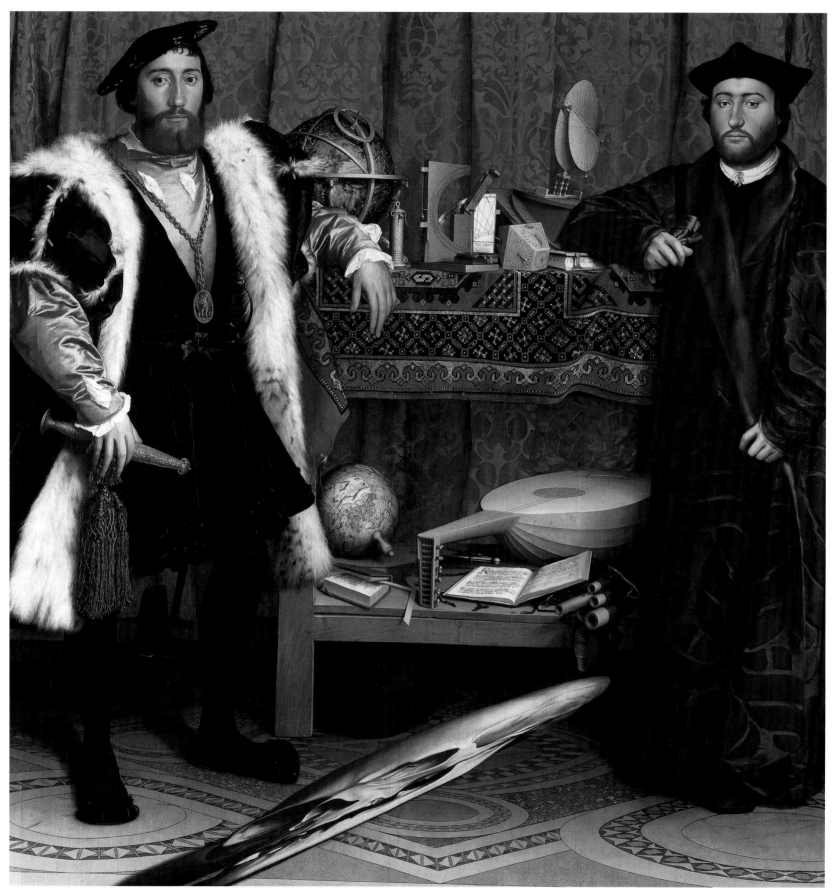

something too important to ignore. It has to be pursued. The issues go far beyond photography. Photography is just the excuse but, in a sense, it is photography which is holding us back from talking further.

DH: Absolutely. When I'm attacking photography, I'm attacking the traditional view. I'm sure people don't really think the photograph is objective reality, do they?

PJ: Well, it depends. If you take, for example, photographers such as W. H. Jackson, Eadweard Muybridge or Timothy O'Sullivan, the pioneers of American photography, many of them went out to shoot landscape photographs when the railroads were being constructed.* Their photographs were sent back as examples of objective reality. In fact, they were some of the best landscape photographs ever taken because they were taken very simply. Beautiful large-format pictures. These photographers are now being promoted as artists. Why do you think Picasso, who used photography as an aid to his paintings, and certainly played around with it, never took it that seriously as an art?

DH: Well, I was told, just about the time when I had started the Polaroids, that Picasso had said the only thing to do with the camera was to move it around.

PJ: Like you do.

DH: I think that's true. As I said, the idea of the camera on the tripod is a Renaissance idea – the drawing machine with the one hole and the man looking through it. It does create a distance effect. The great difference between the Chinese scholar-artist and Renaissance scholar-artist is this: if the Chinese scholar-artist had a garden, however small, he would want to walk in it. He would make his path so that he'd have a longer walk. He would walk up the path of his garden and then he would make a picture of that garden, or of the experience of walking in it. The Renaissance artist sits in a room and looks out of a window, and then makes his picture.

He is fixed there with the window-picture, and therefore he thinks of perspective. The Chinese wouldn't because their experience is moving, flowing, as time is flowing. So they both start off with very different locations: one is seated and the other is not. He might sit down to make his picture, but his picture is not of being seated but of walking in the garden. Then you suddenly see the difference, and see where one leads, and the other leads. If only the Chinese had invented a camera, that would have been something!

PJ: We talked about the *camera obscura*, which was an early device, hundreds of years before an emulsion was able to represent what it saw, but what about before that – was the artist still looking out of a window?

The Ambassadors
by Hans Holbein

DH: Before the fifteenth century? No. You have lateral movement. The story is told moving about. You move along, and that way things appear less solid.

PJ: Two-dimensional?

DH: Yes. In doing that you have the advantage of time. But in wanting to make it solid you must stop time; that's the problem, the core of the problem, isn't it? In creating depth you . . .

PJ: . . . abolish time.

DH: Yes, but it looks solid, so we think it's more like it is. Well, there's a point to it that's half true, but the sacrifice you have to make is the experience of the flow of time, which, in the end, is more important to us. That's life!

PJ: But what about a picture like *The Ambassadors* by Holbein, which must be the apotheosis of that viewpoint?

DH: Holbein must have used the *camera obscura* because that skull is the distortion you achieve with a camera. You can't make that up. It's so perfect when you look down at it.

PJ: Yes, I've seen it through a movie camera from a high angle which can bring the skull into sharp focus and 'proper' perspective.

DH: It's simple. Holbein was playing games, enjoying what appeared to be this new, wonderful instrument which was helping the depiction of reality. It's true, the figures suddenly seem more solid, and even today we would say – and I nearly say it myself – more real. But we must not say that because it simply isn't true.

PJ: Maybe that's one of the few exceptions. It is an exceptional picture.

DH: Oh, it's a beautiful picture! The other weird conclusion I came to, and this may seem contradictory, is that abstraction didn't come from Cubism. It came from the Renaissance picture. Cubism actually opens up narrative again. Cubism is about time, but we have been told that it's the other way around. If you think about it, the fixing of shapes because of perspective limited narrative in painting more and more from the fifteenth century on. Telling a story got more and more difficult. You had to pick one part of the story; you had to stop it. All right, you got solid people, but the figures are frozen, and the picture can only contain one or, at the most, two events.

With perspective people began to pose, as they do, even today, for the photograph. 'Sitting' it's called! And, slowly, it made narrative more and more difficult pictorially until, finally, you got one kind of illustrative action. That's all you could deal with. Whereas Cubism opened up such incredible narrative possibilities that I think I can understand the frenzy of Picasso's work. Of course, you wouldn't stop. You'd just keep on. I think his work will go on revealing itself.

PJ: And they always want to say about an artist: his earlier work was better than his later, or his middle period was more exciting, just to put a value on things, so that they can say that the later pictures aren't worth owning.

DH: It's actually more about commerce than art, but it should be about something really important that would enrich us all, make experience more vivid. I think so. I keep groping.

PJ: What is it that photography has failed to do, do you think? Has it a fundamental flaw?

DH: Photography *has* failed. I talked in the Picasso lecture [given at the Los Angeles County Museum of Art in 1982] about the documentary nature of photography precisely because we think it's a good documentary medium. Well, there it has failed. I had seen it already in the Chinese scroll of the journey. I said a movie couldn't be as good, and any photographic documentation couldn't be as good as that scroll. You don't experience photographs in that way.

How many truly memorable pictures are there? Considering the millions of photographs taken, there are few memorable images in this medium, which should tell us something. There have been far more images made this way than the sum of all previous images put together.

Twentieth-century art is so self-conscious that it has isolated itself as if it were a completely separate activity. I've heard very serious people say some strange things to me. I had an argument once with [the writer and critic] Suzi Gablik, who said to me, 'Well, art isn't for everybody.' And I said that if I believed that, I think I'd shoot myself! It can't be true. I said to her: 'You've reduced it to the level of jewellery, frankly. Jewellery isn't for everybody, and it doesn't matter, it's not that important.' But art is not on that level, it's on a much higher one. She was maybe suggesting that people are too dumb, but this cannot be true either. How do you then account for the fact that all societies, even primitive societies, make art? We all need it. It may be that the vast majority of people appreciate only very low art, but it is still art.

Without images how would I know what you see? I don't know what you see. I'll never know, but these flat images are the only things that connect up between us. Just because we don't bump into each other, it doesn't mean that we all see the same thing, does it? Obviously some people see more. Their profession may make them see more; it could be just that. Photographers and painters may see more because they are looking for more. The evidence is strong that Picasso saw more than anybody else.

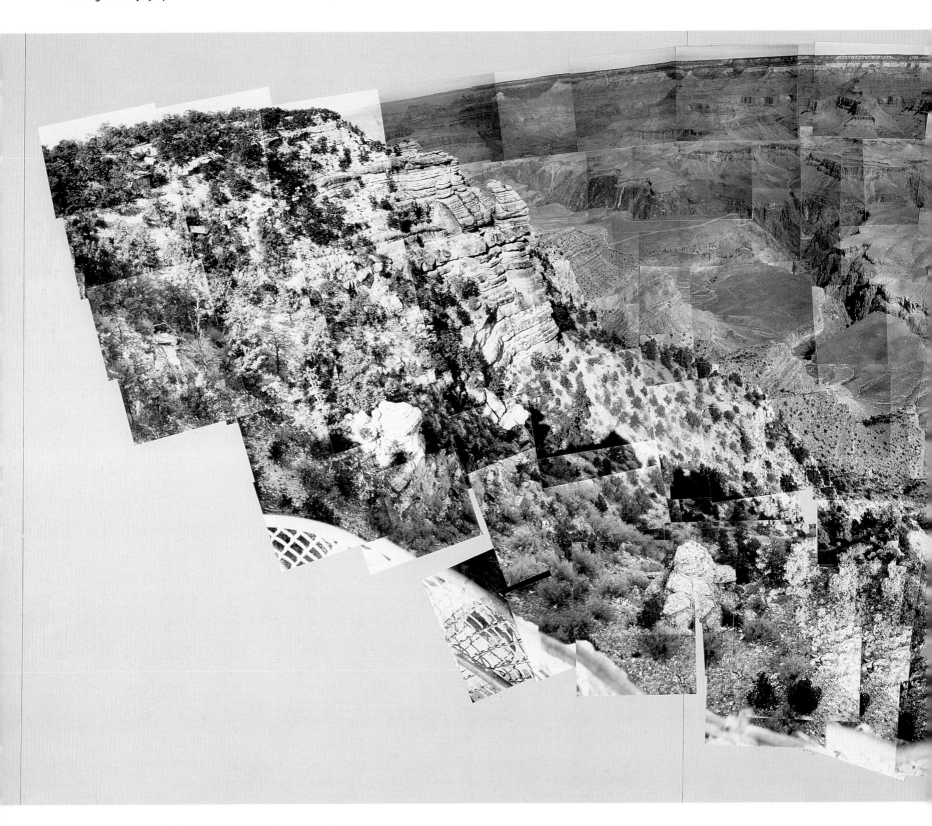

The Grand Canyon Looking North, September 1982. Photographic collage

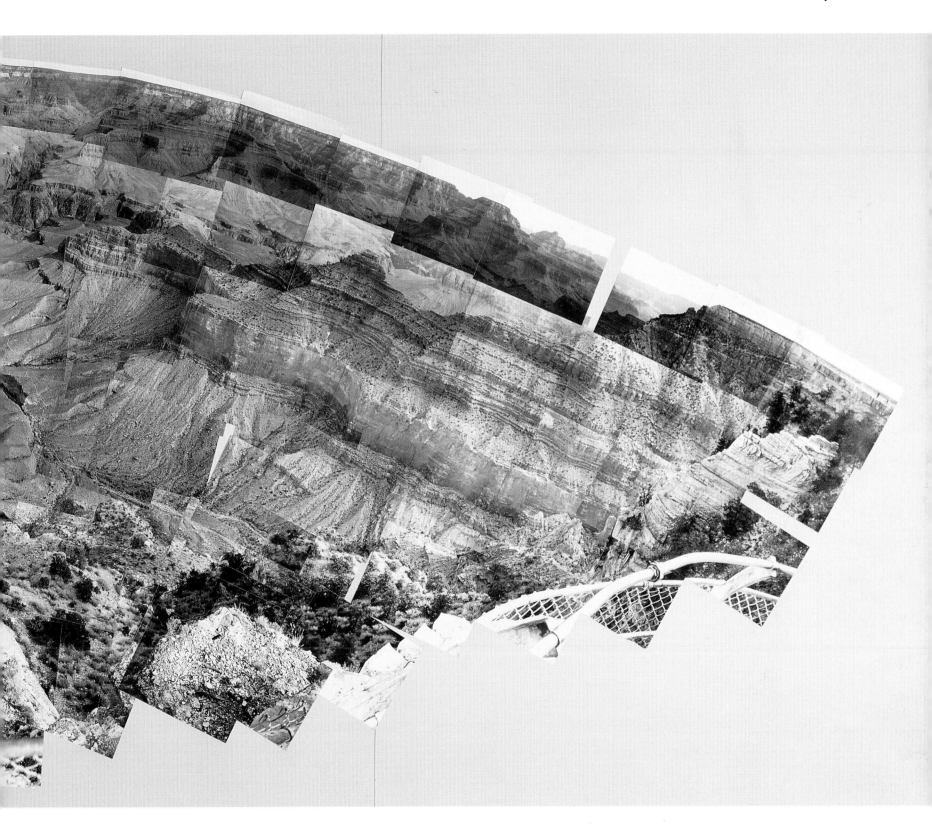

I'm suggesting photography should be attacked partly because it has an official position. If it didn't have that official position it might be slightly different, but it does have all over the world. Photographs have become necessary to identify things. This presents a way of seeing that suggests it is the official and right way. Well, that's what I'm criticizing, essentially. Photography doesn't get nearer experience. Painting gets nearer to it because it can do far more. Its way of seeing can extend all the time because it's related to us. And that's where the hand comes in – then we know our own body is dealing with it. I don't think people have really attacked photography before. They don't bother! And possibly there was no reason to before. I had no reason to, but the more thought I give it the more reason there is for attacking it. When I say attacking, I'm really suggesting a debate. Let's start discussing it. The world of painting almost stopped the debate. It went off on its own. There's Man Ray's comment: 'I photograph what you can't paint, and I paint what you can't photograph.' That's very good. It's a start!

Now, apart from the other problem with the photograph, there is a pictorial flaw. It all boils down to the lack of the hand. When I suggested that you couldn't look at a photograph for very long the way you could a painting – that photography does not have the ambiguities that painting has – I said so because of my realization of what I call 'the flaw'. And 'the flaw' gets more and more obvious the bigger you make the picture. In the Anthropology Museum in Mexico City there are some very, very large photographs, and the bigger they are the flatter they seem. Partly this is to do with scale, because your eye has to move from one corner to another. You are moving through time and the image is not. But any drawn image is moving through time because of the hand at work. So I think that flaw is serious, although it can be overcome by the techniques I use myself, and then the experience of looking at something is much more parallel to real experience. The work I did is certainly not all the same. I think there's a clear progression of rising complexity, the more I realized what I could do with it. The last ones are the most complex and the most satisfying, I think. These get closer to experience. I'm moving about more and more. I had to remember not only where I had been and what I had photographed, but where I was when I took the photograph. I had to train my memory to do these joiners. The great big *Grand Canyon* photographs trained my eye to see things in a certain way. Photographing the world's biggest hole, I was photographing space. We can't comprehend space itself – it's infinite – but we can glimpse it in the huge hole of the Grand Canyon.

Obviously, there are limitations with this work: the photograph can't make the picture as I'm making that painting there. I have to go somewhere with a camera to photograph something. With painting I don't, and that means there's something more going on in the head. That's the exciting thing to me, and the reason I stopped using the camera and went back to painting.

Of course, photography completely altered my painting. Although I said I was drawing when I made the joiners, the work I was doing was also photography. It was made with a camera and with what I know of photography. In another sense it is drawing because you are making choices all the time, and the choices seemed to me to be the kinds of choices you make when you are drawing. It

might appear that you're cutting down what's there, but actually you are finding out more of what is there. It's like editing, really.

I couldn't make these statements without the work. I've heard people say: 'I don't think much of photography!' Alan Bowness of the Tate Gallery has said that to me, but he couldn't state why. It would be difficult to make my case without something positive. I suggested my work was a critique of photography made with photography. After all, it's no good using language to do it. You've got to use the photographic language.

Certainly, the pictures are difficult: true art can be difficult. Cubism must have seemed very difficult and strange to a great number of people – it looked as if things were being smashed up. Actually, it was the opposite. Things looked strange because Cubism was a different way of seeing, a different way of making a depiction. It looks a lot less strange to us now, even though many people think it's not reality. But Cubism has a long way to go. My photographs should make people look at Cubism a little differently.

PJ: They have. They are both commentaries on and extrapolations from Cubism.

DH: People should go back to Cubism more. Somebody told me it was a pity they didn't have my show before the big cubist exhibition at the Tate Gallery [*The Essential Cubism, 1907–20*, 27 April–31 July 1983] because more people would have gone to it. I thought it was the best cubist show ever put on. I went eight times: I thought it was absolutely thrilling. I got such a feeling of closeness.

I'm sure that not many photographers would have thought of going to the Cubism show. They would not have thought it relevant in any way. But I'm sure good photographers look at painting. Cartier-Bresson must have done: he trained as a draughtsman. I would have thought that anybody who is interested in pictures would be interested in photographs. I said there had been no cubist photography, and the historians of photography attacked me for that. But I'd still say it because I think what they call cubist photography is very superficial.

PJ: They were simply using abstract shapes.

DH: Yes, shapes and shadows and so on. I wouldn't call that Cubism. I don't think many painters, or even many critics of painting, would. Douglas Cooper, who organized the Cubism show, would dismiss it. He was dismissing a lot of other painting that claimed to be cubist. I can see what he meant. It takes a long time to understand Cubism fully. The advantage in photography is that people do believe the photograph. They believe it was made in a certain way, and they believe the photographer was there, essentially.

Last Christmas I was in London, and Mark Haworth-Booth [Assistant Keeper, Department of Prints, Drawing and Photography, Victoria and Albert Museum] had come round to get me to talk

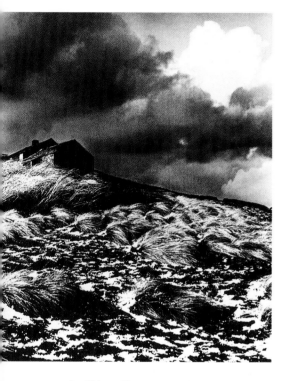

**Top Withens, West
Riding, Yorkshire**
by Bill Brandt, 1945

on the tape recorder about Bill Brandt's photographs – specifically those in the book *Literary Britain*. Many of the photographs are very striking – there's one of Top Withens in Yorkshire, which is a very dramatic photograph. I looked at this one for quite a while, and I started asking him some questions about it. I said: 'There's a very bright light in the sky back there, but the grass in the foreground has also got a very bright light coming towards it here. He must have used a flash of some sort.' And he said: 'Ah, the sky is from another negative.'

Well, this horrified me, and I suggested this was Stalinist photography. It was a collage, really, but there was no evidence of it being a collage. There's nothing wrong with collage at all, but it should be quite clear that one thing is stuck on top of another. This photograph was not like that, and so people would assume that it had been made from a single image. When you can tell that the sky is from another day and yet you pretend that it's not, then I think you can talk about Stalinist photography. The reason that Stalinism works in photography is that we do believe what is there in front of us. When Trotsky is next to Lenin, and then he's taken out, the picture suggests that Trotsky was not there at all. Painting is not the same. You can paint a picture of Lenin making a speech and never put Trotsky there, as though you never noticed him. But the camera is not like this, and so you're back to the point that what you depict should be in front of you. So these techniques seem deceitful to me.

PJ: I think you're using photography to address a much wider audience.

DH: I am. I'm suggesting that painting should do certain things again. It should be telling us about the visible world. Picasso was always telling us about the visible world. He never went away from it. That's no accident, you know. There's a good, solid, sound reason for it. And I'm speaking to myself, for my own painting, but I'm also speaking to others.

The great pity is that now you need something like the Royal Academy was, but is no longer. When it was founded, most of the good artists of the day were either members of it or they exhibited there. It was an organization of artists run completely by artists. There were no critics; there were no curators; there were no people who were not involved in both the theory and the practice of painting. The Royal Academy today is not like that. It's become a charming, idiosyncratic little place, but nobody takes it very seriously.

Only artists look at late Picasso and see what's there, because only artists can do something about it. They are the only ones with influence. A curator can't influence anybody. All he can do is write books. The change must come from artists. If our generation doesn't deal with this another will. It's too rich; it's too interesting. If the Royal Academy was seriously committed to art, it would know that. I'm not criticizing; I'm simply saying it's anachronistic.

I went in one night just before *A New Spirit in Painting* [15 January–18 March 1981] opened at the Royal Academy, and Howard Hodgkin was hanging his pictures. The people who organized the exhibition suggested he take one of the pictures out: they didn't like it. I said to Howard, who quite

liked it: 'I wouldn't take it out. You just keep it there. If they ask you again, just say you'll take the lot out and leave an empty room. They'll notice Howard Hodgkin's empty room!' Anyway, Howard took it out in the end. I argued with David Sylvester [the curator of the exhibit] that they should give Howard the benefit of the doubt. If Howard wanted his painting to stay in he had a reason. He's an intelligent artist, a very good artist. Who is the other guy to make him take it out? And I asked David Sylvester if he could imagine, in 1890, some men in Paris, intelligent men, organizing a show called 'The Painting of the Eighties' – what did he think would have been in it? I bet you very little of what we now think is the good painting of the eighties, probably no Van Goghs. He'd just died. If people had seen one or two of his paintings, they probably would have thought they were not very good.

It's the same now. These people, with all the good will in the world, can't see. In fact, the treatment of late Picasso is a classic example. I think this is what happened – and people will tell me off. From 1910 to 1950 Picasso dominated painting. Anybody who had a serious interest in art knew and looked at Picasso. After World War II, American painting was probably the first painting that looked as though it was un-Picassoesque and yet modern. It was thrilling for people. Thrilling. They thought they were out of this terrible yoke, this dominant thing. It did look as though Jackson Pollock was un-Picassoesque. Well, he is Picassoesque, actually. His work is from Picasso. It couldn't have happened without Picasso, and his debt is bigger than we think. You can understand why people were thrilled to think they were getting away from this giant, but we haven't got away from him; that's the problem.

I've always complained that the trouble with a lot of modern painting is that it is not interested in the visible world. That simply means that artists must go in on themselves, and their art becomes an internal one. This is okay but it can be merely therapeutic, and then it moves out of the realm of art. That's the theoretical flaw in it. I'm not suggesting exciting art hasn't been produced in this way. There is certainly exciting abstract art, but I think the claims for it were very overdone – especially the idea that the visible world would disappear from art. I do think that is a naïve idea. It cannot be. The visible world is too interesting and fascinating to us, especially the figure. The figure can't disappear from art. In fact, the only time it disappears from art is when it's proscribed, as in Islamic and Jewish art, which is abstract, highly developed and of great beauty, but inevitably becomes ornamental.

I never saw abstract art as 'new'. The principles are certainly a lot older than 1910! People have known about them for ages. But an art that's not based on looking inevitably becomes repetitious, whereas one that is based on looking finds the world infinitely interesting, and always finds new ways of looking at ourselves. I did get embroiled in a few arguments in the art world over this theory, but I knew that painting would deal with the physical world again. Of course, without drawing you get very crude results; you need this skill to accomplish things. It will happen though. There are signs that painting is recovering, taking notice of the physical world once again.

Lenin Addressing a Meeting in Moscow.
The figure to the right of the podium is Trotsky, who was subsequently eliminated from official versions of this photograph

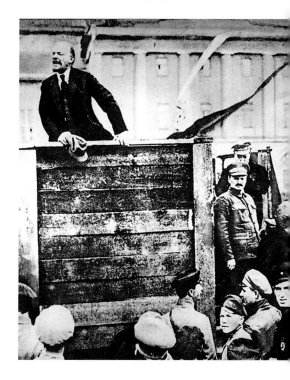

There was a crisis a few years ago when people moved on to conceptual art and the idea that you could have art without the object. But all that was leading to a dead end. There's always been art without the object: it's called poetry or music. It's always been there. But the idea of being able to make a visual art without an object is just crazy! We need depictions. Unfortunately, people were leaving depictions behind because of photography. The depictions that were being made used the camera. 'That's fine,' they thought, 'the camera's dealing with that area now.'

Look at what happened a few years ago with what they called 'neo-expressionism'. It seemed then that people wanted to make depictions. But we all want to make depictions. It's a very deep desire and it won't go away. The moment depictions appeared again in painting, people had to reconsider Picasso's work. It couldn't be ignored. Of course, the moment it is looked at, it is obvious that Picasso's work is much more interesting than what we call the new depictions, which are mostly an old way of seeing.

Unfortunately, according to art history, Cubism's influence was on abstraction and not on realism. Realism went its own way, they said, but Cubism *was* realism; that's the point. It's all difficult. Picasso made it difficult, but it won't go away. It has to be dealt with. I certainly have to deal with it, and I don't know whether I can; I haven't that kind of talent. Nobody has the kind of talent that Picasso had, never mind the soul! He has opened up things, so that they can be developed. In that sense his achievement is incredible and unique. But his work is open-ended. It can go on in a way that Mondrian's art, for instance, cannot. Mondrian took his art to a kind of conclusion.

I'm sure that the only way art can be replenished is by going back to nature. You don't just look at Picasso: you look at him and he tells you to go to nature. Nature is infinite. The idea that we've absorbed nature, and painting can go on to something else, seems naïve to me now. Of course, many abstract painters never said that. They said: *this is about the visible world*. At least the abstract expressionists said that, but in the sixties people did claim otherwise. Frank Stella, for instance, said that it's just what you see there, that's all there is. Essentially, he was saying that there's just the surface, and that's it. That takes away what you might call magic in art. I use the word 'magic' because I don't know what else to use, but the magic is there, I've no doubt of that. The magic is the bit you can't quite define.

I think we could be entering a much more fascinating time in art once again. I know there are people who think my claims are ridiculous, and I know those people would love to push me aside. I also know that they can't quite do that! People are annoyed that I might be more serious than they think. Well, that amuses me, of course. I'm perverse enough to be amused by that. You know, if people ask some kind of dumb question, such as 'What's it like to be a successful artist?', I don't know what to say, and so I say that I don't really see myself that way. No artist could see himself that way, really. It's a struggle; it's always a struggle.

PJ: You are well known. That must make life difficult at times.

DH: That's why it's better for me in Los Angeles, you see. If I was in London I couldn't isolate myself quite the way I can here. There's a constant barrage of 'Would you do a talk on TV?' and I get a bit fed up. I only do it if I've something to say. I think that's the main reason I came back here, apart from the visual stimulus from the surroundings. You still have to deal with the mechanics of life, everybody has to deal with these, but I've got it quite well organized – other people do it for me! I'm not an extravagant person; I work most of the time. All I need is space and equipment, and as long as I have that then, frankly, I couldn't give a damn. Although I think the public image is quite different, isn't it?

PJ: Your public image is one of colourfulness and flamboyance. You duck behind the public image which is in effect a smoke-screen hiding the serious work.

DH: I don't really do anything else but work.

PJ: That's clear. Your output is prodigious. And it was clear that you weren't sleeping when you were working on the joiners. I knew you couldn't have slept to have got through that. And somehow it's photography but it's not photography. That's what fascinated me.

DH: Well, I said that: it's not photography because it's to do with drawing, yet it is photography because it's using a camera!

PJ: It's interesting that painting moved away from so-called naturalism at the time when photography was proliferating in that area. Photography has got a lot to answer for in that respect, hasn't it?

DH: Yes. And also it's probably no coincidence that about the same time Cubism was being formed, when only a few people had seen it, the movie happened too. Now, the moving picture would appear to be much more radical than the cubist picture. In one way it's more like life, but in another way it's not. The movie is still the same way of seeing. It gives an illusion of movement, but the time experienced is linear. You can't go back with it, you can only pretend to go back, while that wheel is relentlessly going forward. And that fucked up the flow of ideas which now we might be beginning to see . . . But the movie was so exciting! Wonderful things were done with it, so what did it matter? You could make movies in a different way. All attempts at 3D movies or 3D photography are trying to make things more real. They bring the screens right round you. There have been various experiments, and all of them failed because they didn't bring you closer.

The joiners do bring you closer. You could make a much more 3D movie on the same old flat screen using a depiction. All those attempts to bring everything in around you are part of a naïve belief that you can re-create the whole world. Well, you can't. Where would you put it? Next to the

**My Mother, Bradford,
Yorkshire, 4th May 1982.**
Composite polaroid

whole world? I mean, there's no place for it. It's a mad idea. It has to be a depiction, and depictions can be made more vivid with the present technology. They could have been made more vivid fifty years ago. But it takes time to see all these things. They certainly could be made now.

PJ: There seems to be something in the very nature of the photographic medium which is not life-enhancing. You know that John Berger [novelist and art critic who has written extensively on photography] said that photography is all about death.

DH: There's something in that, in the sense that duration is life, and the photograph has no duration. It is dead in that sense.

PJ: I came out of your exhibitions, particularly the one with the picture of your mother *My Mother, Bradford, Yorkshire, 4th May 1982*, and the one of the yellow guitar feeling more excited and wanting to go back to life, more so than with any other photographic show I've ever seen. It was full of life, and there's death in almost every other photograph that I know.

DH: All photographs share the same flaw: lack of time. Painting has never suffered from that. With photography, the way of seeing is one problem, but there are still those chemicals which take away the time so that it is all seen instantly. It does all relate, you know.

PJ: Only for those with the eyes to see!

** The Ryoanji Garden in Kyoto, Japan, one of the oldest and most renowned of all the Zen gardens, was probably laid out by the tea master and painter Soami, who was active in the late fifteenth century.*

** W. H. Jackson and Timothy O' Sullivan were both official photographers for the US Geological Survey, which was a government agency set up to record territory for the purposes of creating national parks. Jackson was employed by the Survey from 1870 to 1878 and his documentation of the landscape was instrumental in establishing Yellowstone as the first national park. O' Sullivan joined Clarence King in his expedition along the 40th parallel for the Geological Survey in 1867–9, and photographed with the Darien Survey to Panama in 1870. In 1871–5 he worked on the Wheeler expeditions to California, Nevada and Arizona, and documented the culture and landscape of the South West Indians in 1874. O' Sullivan was made Chief Photographer to the Department of the Treasury in 1880. Muybridge was a photographer for the Coast and Geodetic Survey.*

Mexico City, May 1984

David, who had known Dennis Hopper for twenty years and rightly guessed that he would require more than a couple of weeks to recuperate, invited me to join him on a visit to Mexico City. The Museo Rufino Tamayo was mounting a retrospective exhibition of theatre designs (organized by the Walker Art Center in Minneapolis and subsequently shown at the Hayward Gallery in London) which also included a room devoted to David's photography. He planned to supervise the reproduction of certain exhibits for the London catalogue and posters, and to experiment within the model of an opera set with his own photography.

Because the exhibition at the museum was open all day, we had to work at night, between 8 p.m. and dawn, lighting and photographing the exhibits. David, all the while, was making his own 35mm and Polaroid joiners. During these nights I was able to shoot a few pictures of my own of David – often when he had dropped off to sleep.

The week we spent together in Mexico produced some of our longest and most intense conversations. It is rare to have so much of David's time so freely given. Even at his Los Angeles studio (which is deliberately cut off from the telephone) there seemed to be constant interruptions and demands made on him. In Mexico he was able to relax. He also became passionately interested in Mexican history, devouring book after book, visiting the museums and spending hours in front of the Diego Rivera murals. Rivera's depiction of social and historical events in Mexico's past engaged David's attention greatly (although many key references were lost on me) but it was the human interaction and movement of the figures which he studied in particular detail. The physical size of these works would have intimidated most artists, but David examined them at the closest of quarters. Sometimes when I glanced at him he seemed to be almost absorbed into the murals themselves, a fascinated participant rather than an objective spectator. A whole day raced by at the Anthropology Museum, which David rightly believes to be one of the wonders of the world.

It soon became clear that David was communicating in a quite unusual and concentrated way. I would start each session with a definite set of questions but these would largely go unspoken. He would move from topic to topic with great speed. I had to go with the current; any attempt to fight the tide was tiring and counter-productive. These conversations were undirected, but I believe they constitute Hockney's most sustained dissertation on the relationship between art and photography. We stopped talking only when David was working or sleeping. The pieces of extended question and answer were beginning to interlock like an enormous, philosophical jigsaw puzzle, and it is in this spirit that they have been edited together. Thus the necessary interruptions to the dialogue were less important to acknowledge within the text than keeping the flow of what was effectively a week-long conversation.

Our discussions in Mexico took place at: the Museo Rufino Tamayo; the Anthropology Museum;

Hockney asleep on route to Mexico.
Photo Paul Joyce

Hockney looking at Murals by Diego Rivera, Mexico 1984. Photo Paul Joyce

the Camino Real Hotel, David's suite there and the coffee shop (he avoids bars, being uninterested in alcohol and bored by drink-induced banter); in front of Diego Rivera's murals; at two or three fine restaurants; and in the streets between the hotel and the museum, a walk of some twenty-five minutes during the late evening rush hour and the extreme quietness of dawn.

PJ: Can you talk a little bit about memory, the building of memory into images?

DH: This is the hardest thing of all to talk about, because it's so weird – memory, vision, what we're seeing now. And when I say now, I mean at this moment, now altered because time is always flowing – our life is going on. Memory must be part of vision, because everything is now. The past is now. Because each of us has a different memory, this proves to me that objective vision cannot be. When you look at this, you remember that you've seen things like it before. Your memory comes in and forms part of it, contradicting the objectivity of vision. I think that garden in Ryoanji is one of the most radical of the photo-collages because it's a memory picture in a way that an ordinary

Walking in the Zen Garden at the Ryoanji Temple, Kyoto, February 21st 1983.
Photographic collage

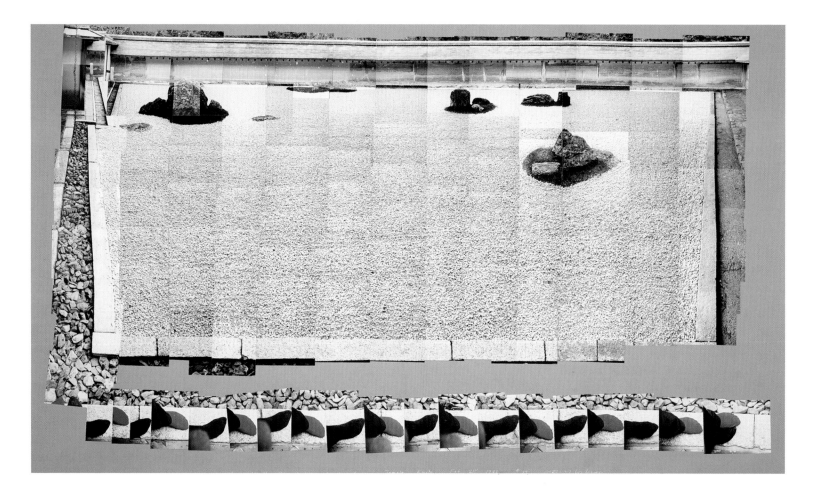

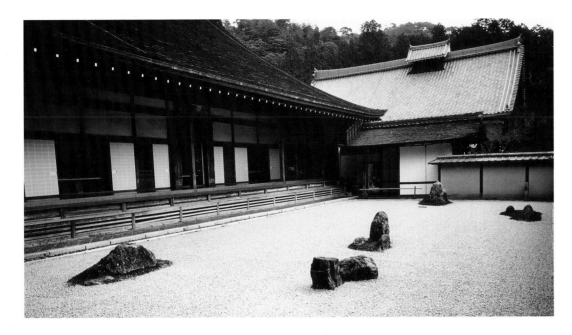

Standing in the Zen Garden at the Ryoanji Temple, Kyoto, 1983.
Photo by Paul Joyce

photograph can't be. It's not possible to see the garden that way. You can only see it in an accumulated way in your memory. If you stop at any one point, it doesn't look like that, yet it must look that way in your mind, especially afterwards.

Think of that garden! When I think of the garden I think of my pictures of it, because they were a scrutiny of it. In a way, this is the most interesting aspect, because it makes you realize that what and how we're seeing are different for everybody because their memories are different. Again, this is what Picasso is about. If he makes a painting of a face showing front and sides, different aspects, it's a memory picture because we can't see these all at once. We see them over a period of time. It's really a more truthful way of representing what we see. My photographs are linked very deeply to Picasso. I always said that his questioning of the way of seeing was the source of his art. The most mysterious aspect of it is the hardest to grasp. Do we see after images? Do we see before it happens – which sounds absurd and irrational but might not be? Oddly enough, the movie can't quite deal with this because it deals with linear time. You're seeing many pictures that give one illusion. The pictures are made in the old way of seeing just one thing at a time, and they simply accumulate. The movie and the photograph, that way of seeing, may have affected us much more deeply than we think.

PJ: So it's more difficult to effect change, more difficult to make people see the other possibilities.

DH: Yes, this may be why people lost interest in Picasso. I've noticed I'm more interested in Picasso than I am in the movies, but I loved them when I was young. My father loved them too, and we went two or three times a week. We would see anything, anything. Just looking at the moving picture

was enough. Imagine what it was like in 1910 when people first saw moving pictures. It must have been thrilling! It's less thrilling to us now because it's all around us, twenty-four hours of continuous television. You can see it any time you want. And we accept it as a vivid depiction of reality.

Remember that the movies were a silent, totally visual medium. Most movie techniques were worked out by 1928. Then sound was added, and they thought they were making films more real by doing this. Unfortunately, they simply added sound to a form that had been worked out for another way, a visual way, of telling the story.

It's interesting that television is actually the other way around. It began as radio, simply as sound, and then they added pictures to it. In the silent movie you had to fill in the dialogue yourself, although the characters were there in front of you and you somehow knew what they were saying. The radio play was devised to give you the feeling of what something was like. They

Still Life with Apples 1893-94 (detail)
by Paul Cézanne

worked out a form to tell the stories only with sound. Both have become polluted mediums, meeting somewhere in the middle. They have not been worked out properly. The first talkies worked so well at the time because they relied heavily on the dialogue. They were witty and enjoyable and clever. But I think now something has happened. Both TV and films are a bit flat – they need expansion.

More vivid depictions can be made, and will be in the future, I've no doubt. This leads to the central problem of depiction: that it is not an attempt to re-create something, but an account of seeing it. That's what a depiction should be. Cézanne told us that. He wasn't concerned with apples, but with his *perception* of apples. That's clear from his work.

I told Alain Sayag that the main problem with the photograph has to do with time. I said that

Opposite:
Noya and Bill Brandt with self-portrait, Pembroke Studios, London, 8th May 1982.
Polaroid collage

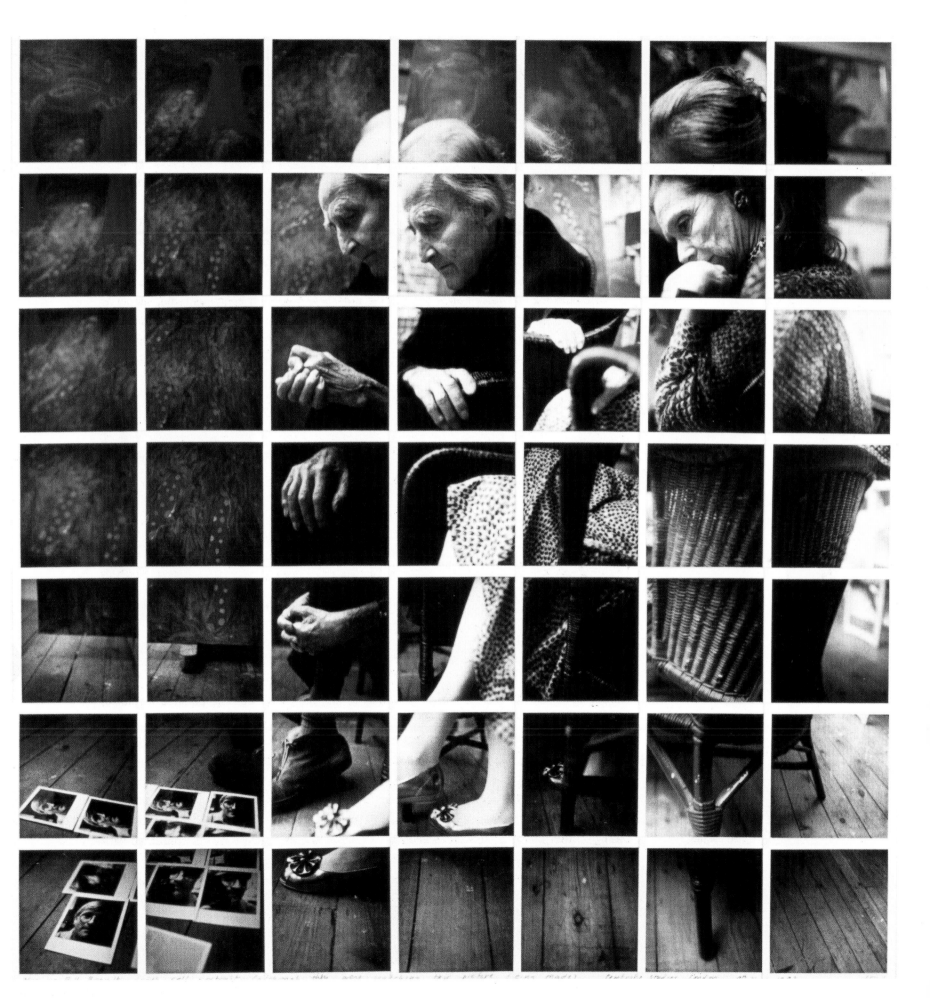

there is no time in a photograph. He replied that sometimes it takes a long time to compose a photograph if you are arranging things. I protested that this didn't count because the time wasn't then in the seeing. That is like suggesting that the genius of Cézanne depended on how carefully he arranged the apples before he started painting. The important point is not the arranging of the apples! He spent very little time doing that. It's the seeing of them, and his account of his seeing them, that is important. All Cézanne's questions are there in the seeing, and he questioned things all the time. People simply hadn't questioned things before. They accepted the way in which they saw.

Picasso and others then took off from Cézanne, and now I'm trying to take off from Picasso in an even more radical way. Things can become more vivid because they are closer to the truth. I haven't seen anything anybody has written about those photographs [the first Polaroid joiners] which would link them to Cézanne, questioning what's happening when you see using a camera. Cézanne would have done this with a camera – in the end he would.

A Professional Fireman,
black and white reproduction from a colour
photograph by John Hinde c. 1944

PJ: Perhaps movies or television are closer to most people's perception of the world. Life is a moving picture that comes through a tube courtesy of somebody else. You gaze through your little frame, it passes by, and you go to sleep. You wake up and there's another little frame. Life, though, shouldn't be like that.

DH: I've no doubt that the photographs I took will make people look at everything in a more interesting way: the little tear on one piece of paper, the shadow on another. But good painting has always done that – made you see things. The most ordinary can be the most extraordinary.

PJ: Why is it that photography, which, after all, has been around now for a hundred years in a fairly advanced state, hasn't taught us to look at everything in a more interesting way?

DH: Well, it's because its way of seeing was fixed. I'm sure of that. I had a lot of conversations with Annie Leibovitz a year ago when she photographed me – she's a very bright girl. She confessed that my photographs disturbed her, but she thought what she was doing was all right because she was working within the limitations of photography. My photographs had disturbed her because they had extended the limitations, and therefore she was now working under artificial limitations. She then asked me what she should do? I said: 'If I were you, I'd adopt these joiner techniques because they will make things more vivid.' She was frightened of that because she thought it was my style. I said: 'I don't think it is – you do it in another style.' But it isn't a style, it's a technique, and different people can use it to express themselves in different ways. But are we going to see it?

PJ: I think we're going to see it first from you. Your style won't change, but I think that your interests will, and that will be reflected in new work. What worries me about photography is that people can

produce almost exactly similar images, and it's very often impossible to tell who has taken a particular photograph. Then you get someone like Annie Leibovitz who paints Meryl Streep with a clown's make-up and has her holding her cheek at an odd angle in order to make it a different image. And some of Leibovitz's images seem to me to be stamped with a meretricious surface concern which in turn has become her style.

DH: It's because she thinks that the only thing she can do is alter the subject matter, because she can't alter the seeing of it. I'm suggesting that the subject matter is less important. It's the way it's seen that's more important. That's like suggesting that Cézanne wasn't any good because those apples weren't any good. They were cheap apples. Why didn't he buy the better quality ones?

PJ: Exactly. All Leibovitz does is create a different surface.

DH: It's cosmetic, really. I told her that. She hated me saying that. And when we got out to the desert she'd taken all these lights as if they were making that picture.

PJ: Your picture tells a story. Hers is just a flash picture taken in the middle of nowhere with a lot of equipment.

DH: Well, that's why I made my picture. It was mocking it, obviously mocking the process. And it was made with the camera that happened to be in my pocket. Sticking the joiner together, I asked her: 'Could you give me one of yours and I'll stick that on as well?' But she understood, when I showed it to her. She said: 'You've got the picture.' She's not a dummy at all.

PJ: She sees she's trapped by the medium.

DH: She's very aware of that.

PJ: Most photographers are trapped by the medium. It needs an artist to come along and throw the restraints to one side.

DH: In the end, only an artist can do that: it's the artist's job.

PJ: Many of the best photographs I've seen have been taken by artists, not photographers – Humphrey Jennings, Paul Nash, John Piper, Henry Moore, for instance.

DH: I have here a book about people working during the war. [Stephen Spender with colour photographs by John Hinde, *Citizens in War – and After* George Harrap Ltd, 1945. This book was an

An Ambulance Attendant,
black and white reproduction from a colour photograph by John Hinde c. 1944

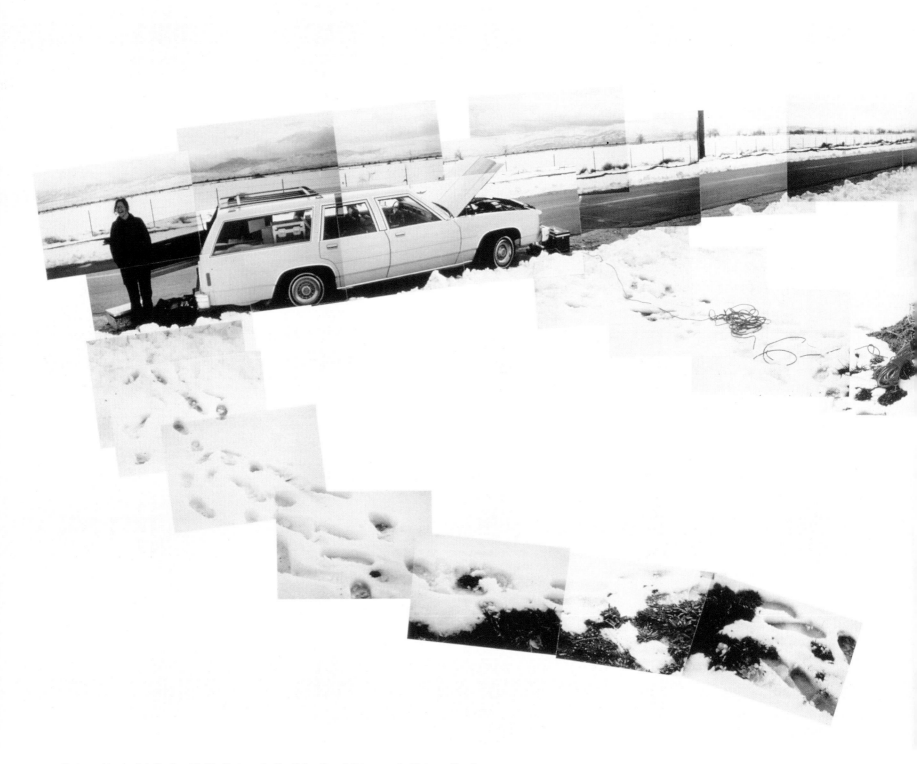

Photographing Annie Leibovitz while She Photographs Me, Mojave Desert, February 1983. Photographic collage

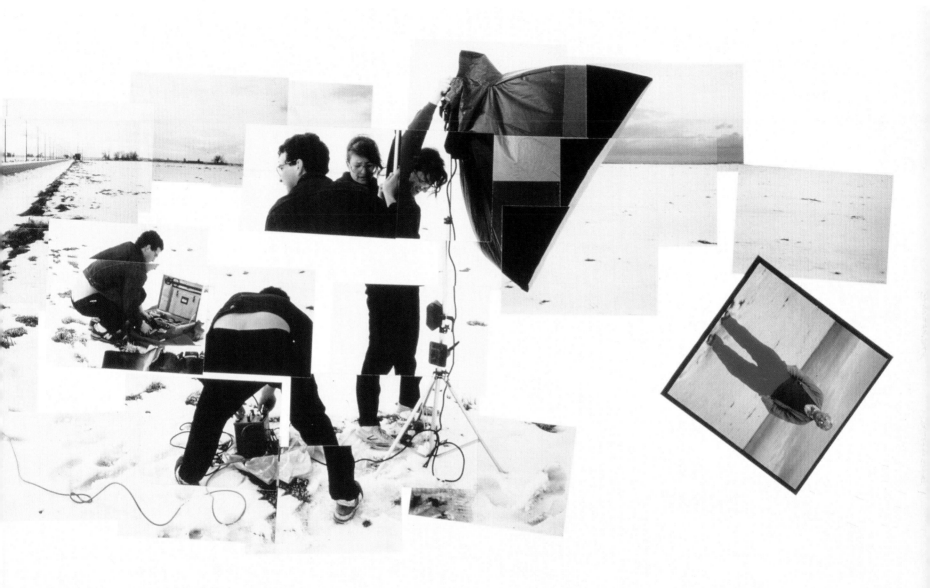

examination of the Civil Defence Services which operated during wartime. Spender's objective was to discover in what ways people behaved with greater 'social responsibility' in war than they did in peacetime.]

Although the people are clearly posed, their faces are extraordinarily good. It took me a while before I realized what it was that was so good. It is something you can't fake because the book was made during the war. The faces could not but show that people were worried. You couldn't re-do the photographs now because people would not have that look in their eyes, that expression on their faces. But the book was simply made as a document to show what everybody was doing during the war. It has an earnestness about it. The people weren't models; they were real firemen, real porters, real miners and so on. You can read in their faces that it must have been a pretty bad time. Even when they were trying to relax, their faces show anguish.

If you were filming now, say, making a movie of the Blitz in London, you would never get faces in a crowd to show real anguish and concern. Many photographs were taken in the war by many famous photographers, but these are very special. The photographer may have been known at the time but his work is not well-known now in the way that, say, Bill Brandt's work is. I'm beginning to think that photography has fashions about it, even from the past: Atget, for instance. Berenice Abbot discovered Atget and then somebody else discovered Lartigue.

PJ: I wonder if photography isn't best suited to documentation, and I'm reminded here of August Sander's best work – those marvellous portraits which pinpoint a specific historical period.

DH: And he didn't really make the portraits as art. He wasn't concerned with art; he was concerned with documenting types of people in this period, wasn't he?

PJ: That's right. Don't you think, even though we've been highly critical of photography, that the photographers who have made it into the international arena have really dedicated themselves to that medium? Edward Weston dedicated himself, and Sander and Atget did too.

DH: The only other interesting photographers were painters. As soon as the art galleries started dealing in photography, the prices went crazy. With Walker Evans, no matter what they were selling for in the galleries, you could write to Washington and buy a Walker Evans photograph for ten dollars.

PJ: I think you still can. I ordered six and paid twenty dollars.

DH: Yes, and they are made from the negatives, and just treated as ordinary photographs.

PJ: The same was true of Bill Brandt's photographs in the old Hulton Picture Library [now the

**Pastry Chef,
Cologne 1928**
by August Sander

Hulton Getty Picture Library]. You could buy a print from the original negative for a fiver, which makes a nonsense of the photographer paying a printer and saying 'this print's all right', then signing it – and charging five hundred pounds and sometimes much more.

DH: I loved that when I found out. I suppose if some care is taken in the printing, all right, you're paying for it, but that's an artisan's job, really, not an artist's. It's not a drawing.

PJ: This is where we get to the crux point really, between art and photography. Is the moment when an artist chooses, frames and takes that picture a work of art, or is it just a well seen view? How do we answer that?

DH: The problem is it's still not like drawing or painting, is it? Time sorts out what is art and what isn't, so it's probably folly to try and judge it all now. I mean, some things clearly are art straight away in the sense that all Picasso's marks are art. There's no doubt at all.

Photography will have to wait. It's only a hundred and fifty years old. It's not that long when you think that pictures have been made for ten thousand years. It's not arrogant to suggest that. When I said the camera might have been used wrongly for a hundred years, people said it was outrageous, but it isn't actually. A hundred years is not that much in the history of images, is it?

PJ: You know what Walter Benjamin said about the question 'Is photography art?' He said that it was no longer an appropriate question because photography changed the nature of art. And I always thought that was an interesting interpretation.

DH: I've read his essay, '*The Work of Art in the Age of Mechanical Reproduction*', and I don't actually agree with it. In fact my little essay for *The Artist's Eye* (see page 39) was taking an opposite view. Mechanical reproduction is not as mechanical as we think. That's the flaw in his argument. The printer who puts more love into it will do a better job. It's not just the machines; it's somebody caring. And it's still like that. What he misjudged was that mechanical reproduction hadn't been going that long. Benjamin wrote in the thirties, and it had only been going for thirty or forty years. It's certainly developed a great deal since then, and, no doubt, it will get better still with new machines and things. But people invent new machines because they think they can make the reproductions better, which is a subjective judgment in a way. So it's not as mechanical as we think.

I bought the reproduction of Van Gogh's chair – the one in the Tate Gallery – for a pound in Leicester Square. You can buy it cheaply because they've obviously printed thousands of them. It's a very, very good reproduction. You can see the paint with all its lumps. The illusion of depth in the photograph is about half an inch, which is very good indeed. With a bit of side-lighting you get this in the reproduction. I also have a Van Gogh book in which all the pictures must have been re-photographed with a little side-lighting. You wouldn't have got that in the thirties. You might have

Vincent's Chair and Pipe 1988.
Acrylic on Canvas.

got a Van Gogh reproduced, even in colour, but it wouldn't have looked like that. What made it look better? Somebody cared; somebody wanted to do it better. You can use machines, but it isn't merely mechanical. You can't say that.

PJ: That's why some books have such a wonderful presence to them, don't they?

DH: Even in the printing of a photograph with the same equipment, one person will do it better than another because they care that little bit more, and put love into it. The source of creativity is love, the source of all creativity. A really mechanical age would be inhuman. We wouldn't want it. It's just a science fiction horror. I like to think that!

PJ: When the printer is spending the time and the effort and the attention to get that reproduction right, his hands are what are doing it. You're back again to the hand, aren't you?

DH: Oh, never underestimate the hand. In the seventies a lot of what I would now dismiss as very foolish art underestimated the hand. I went to see Gilbert and George and I had an argument with them about the hand. I said that the hand is far more important than I ever thought. They said: 'We don't like the hand. We don't care about the hand.' I think they are stupid, actually. I don't care for their art.

PJ: Well, I don't think it *is* art, frankly.

The artist's hands.
Photo by Paul Joyce

DH: I think their art suffers from all the same problems as photography. These things might work for other people but they can't work for me now, because once I begin to see the problems I see them all the time. When I had the argument with Gilbert and George they thought I was talking a lot of rubbish. I'm convinced about that. They told people I'd gone bonkers. Without the hand we wouldn't have been able to do anything at all.

PJ: And it's apparently this – the thumb-finger relationship – that's vital, because without the thumb you can't do anything. Isn't that how they check the development of children?

DH: Yes, think of your life if you didn't have hands. Far worse than being without feet. The hands and eyes are the two elements that the Chinese are concerned about in their paintings. When the eye, the hand and the heart come together, that's when you get the greatest art. I think that's profoundly true. And the eye links to the hand, and the heart gives the love. That's where the creativity comes from – the heart.

PJ: I think that there is also an intense desire to communicate at a non-verbal level.

DH: Why is that intense desire there? Love. Why do you want to communicate? To express the joy of life, of living, however bad it is. Art by its nature must be optimistic in wanting to communicate. The fact that it can happen is in itself a joy. The message might be that we're terrible, but it's a start to make us better, isn't it? That's the paradox of art, in a sense. It's why, in the end, angst works only for a while. But an art that's saying everything's terrible, everything's awful, can't really exist. It's a contradiction of the fact that some communication is taking place.

PJ: Do you ever think about your audience, the people who will maybe own or see the pictures?

DH: I don't think of them that much. I know that the vast number of people who know my work know it only through photography, through reproductions. It works through reproduction on one level, and that's nice. People respond, and it must mean that there's something there. With really junky art people respond to it for a little bit, but they don't respond fully. Nobody does. In the end, really good art is what people respond to. The definition of whether something's really popular is when it's popular from one generation to the next. There are things that just affect a moment, whereas the genuinely popular, like the Laurel and Hardy movies, Celia [Clark]'s children will laugh at still. They touch universal things, and they are truthful about people. They must be, otherwise children wouldn't be laughing. The only kind of people who don't like Laurel and Hardy must be dull bores. They touch something universal in a very profound way. The Laurel and Hardy films never got Oscars, yet they are going to live longer than a great deal of stuff that was taken much more seriously.

PJ: Do you think they considered their audience?

DH: I don't know whether they did, but they genuinely touch their audiences. My father loved Laurel and Hardy. I think he identified with Stanley (Stanley's the English one). The fact that they always fail at everything is so human, although the paradox was that they succeeded with their films. Have you seen the one where they are borrowing money from the bank, and the banker says: 'What is your business?' Stanley says: 'We're in the restaurant business.' So the banker says: 'Where is your business?' He replies: 'Why, it's just across the street.' The banker looks out of the window and there's a big sign saying 'Hotel and Restaurant'. But the camera moves out of the window, down the street to a little peanut stand which you know is theirs. I laugh even now and I've seen it so many times. You can't not laugh . . .

PJ: Do you think photography was adopted for a while by the art establishment simply in the hope it would make them rich?

DH: There was a period in the seventies when a few galleries began to show photographs as works

Laurel and Hardy dolls in Hockney's house.
Photo by Paul Joyce

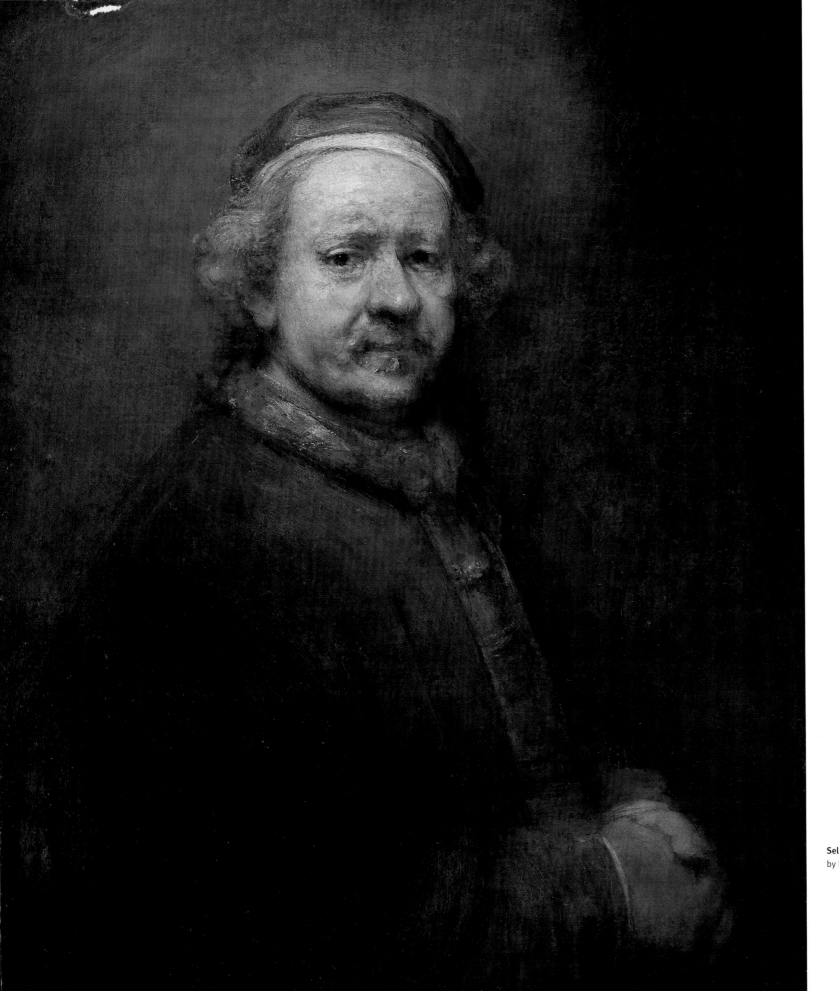

Self Portrait, aged 63
by Rembrandt

of art. At that time Ileana Sonnabend started publishing prints. It was partly because the photograph was being used in conceptual art to show the documentary side of things. There was a craving for images. Intellectual corruption is a complicated issue, but generally there was a belief that an art that was representational was inferior. Somehow people believed there had been a progression from mere representation to a truer definition of art. The idea seemed naïve to me. The theory suggested we had no more to learn from looking at nature than simply seeing what the process of looking was like. It couldn't be true.

The problem was that the people who had suggested this theory were treated very seriously, very seriously indeed, by a small group. At the time, the photograph was accepted unquestioningly. People believed the camera to be a machine for recording an objective truth. What I did with the camera made it a lot less mechanical. We tend to jump to conclusions about what is happening at any moment, but as soon as we begin to look into things more deeply we find we have not necessarily arrived at the right conclusions. What we call the art world, which I happen to know because I'm involved in it, reflected a lot of these wrong conclusions.

I don't know whether you remember, but there was a lot of talk about the death of painting. I never took it very seriously. There's something wrong with that argument; it doesn't hold up. The moment you look into the idea it seems to collapse. It might look as though there's a good deal of junk painting around, but that's probably always been the case. Our view of the past is edited. We tend to see what's good from the past and all the junk simply disappears. We tolerate our own junk, but the future will keep only what was good from now.

We are forced to make depictions. We have made them for ten thousand years now, and we are certainly not going to stop. There's a deep, deep desire within us that makes us want to do it. Every depiction was made by means of painting and drawing until the middle of the nineteenth century. The hand made them all until it looked as if the hand was stopping and then they were made by machinery. Now we're getting to the core. It looked as if the hand was disappearing, but, of course, it can't disappear, even from making the depiction. The cry 'From today painting is dead!' expressed a misunderstanding of what painting was. Painting, after all – realist painting – had been based on the ideas that had made the camera. That's the point. That's the point you mustn't miss. The point that Susan Sontag [American critic whose writings include a collection of essays, *Under the Sign of Saturn*, incorporating a critique of the German writer, Walter Benjamin] does not deal with in her book [*On Photography*] is the fact that the invention of the chemical process was simply added to a Renaissance drawing machine. The moment that happened, I think then you should have seen in a different way with it. That is my criticism. For a hundred years nobody used the camera properly. They were simply using it in the way Canaletto would.

PJ: They were simply peering through a dark tunnel at an upside-down view of the world.

DH: They were in the past, weren't they? What started my argument off was the realization that the

photograph essentially wasn't good enough. It couldn't compete with the great painting from the past. Nobody has been able to make a photograph that moves you in the way that a Rembrandt does. Nobody has been able to make a photograph that is as exciting as most of the art from the past. After a hundred years it has not happened. Well, I know it's strong criticism!

PJ: You obviously want to talk, but I'm afraid – and here I might be the exception – that you're doomed to a dialogue with yourself.

DH: Oh, I'm aware of that now, yes. And it's simply because you can't expect somebody else to be following your thoughts. On the other hand, if you don't talk to someone you get the most frightening feeling of isolation. You want contact with people who are interested in it. People have found me – you found me. In a way that's no accident. When it happens it's because our wavelengths are similar. You meet all sorts of people who you don't bother meeting again, don't you? Nobody can work in *total* isolation. Picasso's last twenty years were a dialogue with himself. There was nobody near him at all.

Now I'm gathering momentum back into the painting. I will soon be at the point at which I will wish to cut myself off, and I'll just do that. As Henry Geldzahler [Curator of the Twentieth Century, The Metropolitan Museum of Art, New York, 1960–8] once said, 'You just want to be a little artist whistling down the road of life with a few credit cards in your pocket. That's all you want, David, so long as nobody disturbs your work, you couldn't care less.' But as you go on in life you suddenly have to face up to responsibilities – they catch up with you. So I deal with them because, basically, I'm a responsible person. But even though I'm selfish about my work, naturally, as artists are, there are loads of people I've put off – the kinds of journalists who make you into a celebrity, for instance. They are a bore and they just make a lot more trouble for you.

On the other hand, I'm terrified of cutting myself off completely from people who are interesting. But I always think, in the end, that the people who are really interested in your ideas will find you. Like John Dexter [director of plays, operas and films, and Production Adviser, Metropolitan Opera, New York]. I have not met him, but he wrote a letter that was interesting enough for me to write back. It's a terrifying dilemma: if you cut yourself off completely, you cut yourself off from life, or the things that keep you going. And it gets harder.

PJ: Is that something to do with being successful, or is it something to do with getting older?

DH: Something to do with getting old, yes. It's simply that as I get older, more and more people become aware of my work, that's all. An awful lot of artists who are quite famous within the art world are unknown outside it, and the number of artists who break out is very small. And they must break out for some reason. There must be something in the work that demands it. For instance, Picasso is a much more famous artist than Kandinsky. You put on a Picasso show and millions of

David Hockney and Henry Geldzahler.
Photo by Paul Joyce

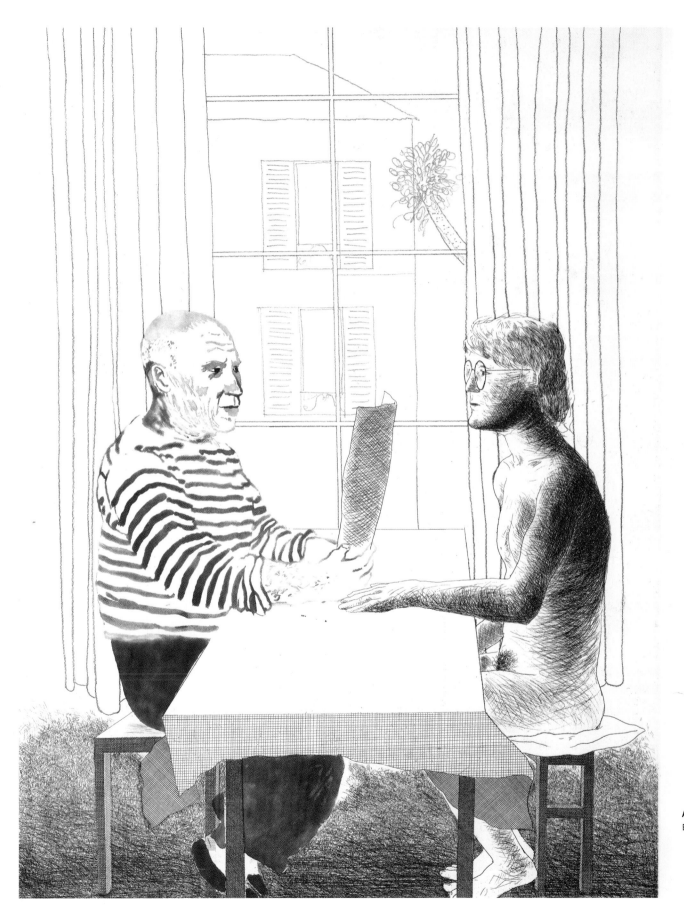

Artist and Model, 1974
Etching in black

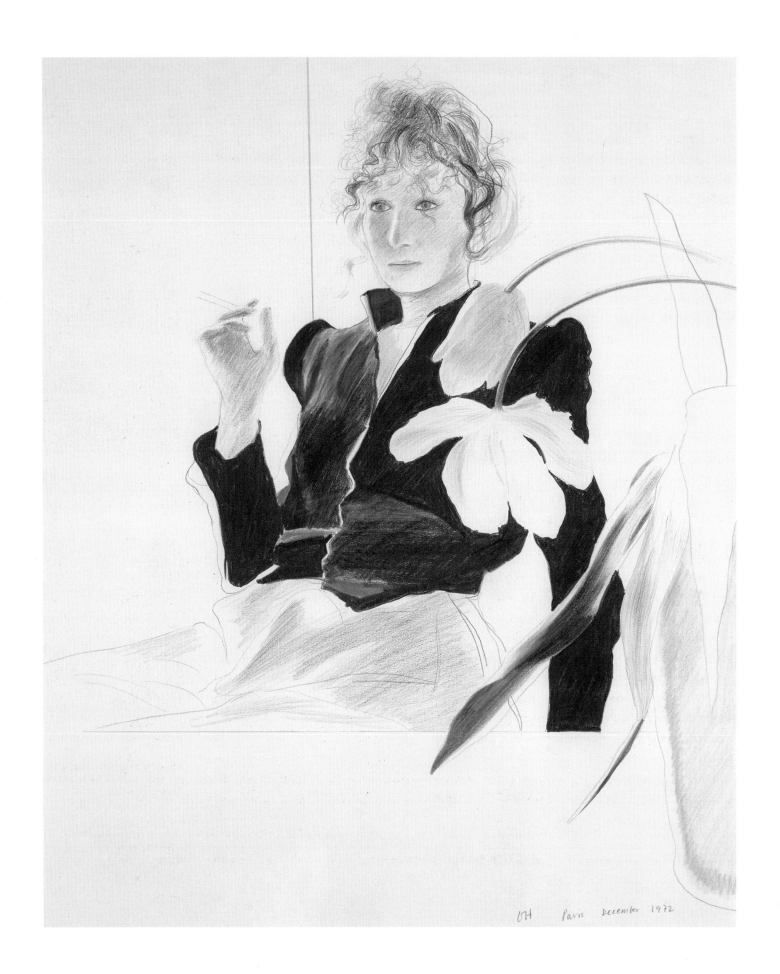

people will go to it, but you wouldn't get that number for Kandinsky. Nevertheless, Kandinsky's an interesting artist, and, within the art world, a very famous one. Picasso affects people, his work does get to people. And I've no doubt at all that he'll become a more and more popular artist, like Rembrandt did. His work is not that difficult, it's deeply human, and that's why a million people go to the shows. I mean, you wouldn't have a million going to Andrew Wyeth. They might describe him as a popular artist but his art is a peculiarly American regional thing, isn't it? Picasso's is not. He touches universal things. But after the war he had to isolate himself because he needed his own time. His wife started sorting it out. She became a kind of terror to some people.

PJ: Picasso was a media personality in his time. He moved from country to country but everybody knew him. He isolated himself. You're the same. I mean, everybody knows you within Western artistic circles, and you're very well-known now in Europe, Japan, probably in China – and it looks like in Mexico at the moment too! But you said there must be a reason. If somebody does have that appeal, it's obviously the work, but there's another quality. Now what is that? With you it was up-front very early, wasn't it? With gold suits and so on.

DH: Yes, but it isn't just hype . . . Do you remember when Elvis Presley died, *The Times* ran an editorial arguing that Elvis was an invention of Colonel Parker's plus a lot of hype? Even I was going to write a letter saying that it couldn't be, but other people wrote saying that Elvis was too big to be put down to hype alone. There was something real there. Whether you cared for the music or not, there was something that hit people. What it was exactly I can't say, but think of all the hyped-up pop singers that have been forgotten – hundreds of them – and Elvis is not among them. He touched something. The hype might have helped , but it was the work itself that made him.

I like talking to people, but there's another side to me. I have to isolate myself because I know I have to do all the work on my own. It's lonely. I'm very aware how deeply lonely I can get at times, and how difficult relationships are because of what I'm doing. So there are moments when I try and overcome this and find a sympathetic person to talk to. On the whole the world I live in is rather small. I'm not actually a very sociable person. I hate going to big parties. I'd much rather go to dinner with five or six people than thirty. You can't talk to thirty people! Most of the friends I've had I've still got. I still see them. Very few people have gone out of my life. They sort of stay there. Somebody pointed out that the same people are in my first album of photographs as in the latest album twenty years on. They are there still!

PJ: I think it's wonderful that you can see new things, with Celia, and all the people that you draw again and again. It's almost as if you have to look at something familiar in order to see some change.

DH: Well, I always used to joke about Claude Bernard, who used to give parties for three hundred

Above: **Hockney at Breakfast in his Hollywood house and on the beach at Malibu with Celia and the dogs.**
Photos Paul Joyce

Opposite: **Celia in Black Dress with white flowers 1972.**
Crayon on paper

of his intimate friends. Nobody can have three hundred intimate friends. How many people in the end can you know that you care about? It's always a small number of friends. You know that there are people who want to come into your world, but you build up a resistance to people. You meet all types of people, awkward buggers, and all sorts. You set up a resistance to some and choose others. It's instinct, isn't it? I work by instinct, intuition, and follow my passions. That's what I've always done.

What we call art starts about the fifteenth century with the invention of perspective and the development of the *camera obscura*.

PJ: For Renaissance man the perspective that you're questioning now was precisely that sort of amazing revelation.

DH: Oh yes, that's the connection. When it happened they must have been deeply excited and thrilled because pictures changed.

PJ: It's taken a long time for that tradition to be seriously questioned. And you would say, I guess, that photography has unnaturally extended that Renaissance viewpoint.

DH: Yes. It's only recently dawned on me, that photography is the Renaissance picture extended, at a point when Cubism really was breaking it up. And if photography hadn't been there, Cubism would have broken it up more easily. Many more people would have sensed it. But photography extended it. That's why I say that photography is the end. It's the final version of the Renaissance picture and it's time to move on. A new way has already been seen; it has been laid out somewhat primitively. And the more I think about it the more excited I get, but I don't think the art world sees it that way. One aspect of photography is that it's popular, whereas painting is not that popular an art, and probably never was. A certain cultivation is needed to be able to read painting to derive real enjoyment from it. But photography is different. The number of amateur photographers around runs into millions, doesn't it?

PJ: Second only to fishing!

DH: Is it? God, I would have thought it would have surpassed fishing!

PJ: Throughout the world, maybe yes, but in the United Kingdom fishing comes first. Photography is number two, apparently!

DH: Why is that? I don't know about fishing, but the urge to depict, the urge to deal with images, is a deep urge. We all have to have depictions of some kind. With the joiners I'm trying to bring the

The Annunciation with St Emidius
by Carlo Crivelli

picture to you. I'm positive it does make you feel closer because it puts you there, in a sense. The world then begins with you. The picture of my mother on the cover of the Japanese catalogue [of the show *David Hockney – New Work with a Camera*, Nishimura Gallery, Tokyo, 3–29 October 1983] comes right to where you would be standing, and at least breaks the window idea. There might still be a door, but you do go into the picture.

PJ: At least a door takes you . . .

DH: . . . to the floor, that's it, and a window does not. George Rowley said [in *The Art of Chinese Painting*] that out of doors our eyes were forced to move about to encompass the scene. Well, that's true indoors; that's true anywhere. In fact, the closer things are to us, the more our eyes have to move. With the joiners the effect is a very strong one of putting you in the place. It gives you a

much greater feeling of being there. Although it appears that we don't look at the ground, we do if we move. We scan it very carefully and quickly. If there was a great big black hole we would not walk into it. Now, there are other ways of doing this, because the Chinese scroll also takes you into the picture. You're not a spectator. You are walking down the streets, as it were. That's due to the fact that the focus is moving and so are you. It's all related in a way. The static nature of the viewing position, whether in a photograph or in a Canaletto, results in a fixed scene from a very fixed point. In the Canaletto painting at least your eye can move. It follows the hand making the depiction and therefore the time is depicted.

You have to learn quite a few things to be able to see another way, and to be able to depict that way of seeing on the canvas. Unless you learn about your own movement and your own body, you will still look at things the old way. There are people who try to put the whole room into a painting. You don't feel the body is moving. The painting is just trying to take on more – rather like the way the wide-angle lens sees. If you take in a head movement, that point becomes much bigger. It becomes what George Rowley calls 'the moving focus'. Movement is life, essentially, isn't it?

PJ: Once one begins to see the world without the restrictions of conventional one-point perspective, everything changes.

DH: It is a vast change. It affects everything, far more than just art. The movie, for instance, is still involved with the old perspective. The movie appeared to be the most vivid depiction of life yet made, and in a sense it was. And although it has advantages and the movie works, nevertheless that too can be made even richer. People have tried to open films up. Fellini made serious attempts. Others have done odd things but there's nothing more boring than an abstract movie. Did you ever see any of the 'Scratches on Film'? (A loose term for an animation technique where lines are etched directly on to motion picture film which is then projected.) Ten minutes of that and everybody is bored to death. The wider perspective opens up completely new possibilities of visual narrative. And when you think about it, I'm right about the narrative aspect. When the figure is static, it's solid; it appears so. If you're still, all the subtleties I'm talking about, the small movements do appear very, very solid. But with the new way of seeing, the volume, the air in your body is replacing, is constantly moving and changing. So that opens up the possibilities of narrative, whereas traditional perspective limits it. Even with Caravaggio the narrative is stuck, isn't it?

PJ: Yes, it is. And it is, in a sense, very photographic.

DH: Yes. In Titian's *Bacchus and Ariadne* the cloak is frozen in the sky, isn't it?

Bacchus and Ariadne
by Titian

PJ: Yes, the cloak is for ever stuck there. It's only an extraordinary skill that gives you the

impression of movement. In fact, in the Caravaggio, you get the feeling that there is no movement; you feel that the arm is actually held there.

DH: You have a feeling of depth, but the depth stops movement. It's as if he had to fix the depth. It's amazing, isn't it?

PJ: Very important. It brings you back to people and life and relationships, even if it's just the relationship of people to objects.

Do you think that there's anything that photography can do that other fine art techniques have not been able to achieve?

DH: Yes. One thing photography can do is to make replicas of things. With the aid of photography we certainly make very good replicas of drawings – very, very good. You have to be quite an expert to tell the difference. I think there are moments of documentation when photography achieves something. Cartier-Bresson has made some memorable photographs, if you think of the family picnicking, or the one with the girl at the end of the war – *The Informer*. I can't remember every detail, but it's a very strong image that goes into your head, such is the power of photography. There aren't many images like that considering the millions that exist. With the photograph that resonance is the reason that the image works. With painting it does not necessarily have to happen. There's a difference. Now when that happens it's triggering images in your memory, isn't it? In a sense your memory might be making them. These photographs are powerfully still, aren't they? It's the stillness you remember.

PJ: But think about *The Informer* photograph. There's a woman actually striking the informer. Her face is frozen but she's in the middle of a violent action. It can capture that.

DH: It does capture that, and you can understand that the woman who is striking her was wounded in the war, psychologically wounded. It's a moment of revenge. It's overcome her. And that's the moment we see her. But it might be a one-sided picture of her. There might have been a moment or two later when there was a flash of compassion within her. We don't know. She might have continued to be angry but we can't tell from the picture. Well, you could say that the movie would tell us that, but in the presence of a movie camera people don't behave that way, do they? Cartier-Bresson, after all, had a technique that was very unobtrusive. I'm sure she hardly noticed him, hardly noticed his camera, whereas with a movie camera she might well have stopped herself acting in the passion of the moment. I'm trying to question all the things surrounding the image.

This photograph makes you think of the war. This was 1945 and there had been informers in France who had been callous and cruel and thoughtless, and to gain something for themselves they had given other people away and caused a lot of misery. We all have anger and we know that

Dessau: Exposing a Gestapo Informer, 1945
photograph by Henri Cartier-Bresson

Untitled sequel to the photograph above

**Hockney looking at Murals by Diego
Rivera, Mexico, 1984.** Photo Paul Joyce

the woman striking the informer could be ourselves. We are all capable of that and we all have these moments of hatred. It doesn't matter about the side of the war, whether we are German or French. It's not political, in that sense; it's about emotion, the emotion of anger. It couldn't be posed: the face wouldn't look like that. Maybe these are the reasons why many people say that Cartier-Bresson is an artist.

PJ: With Cartier-Bresson we're talking about quite a finely-tuned aesthetic, aren't we? And that aesthetic reveals itself in the rules of composition he followed, which are still being adhered to, unless all those are going to be totally smashed. I doubt that. In fifty years there will still be exceptional pieces of photography.

DH: We don't know that for sure. Take a fourteenth-century woodcut. It looks different to us now than it did to somebody in the fourteenth century, but there are certain things that still work in it. We know that it's a product of the hand – again we go back to this! We used to talk about primitive art – we talk about it a lot less now – but one reason we talked about it was that certain forms looked very different. We were so used to European forms. We can understand Cortés coming here to Mexico, seeing the art and wondering whether it was devil-worship. Three hundred years later we're so removed from it that we can see the beauty of the form and realize that it is sophisticated, not primitive in any way. It could be that the photograph is a primitive picture.

The Spaniards came to Mexico and South America and found civilizations that in some ways were incredibly sophisticated and advanced, but in other ways was unbelievably primitive and evil. They saw the sculpture as hideously ugly. With a leap of the imagination we can try to imagine what they felt. When the Spaniards looked at this sculpture they associated it with foul practices and with devil worship, and the beauty of its form was irrelevant to them. The more we hear about a society that killed people all the time for sacrifice, the more difficult it is to understand them. It's beyond the imagination almost. But that culture was smashed, built upon, and naturally some of their ways and beliefs blended into the new religion which the Spaniards brought with them. It blended amazingly well for all sorts of reasons.

It wasn't until the later nineteenth century that people began to take a real interest in 'Primitive' Pre-Colombian Art. Well, we've seen several things in the museum in Mexico City and we know they are not primitive, they are highly sophisticated and skilfully made, and the people who made them worked with the same problems that artists work on today. It has taken three hundred years for us to be able to see this form and divorce it from its original purpose. We see a beauty the Spaniards did not see. We're looking at the same objects. They have not changed, but the minds being brought to look at the objects have changed.

We need people now who would agree that in another hundred years the movie of today will look primitive. We cannot say what the movie in a hundred years will look like. We are interested to know what form it will take, what future pictures will evolve, but it's pointless to sit down and

speculate. It grows slowly. We do know we change. We've observed that from the past. There's no reason to suppose that it won't go on. It would be naïve to assume that we've reached a culmination, that this is it. But the fact that some photographs work in a special way is true. They do. It would be silly to deny it. When I say that photography is a failure, I'm not denying the resonance of some great photographs. That's obvious. It's in front of your eyes. I'm saying that we don't know how that resonance might alter in time.

PJ: Photography is actually primitive. I think you're right. But it *seems* to be sophisticated. We have been fooled, perhaps, by the surface of it.

DH: Well, that's my basic argument. That's my main thesis in fact. The leading question is 'What can photography do?' I did state one clear thing it can do: it can copy itself. Certainly it can copy another photograph perfectly. It was no joke when I said that the best photographs were of drawings or paintings. You must deal with that side of photography and say what it can do, and that aspect of it has enriched our visual experience enormously.

PJ: It's given us photographic art books, it's opened that up for us.

DH: Yes, you can have a book of Rembrandt etchings that aren't printed from the plates, and you can buy it quite cheaply. That kind of reproduction is very, very close to the original – the subtleties are not there, but a great deal is there. It's the great photographic skill, and it's a lot less mechanical than we think.

PJ: You've actually taken the mechanics and extended the possibilities. You've done it with smaller formats, and taken it a step beyond the purely mechanical reproduction of a particular object. With your three-dimensional paintings, you're actually representing things from many points of view. It's the first time I've seen this in a single, albeit composite, image. And that's what I'm trying to get at – the beyond. You've made the point, and very eloquently, about how photography can copy. Now we see you extending that facility.

DH: Well, when it's not a flat surface, the problems occur. In copying the flat surface, the photograph has no illusion of space or depth, it's just like itself – a flat surface.

PJ: How else can the photograph be used, by an artist, say, or the photographer?

DH: Well, the one problem that I have now is that, because of what I've gone into, I begin to see the ordinary photograph slightly differently. There's no way I can go back. It's entered my mind. It's the way the mind questions something.

Hockney shooting Polaroid photos in Mexico City, 1984.
Photo Paul Joyce

**Trang Bang, South
Vietnam, June 8th 1972,**
photograph by Nguyen
Kong (Nick Ut)

PJ: What are those differences?

DH: The differences are that the photograph becomes more and more excessively frozen. I see it in a way that the ordinary viewer, who does not question it, does not see it. Each of us sees the photograph differently.

For instance, imagine there are six portraits here – twelve portraits of ladies' faces. Among them are a picture of your mother's face, who I've never seen, and a picture of my mother's face. However you look at these portraits, one photo will stand out. It does not matter how good or bad it is. The one that stands out to you does not stand out to me unless it jumps out aesthetically. So, we are seeing different things, aren't we? We see different things here in this exhibition and we see different things out in the world. And it gets down to a disturbing area. It makes you think that there's no such thing as objective vision at all. Do we actually think there is? We certainly think there are objective judgments and subjective judgments. Scientists think there is objective vision.

PJ: A microscope . . .

DH: Yes. If I look down a microscope and a scientist looks down a microscope we may see the same thing, but there's a different meaning. Does it mean that a scientist trained the same way sees the same thing? It could be he or she is looking for a particular thing. But if he's not looking for anything special there's the question of aesthetic pleasure, though his mind might block it out by looking for something else. What I'm saying is that there's so much there. But I still believe that there is an objective view.

PJ: Take the Cartier-Bresson picture of the informer. It's a famous picture. It's in *The Decisive Moment*. It's been reprinted – every history of photography will probably include that image. You and I are not sitting here talking with it in front of us. Yet I guarantee that we can both remember details from it. And we have seen it in a very similar way. We see a number of things in a similar way.

DH: It's gone into our memories because you're interested in depictions, as I am. You look at them in a certain way as well. There's a vast number of people who might have seen the picture but who wouldn't remember it in the same way. But why did it go into our memories? Not just from the emotions involved in the depiction. There are other reasons; there must be.

PJ: But are those reasons actually to do with inherent qualities of medium, which make it special?

DH: I don't know. There's one problem that you have to keep there in front of you when you're photographing. It's right there in front of the camera. It's not a problem that the painter has. I made an example with the Picasso painting: if you had a photograph of an identical subject – some soldiers shooting at women and children – if it was staged, it would be obvious. If you have a photograph that was *not* staged, the effect is totally different from a painting because of the fact that the man was there. This causes a different effect, a profoundly different effect because it can shock people.

The photo of the little girl running down the road in Vietnam is tolerated only because she's some distance away. We know about telephoto lenses, so we understand that the space between the man making the depiction and the girl is considerable. If the distance was not apparent the photograph would horrify us, not just because of the girl who is burning, but because of the photographer who was not helping. [The photographer actually wrapped a blanket around her and saved her life.] You couldn't make a joiner of that subject – the portrait would be far too strong. That's why there's a certain optimism in all these joiners. There is a love of the world.

There's a debate about pornography and the fact that a great deal of it depicts cruelty and sadism. We're never sure whether it's posed or not. If it's not, you tend to know because you become the depictor, and you begin to get his feelings. It's easier to pose cruelty than it is to pose two people enjoying something. Faking two people enjoying themselves is much more difficult,

My Mother, Bolton Abbey, Yorkshire, November 1982.
Photographic collage

and much more difficult to depict. But debates about pornography never get to this idea. Two people's sexual enjoyment has certainly been depicted in painting and drawing because, of course, the third person doesn't have to be there. They could have been one of the actors in the drama. This is not so in photography. If you see two people making love in a photograph you know there must be three people there. Well, to a great number of people this fact makes the occasion unprivate. For someone who has looked at what most people would consider to be lots and lots of pornographic or erotic pictures, I think the kind of joy we're talking about is very, very rarely depicted.

It could be that the sexual act is the ultimate creative act. There are many ways of looking at it, but it could well be that it presents a problem for photography similar to the problem of genuine documentary cruelty. The way a painter can see or feel something is very different. Take Picasso's major painting in 1951 [*Massacre in Korea*]. He had never been to Korea, and I don't think he was making it as Communist propaganda. He was simply moved by what he saw as yet another war. He'd seen one in Europe as an artist resident in Paris. He saw, as everybody must have seen, photographs of the people at the fronts, and of incredible cruelty and madness. It must have affected everybody. I can remember seeing photographs of people like skeletons. Clearly, Picasso felt very deeply about it and he made a picture that is illustrative. I think he was also dealing with the problem the camera has because of its nature.

The camera is a medium unlike all other artistic mediums. In a sense it's autobiographical because it's about you, it's something in front of you. Painting might be autobiographical but not necessarily in its subject matter. Part of the subject matter of a photograph is that the photographer is there, and it's an aspect that makes it peculiar. I accepted this and I'm dealing with it in order to emphasize it. Although it's a perfectly simple truth, at times it's forgotten. It's not forgotten in cases like the little girl burning in Vietnam, when what we're witnessing horrifies us because we do immediately think of the person there seeing it.

PJ: Photography can question the relationship of the photographer to the event quite powerfully. For example, in the famous bayoneting in the polo field in India, photographers were actually called to the event to give it publicity, and they all walked away except one or two [Horst Faas and Michel Laurent of Associated Press – who won the Pulitzer Prize for their efforts]. They stayed and shot the photographs within a few feet of people being bayoneted to death and there was a great debate about whether they should have stayed. The debate is what you're talking about, isn't it?

DH: Well, it's a moral question, but it is peculiar to photography, that's what I'm pointing out. With a photograph we can't question the fact that someone was bayoneted to death. There have been pretty gory movies but we don't believe them, actually. I met a guy who made these 'snuff' movies, and I'd never heard the term so I asked what it was and he said: 'Somebody gets killed.' Somebody might apparently get killed on television every night, but in 'snuff' movies it is real. Well, how do

you know? There are all kinds of ways of faking it. You can fake it in a movie pretty convincingly.

I said that you couldn't make a joiner of the little girl burning in Vietnam. You can, but it would display an unbelievably cold view of humanity. The fact that the little girl is running, she's blurred – all this tells you the photographer saw it. If she had run right up to him he might have put his camera down, put out the flames – we assume that he would have done what a decent human being would do.

I've read that Hitler made movies of people being strangled and so on. Apparently the films were made with the intention of showing the public, until they realized it was so revolting. It's far more revolting that the depictor could be so cold.

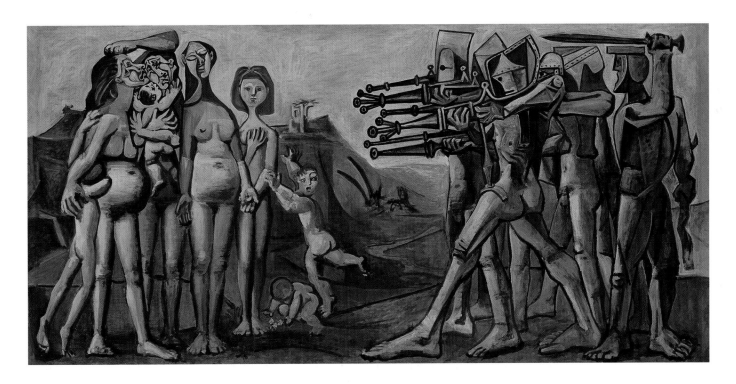

PJ: Are you saying then that by being there you'd have reached a point which is beyond imaginative possibility?

Massacre in Korea, 1951
by Pablo Picasso

DH: I said that we would be horrified, but there are some people who would not be. I would have to say that they are evil, that this is the depiction of evil. Yet, we know that evil exists and that it's powerful, but the fact of depicting it seems to double it. It's very different when the painter depicts it. Picasso in his painting is depicting evil, but he's clearly stating that it is evil. It's very, very clear that he's on the side of humanity which we assume, or I assume, we all are, or should be. It's a question that links up with this other one – is it easier to depict cruelty or joy? Certainly,

A Walk around the Hotel Courtyard, Acatlan, 1985. Oil on two canvases

Fading Away (first impression).
A composite albumen print
from five negatives, 1858
by Henry Peach Robinson

descriptions of hell have been much more vivid than descriptions of heaven. It's harder to conceive what heaven is. Does that mean that we are closer to hell, that there's so much evil in us that our imaginations can get to that more easily? In fact, most depictions of heaven seem to be a bit boring!

The camera seems to be an instrument that's always confirming perspective, so you have to go back and deal with that. The painter has to deal with that. You can't go on ignoring it. Picasso made marvellous discoveries, but he just ignored the camera. He knew somebody else would deal with it. That's why it had to be done. It's only part of a journey; it's not an end in itself to me. You make some beautiful pictures along the way, but it's leading to something else. It's leading to more vivid depictions.

PJ: In working with the camera, if you hadn't actually exploded the conventional notion of a frame you would have had an insoluble problem. You had to do something drastic.

DH: These ideas may have started slowly but once I got into it, there was a time when I just could not stop. The photography was like that. I could not stop even though gluing the pictures down at times got boring. You couldn't give them to somebody else to glue because that's a very deep part of it. When you are gluing them you learn how to see each frame, relating one to another, and that's not easy. I am positive that you must never cut any of the photographs because it destroys the time sequence. I think you sense then a halt in time. The reason you want to cut the photos is to create

an illusion that's based on a single picture, an ordinary picture. Consequently, what I was concerned with would have been destroyed. I decided very early on not to cut up the pictures. Wouldn't we then be doing what the Victorian photographers did by making a picture out of eight negatives? It's the same thing, really, as cutting up pictures, like Bill Brandt putting the sky in from another negative. I decided not to do that. It's harder, but I think you keep the flow of time.

Real photographs are always better than reproductions, aren't they? Partly through scale, but partly through their physicality. And I realized another wonderfully mad paradox. These works of mine are photographs that essentially can't be reproduced, which is not true of any other photograph. You can make a photograph of another photograph and hardly know the difference, but in this case it would never be the same.

PJ: That's very interesting, because the Polaroids as objects actually have depth to them, and your joiners have depth because they overlap. You have succeeded in building depth into an apparently flat surface. Isn't that why they can't be reproduced? You can't reproduce that depth.

DH: The real ones are much more effective, partly to do with scale, but partly to do with the fact that to reproduce them incredibly well you'd need a very, very big camera.

The joiners are about you moving: that's what the principle is. Cubism entails a similar principle. I'm convinced now about Cubism. It is not about abstraction at all. It's about the depiction of reality in a more vivid way. I think the photograph has had an incredible influence on us without our knowing it. It's made us see in a strait-jacketed way. It's mad that we find it difficult to see any other way, but the moment it's demonstrated, we see it's true.

PJ: You're saying that abstraction and photography have gone in a circle, always returning one to the other. And there's no way to break through that circle. It occurs to me that photography might actually have made us look from a fixed position. People now stand around like tripods!

DH: Yes, our eyes have been made to do that because we keep seeing photographs and thinking they are true. If we look at life we then discover that the images have affected the way we look. I think that's now obvious, and it puts drawing and painting back into a far more serious position than even I ever thought possible. Only there can we expand our apprehension of things. Although the camera led me into this, it was only in order to break up what was wrong. I knew there was something wrong. There is still something wrong, even now. There's a difference between scientific representation and artistic presentation, and that difference is the hand. The hand and the eye and the heart coming together. It's clear, now, to me. It opens up a new way of seeing which will make us realize that the world does look quite different. And in that sense it's a bit mind-blowing, isn't it?

PJ: Well, my mind is already scattered all over Mexico, but yes!

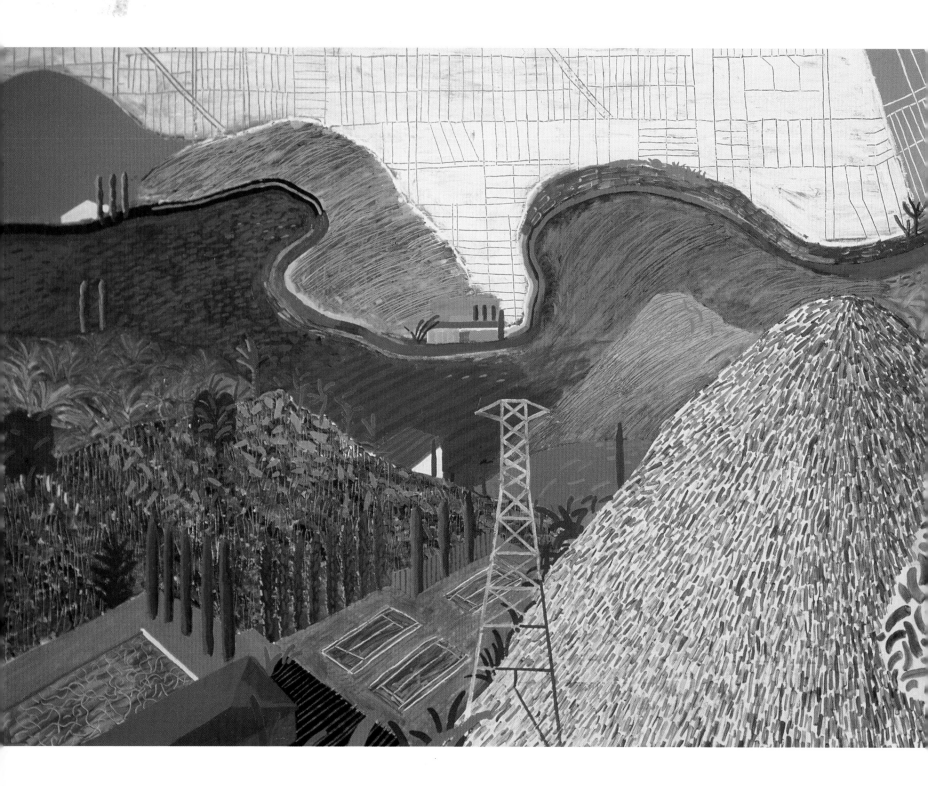

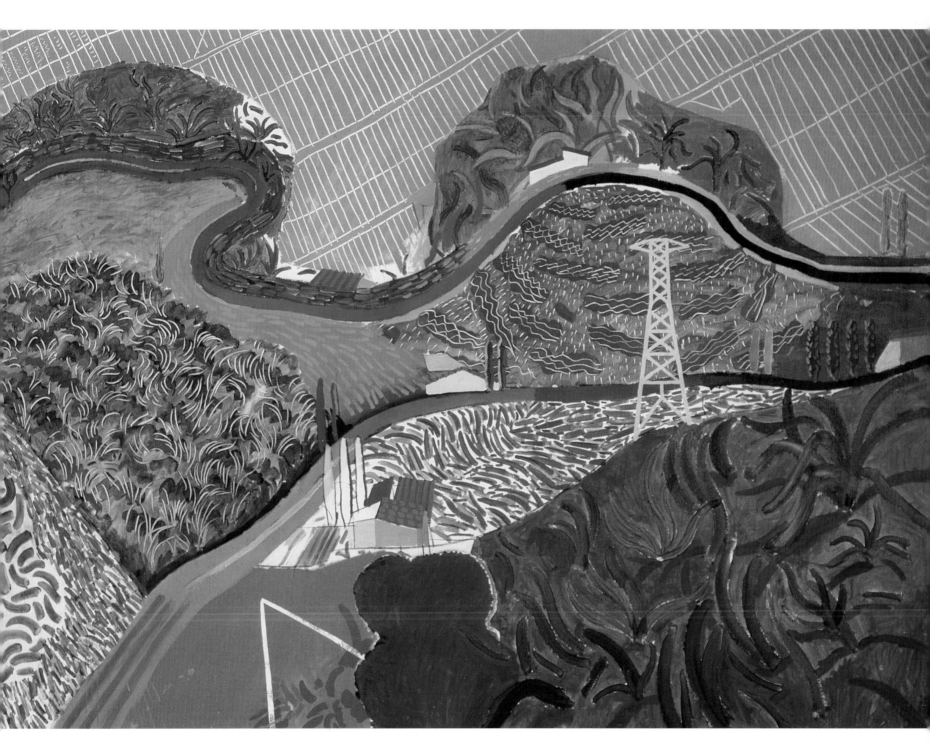

Mulholland Drive: The Road to the Studio, 1980. Acrylic on canvas

Los Angeles, June 1984

Back in Los Angeles we continued our conversations. I had started to shoot some of my own 'mosaic' photographic experiments – mainly of David and his travelling companion Gregory Evans in Mexico – and continued working with these back in California. Our talks took place in his house and studio off Mulholland Drive; in his other studio on Santa Monica Boulevard; and at various lunch and dining places. (David has a very good instinct about where to eat, and combines a fine aesthetic judgment on food with a realistic Bradfordian notion of which establishments offer real value for money.)

David rarely draws or photographs formal portraits of strangers or acquaintances, preferring to concentrate on intimate friends whose features he has come to know over a period of years. One evening, in the middle of our conversation, he said, 'I'll photograph you tomorrow.' I duly presented myself next morning, and the day wore on in conversation without any further mention of the photographic session. At about 10 p.m. he suddenly said, 'Come over to the studio', and off we went. There he put on the lights, and ordered me into a low-slung chair. He pulled out a large sheet of hand-made paper and began drawing. It was a very peculiar experience when David turned his eyes fully on me, and I felt my whole physiognomy under deep scrutiny, as one might be sized-up by a surgeon or bone-setter. I could not help but respond with the same kind of intensity. Afterwards he showed me what he'd done, and I saw he'd represented my eyes as deep black holes – a very accurate representation of my response to the kind of penetrating concentration I felt sitting in front of him.

The morning of this particular interview, I had stopped off at the Liquor Mart alongside Château Marmont, and on impulse bought half a bottle of Taittinger. It proved to be a worthwhile investment.

Hockney meets hi-tec.
Mexico City, 1984.
Photo by Paul Joyce

PJ: You did say you had to purge yourself of photography. That's a very strong word.

DH: Yes, it is. Until it dawns on you that the photograph is the extension of the Renaissance idea. The moment I started on the early joiners and realized they weren't working out, it became clear that there was another way that didn't depend on rectangles. Then it began to dawn on me that I was breaking something else down. The rectangle was the window that we believed in. I was still believing in it to a certain extent. It's hard to break away from it, very, very hard. Why is it so fixed in us? Perspective is only a theoretical abstraction. It is not true to life, no matter what we say. Perspective depends on a fixed point, but if you try to walk up to that point you will never get there; it's like the end of the rainbow!

PJ: And the joiners, of course, smash the rectangle, because, in laying one across the other, you've already destroyed that shape.

Paul Joyce, Hollywood 1984
Crayon and ink

DH: Yes, but it took a long time to really smash it because of that instinct. Look at the Grand Canyon pieces I did. I thought that the horizon was horizontal but, look: it's becoming a curve. The curve is about *you*, not the horizon. It's related back to your body.

PJ: And to the movement of a body.

DH: Yes, because your body moving means you're alive. It's telling you you're alive. That's why people react to it. They *feel* more alive. That's why, in the exhibition, people stand in front of them for quite a while. You can't just glance at them and walk back. You can't do that. We like being alive. We choose it. We cling to it.

PJ: But in photography pessimism is easy; that's the other thing, isn't it? I think that photography has actually extended us into an area of cruelty, depression and negativity. When you think of the photographic images that actually stick in the mind, it's the officer's gun going against the Vietnamese's head; it's the woman falling from the balcony; it's the bayoneting of the troops; it's the Cartier-Bresson photograph of the informer. I've always thought that photography was about death because it fixes the image. There is nothing life-enhancing about it, finally.

DH: Although the Cartier-Bresson photograph about the picnic is joyful because we look at it and we're amused – they are rather a fat family – it's about the pleasures of food, and they've probably eaten too much. It's all there. We are amused, and that photograph has a lot of joy, but it's rare.

PJ: But it was not *that* image we began to talk about. When we sat down to talk about Cartier-Bresson, we talked about *The Informer* (see page 81).

DH: That's because it *seems* more fascinating to us. Just as in the novel or anything else, a story about somebody who was very good all their life isn't that interesting. On the other hand, we do, whether we are religious or not, admire saintly people. I would be hard put to criticize Mother Teresa. We think she's a fine and noble human being, don't we, whether we're religious or not? The point about saints is not that they are absolutely perfect, but that they've struggled to attain something.

I was always fascinated by St Francis of Assisi and his self-inflicted poverty. He was honest enough to admit that there were moments of ecstasy in it, although it looked as though he was making it terrible for himself. Well, that's what we all want – moments of ecstasy. We're not as foolish in this respect as we are about happiness. We think happiness is not necessarily on an ecstatic level, and so we want it all the time. We can only appreciate ecstasy in these moments, and I think that is also true of happiness. There are glimpses of it, and they should be treasured. People have always said my pictures have a certain happiness about them, and they think that

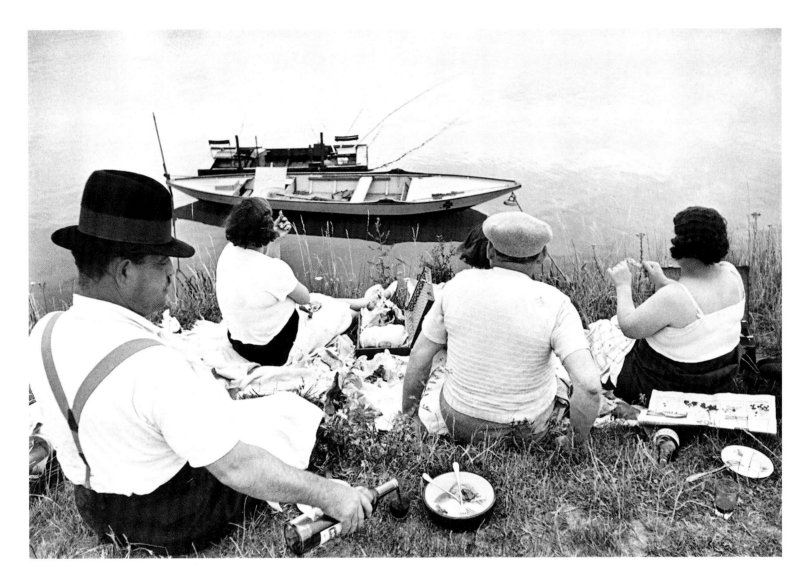

quality lacks seriousness, that it's not true to life. But it is true to life in the sense that those glimpses we keep hold of we linger over. We all want them. It doesn't mean to say that the artist who makes them is always happy. He's not. If you want to know the truth, I know what's going on inside me and a great deal of the time I'm not happy. Van Gogh painted generally happy pictures. The great pictures of his last three years look mostly very happy, so he must have had glimpses of happiness. But he knew about unhappiness, he *certainly* knew the opposite. The enemy is blandness, when it's all the same. Twenty-four hours of ecstasy would be bland. There must be a contrast. Art is about contrast; that's how it works.

The snake in the Anthropology Museum in Mexico City, carved out of stone, can be still in one way and the representation of a movable thing in another. We enjoy it almost more than a real

Sunday on the Banks of the Marne photograph by Henri Cartier-Bresson, 1938

Hockney's studio with self-portrait in progress c 1984.
Photo Paul Joyce

Opposite: **Paul Joyce in conversation in Hockney's Malibu beach house.**
Photo David Hockney

snake. That's why art can be magic. The real snake coiling around might run away. But the artist, realizing in it a thing of beauty, makes a representation of it in stone. It is the contrast between what the stone is, solid and static, and the representation of the movement and life of the snake in another way that gives the object its sculptural beauty. The plain stone is transformed into a beauty that is art. Whatever it was that made the artist do it, the contrast in the forms makes it interesting, makes it art. Form and content unite here. In abstraction, form is emphasized although the content might have disappeared. In banal illustration, the emphasis is all on content with no form. And, frankly, they are both a bit of a bore. The truth is that content and form rarely merge and become one, and when it happens it's magical art. I think nineteenth-century painting, with its fixed views, put an emphasis on content, but limited its ability to move through time. The cubists slowly began to put time back. It appeared at first as if it was totally about the plastic – and it is, in a way. Very few people relate Cubism to narrative, even now.

PJ: I think we now have to approach the problem, given the lessons that you have taught us, of how to break through the conventional frame. You've found your solution photographically and you are translating it back into painting.

DH: In the painting it's working. You don't even know where the edge is. I did a self-portrait – it's made up of a few canvases, but in essence there's no edge to the picture because the mind jumps about, and in jumping about it doesn't need an edge. With the Chinese scroll two edges of the frame are gone. The bottom and the top are there, but the top could be the sky which is infinity – which we understand but cannot grasp.

PJ: They say that photography is truthful, but I think it inclines more to the meretricious. Just keep snapping and you're bound to get a moment of 'reality'!

DH: I've seen professional photographers shoot hundreds of pictures, but they are all basically the same. They are hoping that in one fraction of a second something will make that face look as if there were a longer moment. The fashion photographer normally shoots off rolls of film with the same pose – rolls of it – then he scrutinizes the image, not the person. It's a kind of backward action. And the laws of chance come into play here, don't they? If you take a hundred, surely one will be good. It could be anybody doing it. One picture must catch something. It's the old polyphoto idea. Well, painting and drawing don't work that way at all. They can't. I think the best portrait photography is made by a photographer who feels a strong sense of empathy with the subject. In that case, scrutiny has probably taken place over a period of time before the picture was made. Usually portrait photography is just a cosmetic image – that's all it is. I remember David Bailey did a photo of me in the sixties, and he told me to stand like a bat, or something. It tells you very little about me.

PJ: Like a bat?

DH: Well, he said: 'Hold your sleeves out, like that'; but I did it and that's all there was.

PJ: It's not far from Annie Leibovitz posing you with the red trousers in the desert, is it?

DH: It's very similar. I don't think it could possibly tell you very much about the person. The difference between what you might call a very great photographer and a very good photographer is not as much as the difference between a very great painter and a very good painter. I can think of the difference between Rembrandt and one of his contemporaries whom you would call very good. The difference is still very great. Just name one great photographer. The difference between him and any other good photographer is much slighter. Whereas no student of Rembrandt could be mistaken, not really. You don't have to be too much of an expert to know. Also the laws of chance might work so that an amateur might take a very, very good picture, but he's no chance of *painting* like that.

PJ: But there simply aren't great amateur artists, are there? Look at Winston Churchill's work! Your work as an artist, and as a photographer, brings people back emotionally to their own bodies.

DH: It was the photograph that took away the body. The photographer has no evidence of the hand to make his eye move about to give him life. So it seems as if his body isn't there.

PJ: And this is why photographs seem cold.

DH: If the eye moves, you feel your body move. That's what it's about. This is the bottom line in the end. We're not there, but we're getting close to it. We've gone across the threshold, haven't we? A threshold that now convinces us of the damage the photograph has done.

I do like to talk about it because talking sorts it out for me. The moment I talk, things become a bit clearer. The first lecture I gave on photography was in Auckland. Nobody left, but I was groping around because I don't write lectures down. I then gave the lecture later in London, and it was much more coherent because I'd given it once. I had heard it before! There's a wonderful line from Stan Laurel in a Laurel and Hardy movie: he's reading a letter to Oliver saying he's been left a lot of money and Oliver says: 'That's fantastic!' And Stanley says: 'What's fantastic?' Oliver replies: 'You just read it!' And Stanley says: 'Yes, but I wasn't listening.' I loved it! It sounds like nonsense, but it isn't.

PJ: It all made sense this morning.

DH: Maybe it was that half-bottle of Taittinger!

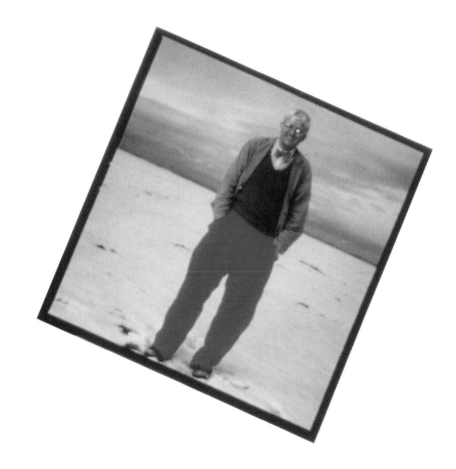

Nude, 17th June 1984.
Photographic collage

New York, November 1984

In November 1984 David invited me to New York for an opening of new work at the André Emmerich Gallery. The show consisted of large oils, paintings, drawings and photographic pieces. It was the first public exhibition of the extraordinary life-sized photographic study of Theresa Russell as Marilyn Monroe in Insignificance.

Her husband, the director Nicolas Roeg, commissioned the study directly from David for use in the film. David told me it took him four attempts with his tiny Pentax to get it to his own satisfaction. He used up his fee in film stock and processing alone. It is one of the very few nude female studies that David has done, and became an exercise for him to achieve a graphically acceptable image of a figure showing front and back at the same time. (He later showed me examples of Picasso's preoccupation with the same artistic, as opposed to visual, problem.) This picture attracted more attention than any other piece in the show.

In New York we talked at the Mayflower Hotel, in David's room and in the coffee shop, walking along Central Park South, and in a couple of restaurants on upper Broadway.

DH: The issue of the objective viewpoint is being raised constantly, I think, in other forms. People don't realize that it is the same issue. Here's an example – the recent case in America of the CBS television network being sued by General Westmoreland.* CBS were saying that theirs was a neutral viewpoint – that was their defence. The whole case fizzled out because ultimately you can't defend a neutral viewpoint. It's always the same problem really – there is no neutral observer. That's what you come to. Well, perspective, one-point perspective, is all based on an idea of the neutral observer: that you, the viewer, are not there, and that there is a viewer outside of us. This is ultimately the photographic flaw. It's the perspective flaw magnified because of the time problem in the photograph. Have you ever read anything in a photographic or art magazine about the problems of perspective?

PJ: Never.

DH: Well, for three hundred years there were debates about it. Artists knew there was something seriously wrong with it; good artists certainly did. If you look at a Velázquez, there are actually a few viewpoints put in. Now, this is not possible in a photograph unless you begin to do something like I'm doing, unless you begin to make a collage. Then you are putting more perspectives there. I think the 1926 Panofsky essay [*Die Perspektiv als 'symbolische Form'*, Hamburg, 1927] is the best on this subject. In this essay he even mentions quantum flow, which perspective cannot deal with. Now, the idea that perspective is about our attitude to space and us in it is clearly taken from what the Italians were doing. People have forgotten that Brunelleschi and della Francesca

deliberately set out to make a new space. We should do that too.

One senses an incredible need to make a new definition, a new attitude, which the camera cannot deal with, nor can the computer if it just works from a camera angle. All it can do is turn it round, but it can't actually alter its shape, which I found I could do in the joiners like the desk picture [*The Desk, July 1st, 1984 (see opposite)*]. In my lecture I talked about the reverse perspective of the desk and what it means. I wish I'd photographed the desk at the same time in a traditional way so you could see both, then it would be very clear what the difference is. Mind you, I did it in the Ryoanji Garden pictures. One is a triangle because it's seen from one point, and the other is a rectangle because you move. And the rectangle is true, which means that our memory of it must be a memory of movement. It all keeps coming back to movement and non-movement.

PJ: If you think about the *camera obscura*, and the fact that once you had a fixed perspective and a lens the world seemed to be ordered, it must have seemed to make order out of chaos. That's why we keep returning to that notion. We don't like chaos: we prefer order.

DH: Yes, that's it, but the perspective that gave order to them will not give order to us. We have to make another order. The idea that perspective is, in Gombrich's unfortunate phrase, 'a conquered reality', is like the ideas of the physicists of the early twentieth century who thought they had conquered reality. That was the phrase in use in the late nineteenth century. They've learned the lesson – there's far more to discover than we think. We have not conquered reality at all. The idea that the photograph is representing it has to be attacked. I'm deeply convinced about that. Of course, photographers, intelligent people, seem to have misunderstood it. Ordinary photographers just don't know what they are talking about.

PJ: Understandably.

DH: I find it fascinating that we still look at the world in the same way. We wonder what it will be like to go to the other side of the universe in a spaceship, but we'll realize one day that we're already there. There is another way. Once you're aware of it, you're actually there. The mechanics of actually moving through that space are impossible because of its enormous size. Eventually we'll discover a *new* perspective. In the old perspective you are totally rigid. Theoretically the furthest point from you is infinity – which means if the infinite is God, He's always a long way away. You never get to infinity. One hundred per cent of our images in the world are like that. When you reverse the perspective, that point is movement, you're moving. Infinity then is everywhere, including in you, which is far more interesting theologically, isn't it? God is then within us, and actually we are part of God. Ultimately it leads you to an idea of wholeness.

When you put it that way to people, they say: 'That's all right but how can you alter things?' You then realize perspective must be altered. How come photography goes merrily off on its own?

The Desk, July 1st, 1984.
Photographic collage

That's why Waldemar Pipsqueak [the art critic], talking about Italian painters on television, said, 'They came from Florence – the city of perspective.' It never occurred to him that the very image you are seeing of him is totally one-point perspective with a history that dates back to Florence. He thinks perspective is a kind of neutral thing, that it is just what's there. He separates art from the television picture of him, as if it had nothing to do with it.

But art was always concerned with making things more vividly real to experience. When they saw Giotto's work, they didn't say: 'God, this is a new, difficult art to grasp.' They said: 'Oh, it's more vivid and more real, and therefore we're moved.' And they were. That is the story. And it's true also of Picasso. At first his work was difficult to grasp because the jump was very great from the perspective picture. We would have understood the problem much more readily but photography came in the way.

I pointed out that Bill Rubin [William S. Rubin, writer on art, and author of *Pablo Picasso: A Retrospective*] refers to distortion in primitive sculpture in a sense that even he hasn't grasped. He thinks they based their idea on the fact that art is not for everybody. If the primitive making his African sculpture had taken that line, he would have held up his sculpture and everybody would have been baffled. What is it? What is it about? It wouldn't have worked, would it? He wanted it to frighten them or please them, or whatever, but in short it had to work. Something had to happen. I'm slowly seeing that the history of twentieth-century art is a bit of a fraud.

PJ: Well, we're still talking about photography, but we're moving into a much more important area, really.

DH: It goes beyond it, way beyond it. I knew my photography was not just about pictures. I knew it took me into another area. That painting there [*A Walk around the Hotel Acatlan, Mexico, 1985* (see page 88)] is not about a hotel; it's about an attitude to space. And there is far more space in the picture than is normal, isn't there? And the longer you look at it, actually, the more you create space in your head because you're converting time to space. They are obviously interchangeable in our minds. Back and forth they go. That's why we can't have a feeling of space without time. The old scientific idea that life was here and space then appeared is dissolving. I know that there's something very, very disturbing about these discoveries, and something thrilling.

In advertising they've realized that cubist photography can give you narrative, but it doesn't necessarily fit into the rectangle of the page. These pictures don't finish up as rectangles. But they can be adapted. I'm going to do forty pages for French *Vogue* without advertising. They said I could do what I want with it. I think they want me to make photographic experiments for the magazine. That's why I'm going to do it. You don't let an opportunity like that go, do you? You have to change things. And then you begin to change the world because you're changing the way you are perceiving it. Your eye should be moving round all the time, all the time. Even while you acknowledge the space outside, you're still moving round in it. And it works. The longer you look,

the more spatial it gets. That's how all these pictures work. And that must be like life.

PJ: And the advance of that work, as you've described it, over the earlier photographic work, particularly the Polaroids, is that, although you were moving all the time so that the backgrounds were represented properly, it was still according with a view of a room . . .

DH: It's unbelievably hard to move away from it because it's so engrained in us. It's taken me two years or more even to begin to realize that I should do it. You then move into territory where you don't know at all what the space is going to look like. You've no idea. It's fascinating, because you then realize that you are beginning to make it yourself, creatively make it. The problem is that the rigid viewpoint is so fixed in us, that aspect of measurement is deeply fixed. It was not so with Picasso, and it's only in the last few years that I've looked at Picasso and realized that there's no distortion. None. Even in Bacon you think there is, because he's still got a traditional space around him which means you are distanced.

Last January I was in Paris with Celia. We went to a Watteau exhibition – beautiful. There was a

The Flagellation of Christ c. 1463-4
by Piero Della Francesca

A Visit with Christopher and Don, Santa Monica Canyon 1984. Oil on two canvases

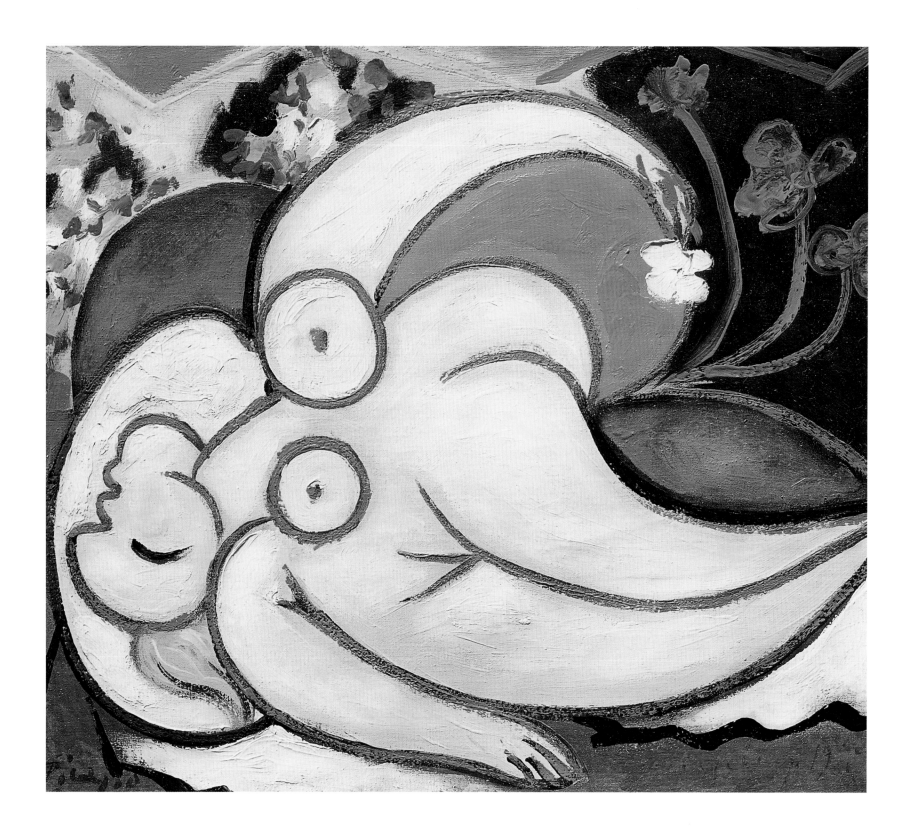

little painting of a woman being powdered by her servant. It's called *La Toilette Intime* [c. 1715] – very pretty, a charming picture, beautifully painted. You feel the skin and the softness. Well, next day we went to the Beaubourg to see the Kahnweiler gifts, and there was a little Picasso in which you could see the front and back of a girl. Now, if you can see the front and back, it means that you, the viewer, are in the picture. You weren't in the Watteau, you were a voyeur, looking from a distance. Picasso has done something more complex. He's made us not voyeurs but participants. And that seems to me to be an incredible achievement, one that we can't go back on. It's more exciting and it makes the world more intimate by drawing us into it. I think that's what we've not fully grasped about Picasso.

We've now got an art world that's trying to say, 'Modernism has gone: we're now into Postmodernism.' Well, you look at postmodern pictures and, frankly, they are going back to the old way of seeing, aren't they? There's something wrong there. In short, Modernism is far from over; it's only just begun. People are very quick to say: 'Thank goodness that's gone!' But they are wrong, deeply wrong, including a lot of serious art people! If painting is just painting to put on a wall – to use Picasso's phrase, 'mealy painting', then it's not that important. But the other way it is incredibly important. And that's what all art was in the past, that's why it was important. It does make us see the world. And it's there for ever. You can't actually go back on it.

PJ: It changes your view of the world, and it changes your relationship to the world.

DH: Have you read *The Re-enchantment of the World*? Beautiful title, isn't it? Morris Berman. And, another great title, *Einstein's Space and Van Gogh's Sky*. And that's by two authors, I've forgotten their names right now. Also *The Dancing Wu Li Masters* is a very good introduction to quantum ideas. And you'll instantly see the connections with pictures. In fact, through what they consider to be metaphysics, a new picture of the world is emerging – wider perspectives, new horizons. They are thinking in metaphors which, I realize, apply naturally to pictures. *The Dancing Wu Li Masters* was written about 1980; it's witty and funny. I'd get that book first. He has a wonderful chapter about the philosophical implications of there being no neutral viewpoint.

** In January 1982 CBS ran a documentary, The Uncounted Enemy: A Vietnam Deception, in which General William Westmoreland was alleged to have been at the centre of a 'conspiracy at the highest levels of military intelligence' to mislead the American President and the public about the success of a war of attrition against Vietnamese insurgents. Four months later unorthodox procedures used in making the programme were uncovered and CBS ordered an investigation but announced that it 'stood by the broadcast'. A five-month libel trial ensued but Westmoreland withdrew his case before a verdict could be reached, while claiming that he had achieved the affirmation of his honour that he had sought.*

Opposite:
Sleeping Woman, 1932
by Pablo Picasso

London, September 1985

David was in London briefly in September 1985 and we arranged to meet at John Kasmin's Knoedler Gallery in Cork Street. As the interruptions to our conversation were constant, David suggested a change of scene, so we repaired to Fortnum and Mason in Piccadilly. The noise level there was politely deafening. During the chat (over, as I recall, tripe and Guinness) David wanted to draw a perspective sketch to illustrate a point he was making. Having no pen to hand, he deftly extracted a cheap ballpoint from a passing waitress, who snatched it back a couple of minutes later, leaving David to complete his diagram in mid-air, to the somewhat perplexed amusement of fellow diners.

Later we moved on to Pembroke Studios where he showed me the new pieces he was working on for the forty-page section in Vogue. *The massive joiner of the Place Fürstenberg at first seemed surprisingly simple, almost a homage to Atget. On further examination its execution was anything but simple, and it made me hungry to see the whole magazine spread. A couple of days later David flew to Paris to finalize the design.*

Hockney was by now displaying visible signs of his deafness, inherited from his father, for which there is no cure. It is alleviated somewhat by increasingly sophisticated micro-chip hearing aids, versions of which he paints different colours. Thus a red sock on one foot and a blue on the other might be matched colour for colour with his two hearing aids. The discomfort and pain of his increasingly lonely condition is a private one, but its public acknowledgement is typical Hockney: colourful, humorous and theatrical.

PJ: Speaking now, as a 'non-practising' photographer, I think you've brought a great deal to photography through your work. I would say you've expanded its consciousness. Is there anything that photography has taught you?

DH: When I began the experiments, about four and a half years ago, I had no idea that it would lead to what it did. It has taught me a great deal and that is its real value to me. Whether the photographs themselves are works of art, frankly, I really couldn't care less. It's what it taught *me*. I was very excited when I began but, in fact, I'm only just realizing now how much it has opened up. It affects painting, it affects drawing, it affects my seeing and thinking. I've now given up the intense work on it. I've no doubt that I'll make some more pictures, but I'll only do them when I've thought it out more, and that will probably be from the painting. Painting can give you far, far more and I'm concerned most about painting as a depiction of the visible world.

PJ: You've had a love-hate relationship with photography for over twenty years. There's obviously something about the camera which is deeply fascinating for you, isn't there?

Opposite and above : **Cover and pages from *Vogue* magazine 1985.**

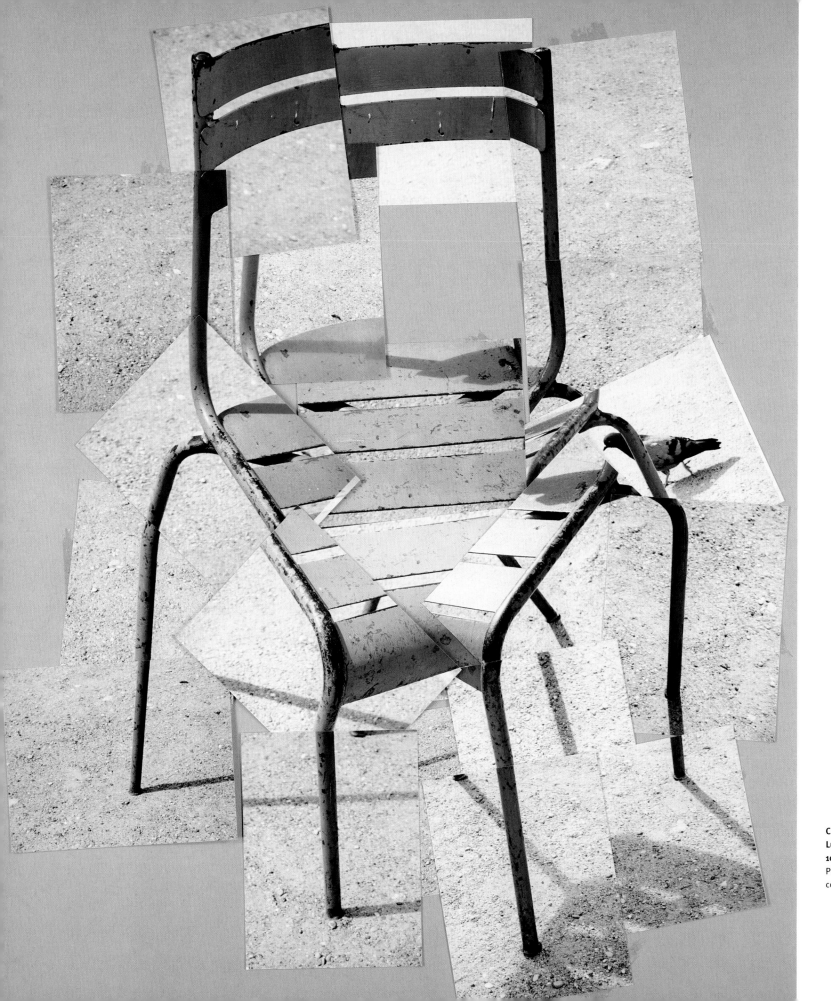

Chair, Jardin de Luxembourg, Paris 10th August 1985 Photographic collage

DH: Yes, yes! But in 1982 I picked up the Polaroid camera just to play around with it.

PJ: It's interesting that when you began seriously with the photographic experiments you chose the Polaroid. That's the one camera that works on the philosophy that it is possible to achieve a 'perfect' single image.

DH: Well, the Polaroids led me to think that what was happening was very complicated, and virtually impossible without that particular camera; in other words, that it was necessary to see the thing half-way through, which I couldn't using a 35mm camera. At first, the Polaroids were far more complex than any of the other pictures. But now the collages have got a lot more complex than the Polaroids could ever be. I don't fully know where it's leading. I do know that it's interesting, though. Of course, there are people who think I'm crazy, who think that I'm barking with madness! And that tells me something is going on.

Yet I realized, as the collages got more complex, that the physical surface they made had to be acknowledged and seen in a way that no ordinary photograph could be seen. The eye cannot always fully recognize the surface. It breaks through it. I was lucky to have the opportunity to do the *Vogue* piece; they asked me at just the right moment. All right, you can do things in a book, but that's not the same as doing forty pages in a magazine that's distributed merely *as* a magazine. I wanted to show that complex photographs could be printed on a magazine page. After all, if a photograph cannot be reproduced today, its effect will be slight; not many people will see it. Most photographs are simply reproduced in books – that's the way people see them.

I can see other artists now going into problems that I went into about sixteen years ago. They have been held back because of their reliance on photographic images. It took me a long time to come out of it. There was a three - or four-year period when I made pictures with one-point perspective, and the one-point was bang in the middle of the canvas. This was when I'd really gone into photography seriously and realized there was something deeply wrong. Backing away from it to get to reality was the beginning of a never-ending struggle.

Nevertheless, I've found much more satisfying solutions to the problems I set now because of the thinking that photography forced me to do. I was forced to investigate exactly how the photograph represents reality. I grasped fully that it must be an abstraction, and I realized why we had been confused by thinking it was not an abstraction. When you know that it is one, you can make better use of it. The later pictures, like the *Place Fürstenberg*, would be very, very hard to make copies of. That one is thickly layered with photographs, sometimes one on top of another because I changed it so much. In a way, even that physicality gives it something which you feel. Before there might have been simple overlaps, now they are much more complex. We've decided not to let anyone else reproduce it, but to make big Cibachrome copies so that it's clearly a photograph of a photograph. So there's only one now, and I'll keep it; that's the solution.

Above: **Pages from *Vogue* magazine 1985.**

PJ: I understand that you haven't sold any of the Polaroid work, and you've kept all the originals of the first state of the photo-collages. I can see why you don't want to disperse them.

DH: At the moment they are dispersed. There are a few exhibitions of them, but I have kept everything, including all the original pieces that I put together, and it's a massive body of work. As I mentioned to you before, there are times when I'm subsidizing an activity. As long as I can get the money from another source, paintings and prints, then I will keep the photographs together. If I sold them it would be hard ever to get them back. I don't fully know what they are, but all my instincts tell me to keep them together.

The other realization I've had, which any artist will tell you about, is that the flat surface is a very mysterious thing – very simple, yet rather mysterious. What you can do on a flat surface is amazing. Physical reality comes through this flat surface of my eye (although it's actually curved, it's two-dimensional) and is converted by the mind into space and materiality. There must be some relationship between this two-dimensionality – the sense of the eye – and the mystery of ordinary two-dimensional surfaces. I've always been fascinated by this. That's why I make pictures, and that's why I don't go in for sculpture. It also accounts for my interest in paintings of swimming pools, or paintings of a surface. Any pattern on water is a pattern on a thin film of the surface of the water, rather like the water that must be over your eye. I now see that a lot of my early pictures were all about this.

There's an early painting of mine with an elaborate frame around it, and in the painting there's a little man touching the four edges of the side, saying, 'Help!' He's trying to get out of the frame and containing edge. I can look at my early work in another way now. The work may be involved with the theatre, but the theatre is deeply concerned with perspective too, and so it led me back to the same area.

PJ: When I left you last, you were talking about the depiction of the crucifixion, which you mentioned in a letter to Kitaj. At that point you were talking about the frozen eye, the moment of death, the relationship with photography, and the figure not moving, being pinned, like us, as spectators.

DH: This is speculative, of course – it's all it can be when there's no sure proof of it. I was struck by the question 'Why did it take so long?' in Gombrich's book *Art and Illusion*. It's a rhetorical question, but he didn't really answer it. Well, why did it take so long for a book on perspective to be discovered, when his argument seems like an eternal truth? I pondered this idea after I read that. Two or three years ago I talked about the *camera obscura* coming from Italy. But quite suddenly, last summer, I began thinking about the crucifixion and how interesting it was. I now realize that you can't really have a horizontal meeting a vertical without stopping the eye dead.

Previous page: **Place Fürstenberg, Paris, August 7, 8, 9th, 1985.**
Photographic collage

Play Within a Play, 1963
oil on canvas and plexiglass

Opposite: **Study of Water, Phoenix, Arizona, 1976.**
Coloured crayon

Hockney in his Hollywood studio.
Photo by Paul Joyce

PJ: So the graphic representation of perspective is in a sense rather like a metaphorical crucifixion?

DH: The sacrifices you make to achieve the feeling of an object in space in conventional perspective is to render everything down to a theoretical point. Effectively it takes your own body away. It must be damaging us. Perspective, it dawned on me, makes narrative difficult. Narrative must be a flow in time and one-point perspective freezes time and space. If you look at the world through a hole, and fix your eye rigidly as well, you're going to kill yourself, aren't you?

Cézanne noticed what happened when you look with two eyes, and doubt where something is. There is a connection between that and the act of crucifying. The action of beheading, or the arrow through the heart, is an action which means there's a moment of life and a moment of death. It's full of life one minute, and full of death the next. Crucifying is a slow death, and it's caused by lack of movement. Lack of movement is death: movement is life. That is clear, isn't it? The perspective picture brings us death. These connections seem so clear now, and nobody's written about them. They are our discovery.

PJ: And then you remember that the Renaissance artists were obsessed with the crucifixion. When artists investigated perspective, the crucifixion must have conjoined perfectly with their theories.

DH: They did. If Christ had been beheaded, the pictorial representation of it would have been more difficult, wouldn't it? It's all about suffering, isn't it? Bodily suffering, not just psychological suffering. Theologically, one can say that this was the first time that man had conceived God as a human being, which is, of course, on the road to saying, 'We are God.' That's part of the trouble.

Cubism moved the viewer into the picture, pushing him, pulling him in. Well, it's by no means resolved. Probably it never will be; we've opened up something that will just go on in a most exciting way. Photography has to change. There are signs that it's beginning. If the people who make commercial photographs realize their photographs look dead – once they compare them with these – then they will start altering them. Dead photographs will make people think about this. It's exciting because it will lead all photographers to think a lot more deeply about their process – looking, seeing. The moment you've got twenty photographs to join up, you've got quite a complexity, haven't you? It's fascinating.

PJ: A computer couldn't give you those combinations. You'd go outside any ordinary numerical projection.

DH: Yes, the moment you get to fifty or sixty, and four corners, the number is gigantic, isn't it?

PJ: An artist may take a week to do a picture, or two weeks or a month, but I reckon each work of yours takes at least a week to put together.

DH: I must tell you that the British Embassy one [*Luncheon at the British Embassy, Tokyo, February 16th, 1983* (see page 172)] took me three weeks. The one of Christopher Isherwood in the house talking with Bob went into three versions before I got it right. And each time what I was doing was re-doing the drawing. That took longer, far longer, because I knew I wasn't happy. It didn't feel like space. Finally, the third time, I got it to work. Frankly, it was lying there for over a month.

PJ: You mentioned to me your greater awareness of space in relation to your improved hearing . . .

DH: I believe that if you go deaf, you must develop a finer visual sense of space. The trouble is that unless you were expressing this in some way, nobody would ever know. You can't describe it in words. You have to express it visually. And I think there's a lot in that, because the moment I got the second ear fixed, space became spatial again. Sound also is spatial. It gives us a sense of space, doesn't it? If you were blind, you would develop whatever kind of hearing you've got spatially. You would learn directions of sounds. If somebody speaks to you from over there, that's the direction you would walk in. So your hearing would be used to define space a great deal. Well, obviously we can do this. I just added this as a kind of postscript, really, but I think there's a lot in it. It made me very much more aware of space, and my work is often about space.

Hockney with his Pentax 110 camera which he used for many of his early 'joiners'.
Photo Paul Joyce

PJ: You've moved through photography to a different kind of drawing and painting, and you picked up a camera to help you with space!

DH: Well, the joiners ultimately make the camera a drawing instrument, and so you're back to drawing as a very important thing. The camera was seen as the destroyer of drawing, wasn't it? Now, *that* was a mistake . . .

PJ: But there's something a camera *can* do. Look at the desk picture [*The Desk, July 1st, 1984* (see page 105)] – what it represents is the surface of the desk in a way that would take you weeks to paint.

DH: In painting you can do it another way. You wouldn't bother doing the exact surface that way, but the camera catches it, so that's what you use. When you take a camera close to the desk you can show the wood. It gives that strong illusion. But the stronger illusion, which you can realize fully, is that you are connected with the desk, and the whole world is connected, the universe is connected. This is opposed to the idea that we are separate from it.

PJ: Have we found there a photographic strength? Do you think in texture, in detail, the camera can record the way we know things to be?
DH: The camera can record light on to surfaces wonderfully, but it can describe as well. Description

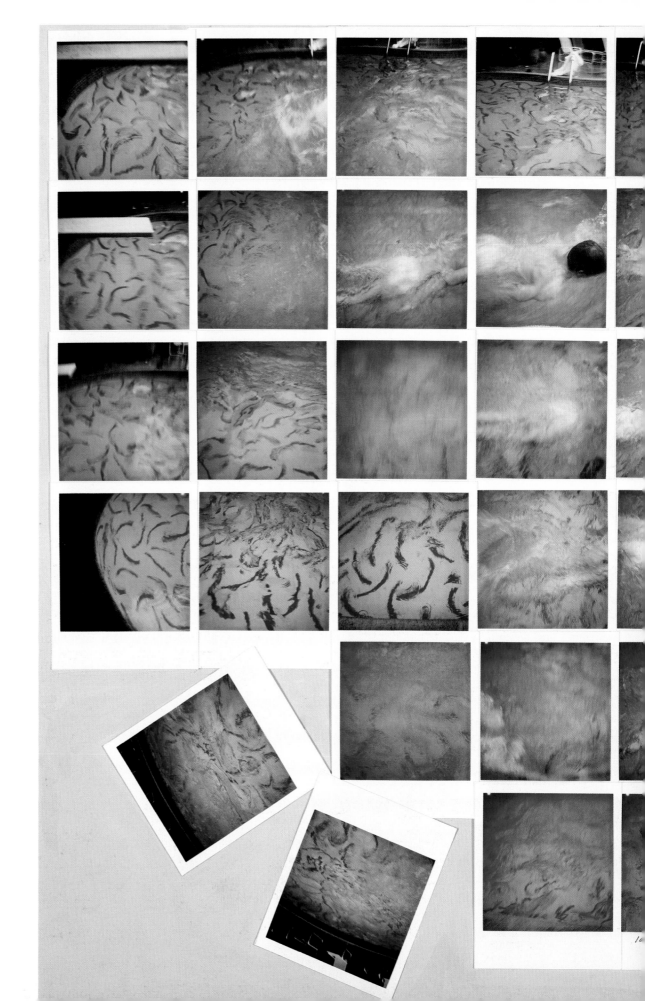

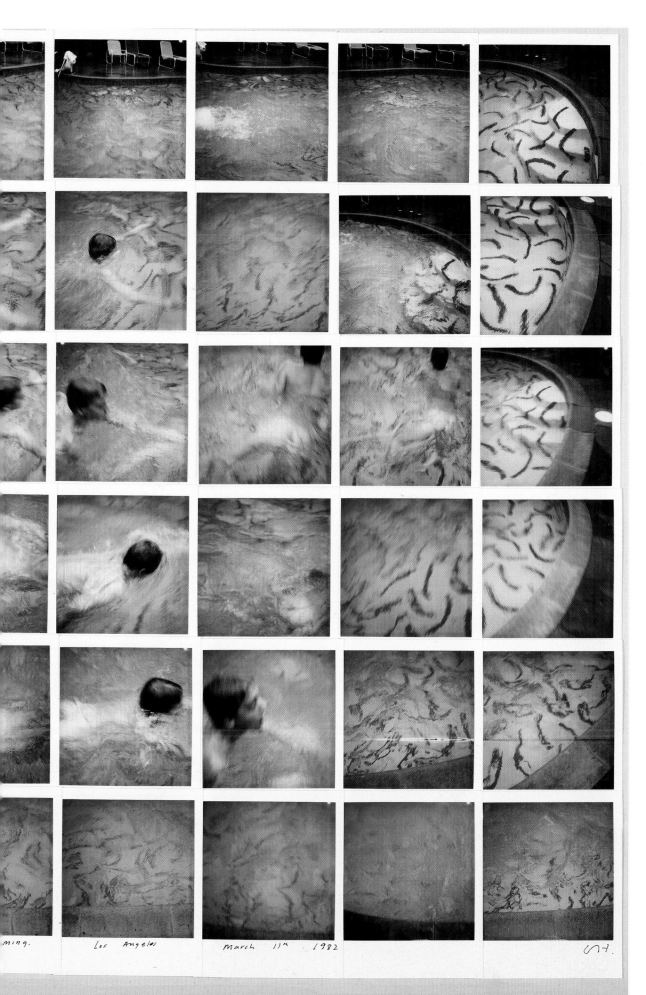

**Ian Swimming, L.A.
March 11th 1982.**
Polaroid collage

is subjective; it describes that desk and, therefore, connects you with it. The description means the desk is not on its own, there is a describer involved. Again, we're back to the participant, not the observer. To say that the camera can do that as well then involves it in drawing, and that would upset a lot of things. I think what will happen ultimately – in another ten or fifteen years – is that the ordinary photograph will begin to have a primitive look to it. Most people would not think so now. It seems the least primitive of pictures. That's exciting as well, because you can only make a picture look primitive if you've made more complex ones. When you look at the *Rossignol* photograph I made and compare it to the earlier ones, they look flat by comparison, don't they? Absolutely, totally flat. But no artist sees his work as separate. His ideas are continuous, they go through into everything. I'm sure not that many people figure it out – you have to do a bit of work.

DH: When I first showed these photographs in New York, some woman in the *Village Voice* said: 'He's done it all wrong.' Well, you make an experiment to learn something; it's not a question of right or wrong. If they say that to begin with they are looking at it in a wrong way. You must put it down to ignorance. I don't mind. The criticism of modern art was always from an ignorant viewpoint. I don't think that has gone away, even among people who think they know about modern art, or write for the *Guardian*. I don't think we should expect anything else. It's interesting that it should still go on after eighty years!

PJ: But they're a generation behind. They always will be. The artist, by definition, is far ahead. Everyone else is going to take some time to catch up. I don't think we should take account of it. You gave a wonderful description of colour in photography [in the lecture at the Victoria and Albert Museum]. You spoke about the fugitive nature of colour.

DH: The idea of getting the colour 'right' comes from the belief that there's a fixed colour out there. Well, of course, there isn't. The notion of there being a true colour would mean that colour is separate from everything. It's the old idea of separation. It all becomes irrelevant. As the colours fade, there will still be a lot there. They don't fade completely away; you don't suddenly have blank paper. There's always something there. Of course the line won't fade, and the photograph is deeply about line. I never worried about colour. You might prefer one to the other sometimes, just for your own pleasure. But the idea that colour is fixed and separate from you is nonsense.

PJ: You'll obviously do some major photographic work in Paris next week, won't you?

DH: I'm going to make the *Vogue* issue fun and attractive – I have to do that, that's my way. There is something serious about it, but I have to put the charm in. Somebody else might not, but I can't help it. I can't really go against my own nature. Artists can't do that. You have to accept it.
If a photographer thinks it would be better to know about drawing, he can be taught. You can't

teach somebody to draw like Picasso or Matisse, but you can teach people to draw quite competently, and at least get the principles. There are principles involved when dealing with a flat surface, and they are not difficult to teach, but they've stopped teaching them because they thought these skills seemed unnecessary: the photograph was doing it. You could get art schools incredibly lively again, because drawing would apply to departments which previously had nothing to do with it.

The more you know about drawing the better, if you're connected to anything visual. Cartier-Bresson can draw rather well. I'm sure that's why he makes wonderful photographs. He understands the principles of pictorial space. Annie Leibovitz started as a painter; she knows a little bit about drawing.

I think one of the main things that has emerged is the idea that there is a difference between abstraction and representation. A lot of serious people think there's a difference, but in the direction I'm going there isn't one. I can't help but come up against this – *anything* on a flat surface is an abstraction. And it's the fact that one particular abstraction of reality is regarded as a very, very vivid depiction of it that causes problems in other areas. A little art problem expands into an area that's a lot bigger than you thought. I realize now that not many people have gone on this path, and a lot of people think I'm quite crazy. But I think I'm absolutely on the right line – I sense it, I feel it. Now, I'm just staying here; I'm not travelling. Everything tells me to stay put and work, work at it.

Walking past Le Rossignol, April 1984.

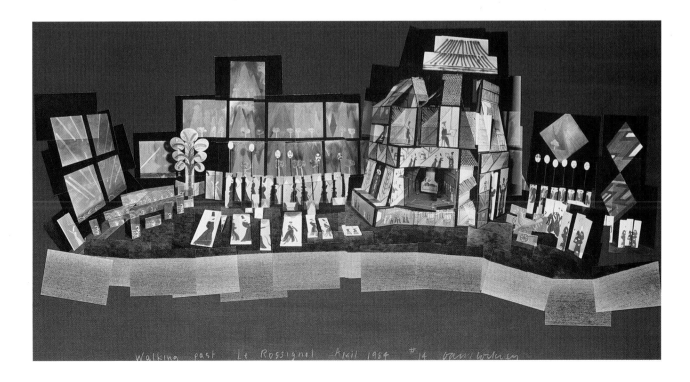

Parade. Metropolitan
Opera, New York 1981

New York, November 1985

In November 1985 I flew to New York for the International Emmy Awards as one of my films,
Summer Lightning, with Paul Scofield, had made it to the final selection. David was there at the
same time for the re-staging of Parade *at the Metropolitan Opera.*

One evening in the Mayflower Hotel David produced the page proofs of the forthcoming
Christmas edition of French Vogue *– forty pages of extraordinary new work, conceived and*
executed to fit into the existing magazine format, using revolutionary concepts of reverse
perspective; 'bleeding' pictures right to the edges; and objects reproduced on the page to their
actual size. These pages seemed to me to be masterly. They showed a great artist adapting to a
medium and transforming it. Three months after publication this issue had become a collector's
item.

David told a story about the Metropolitan's production of Parade. *The kids in the New York*
production are tough little pros, in sharp contrast to the well-mannered 'Home Counties Set' in
the Glyndebourne production. During the New York rehearsals, two seasoned eleven-year-old
troupers were overheard talking backstage. One turned to the other in disbelief and said, 'Look at
that, a red tree.' The other shrugged and replied, 'That's nothing, wait until you see the
designer!'

Apart from such flashes of characteristic humour, David seemed distracted and distant. Several
of his friends were ill, and one was dying in a New York hospital. His relief at the prospect of
returning to Los Angeles was apparent. He looked drained and exhausted. Our conversations
appeared to offer him a temporary distraction. We agreed our work was still not done.

PJ: I'm very interested in continuing with abstraction and representation – photography,
particularly, seems to be totally representational. What you see is what you get. Will this change,
and how soon, would you say?

DH: I'll tell you one thing that's happening. In Los Angeles there are a number of film processes
that are coming to the fore. They might call them special effects and so on, but people will say to
me that there are landscapes that a computer can make 'and it looks real!'. And I say, 'You mean
it looks real in a perspective way.' A man can look as though he's walking around a grand room
which he's never actually walked around. Collage could be made to look quite authentic, even on
a newsreel. This is cunning. It's going to be so easy to do. My point is that it's easy to do in an old
picture, but it would not be easy to do in a cubist picture. Not at all. You'd recognize
superimposition. You can recognize where that's leading. There are political implications in this,
aren't there? Well, I've joked before that if you had cubist television you'd have seen Ronald
Reagan reading the cue-cards because you could see round the corner. And, in a way, that's

Political manipulation. Czechoslovak Party leader Alexander Dubček with President Svoboda.

perhaps what we really need. I see it as a joke. People again will say that it's David's outrageous silly joke. But there's an element of it that's not a joke.

The other day I got a process from a firm in New York through the mail. It's a process that superimposes images. And they sent an example – the Flat Iron Building with lightning striking it and the top bits falling off. Now, it only looks good if you think what an ordinary photograph looks like. Of course, it couldn't work with my method. An ordinary photograph (or even television) is going about abstraction in a most deceitful and manipulative way. Now that deceit lays open possibilities for political manipulation. For how long, I don't know. Stalin's technique of taking Trotsky out of the photograph did make some people think for a little while that Trotsky was not at Lenin's side [see page 49]. But, of course, after a while, they learned about retouching photographs, and the technique couldn't work any more. People learned to doubt the photograph that way. Well, the biggest doubts now are going to come because of these techniques. How will you know that anything you see is real? The unhealthy side of this is that people fall for it. The healthy side is that people realize that it is merely an abstraction.

PJ: Well, they're abstracting themselves from it!

DH: A great deal of the media has a vested interest in an old way of seeing. I'm not suggesting

After his expulsion from the Communist Party Dubček was 'painted out', while Svoboda was enlarged.

people are evil, because I don't think too many people have thought it out. There are a lot of innocent people involved. It could be that any image you see could be made up of twenty images and you won't know it. That is the deceit. Maybe people don't think it's reality on TV. Maybe they see the whole thing as entertainment, including the news, or what they say is news. Maybe that's the only way they can take what is there. Every night there must be a hundred people killed on TV. Well, in the past people didn't see a hundred people killed every evening, did they? What do you think it does to us? Well, our defence is that they are actors. Oh, he was killed last Monday as well!

The only kind of television I've realized is fascinating and gripping is life. Now, if it's life, something else is there. That now corresponds to my now. The only things that are live on TV are sports events, because nobody wants to see a non-live sports event. They don't want to see last week's football match, when they know what happened. It would hardly be exciting. I think it does make a difference: I remember watching Prince Charles's wedding, and I actually stayed up in L.A. because it was great television. It was happening at that time. I wasn't interested in seeing a film of it later. It had to be at that time, i.e. now. There's only *now*. Television is deeply involved in pictorial problems, even though the directors think they're not – they just point the camera and think that's it. There are many other implications, some that people want to avoid. They don't want to know. And it's interesting, even now, watching the news about Libya – you get pictures purporting to be live, as though it were not rehearsed and put on for the camera. In short, you're

back to the old position of the fake fly on the wall. Frankly, I don't believe any of them. I think it's all a kind of TV game. It would be dangerous if you thought you could rely on these images and what they said. Not that you know the truth from the newspapers! But these are moving images, and it looks as if it's now, they tell you that it's live – '*Live from the White House*' !

PJ: You're saying that, in a way, the camera's become the arch-enemy?

DH: You must know about it because you've worked in film and TV. Fellini's stylizations are honest, these are not. 'Stalin's technique' does come apart because we've learned about it. The moment people know how it's done, they won't believe any image at all.

PJ: A lot of artists today have been caught in the maelstrom of film, photography and video. They need to deal with what they think is reality, or what they think people want to see. For the most part I think that the work, not the work of original film-makers like Fellini or Nic Roeg but of artists, has been pretty disappointing when they turn to this new technology. What is interesting now is that more people go to see the great artists of the past – Matisse, Van Gogh, or whoever.

DH: People are certainly more visually literate than they used to be. It is said there are too many images, but in fact people are just repeating them. It doesn't matter how many images are made the old way, there are always going to be too many! But there are never too many of the new kind. The idea that new images can possibly come out of old seems naïve to me. Of course you can get poetic conjunctions of things. Poetry happens, whether in film or television or on a flat surface. It's always difficult to know what the true art of our time is.

I see that Mr Saatchi made a catalogue quite recently, called *The Art of Our Time* – a pretty arrogant title. He obviously thinks he knows what it is. I don't think we do. The picture now is a bit too jumbled for us to see. It takes a little time to sort out. There was a piece in *The Los Angeles Times* on Sunday about the Oscars. It pointed out that loads of the great, great Hollywood people never got Oscars, including Laurel and Hardy and Charlie Chaplin. Well, somehow the middle-brow can never see that certain things are serious. They couldn't see Laurel and Hardy as serious art. They were seen as low comedy. But they have survived to be regarded as serious art. The idea that you know what's significant in art right now – in art that's just been done – is ridiculous. You'd have to be superhuman to know and understand what was most significant.

PJ: Maybe there's so much happening with apparently new ways of representing the world that we can't stand back and say what is good and bad within that. The mix of things is more complicated than it ever was. The choice for artists is simply amazing. Do they go into video? Do they go into film? Do they use the existing photographic images to make their own statements? I feel that this has more to do with a television culture than an artistic sensibility. I don't see how television can

change one's image of the world. All it can do is show you more things happening at once. But then, we always knew that things were happening simultaneously, didn't we?

DH: Yes, but television is becoming a collage. There are so many channels that you move through them making a collage yourself. In that sense, everyone sees something a bit different.

PJ: So, the man sitting at home is his own artist.

DH: Well, if he sees it that way, but he might perceive it rather awkwardly, thinking: 'Where's that programme I really want? What's all this stuff in the way?' Somebody a little more contemplative will enjoy the journey.

PJ: You know they are going to have television soon where forty or fifty channels are showing at the same time.

DH: Yes, well that's collage, isn't it? Collage is the key, the key to break perspective. What I call deceitful collage will do a lot of damage first, but it will fail eventually. The cubists were the first to realize what the invention was, and it's very powerful, a lot more powerful than you think. It's not just a decorative thing.

Photographic collage from *Vogue* magazine 1985

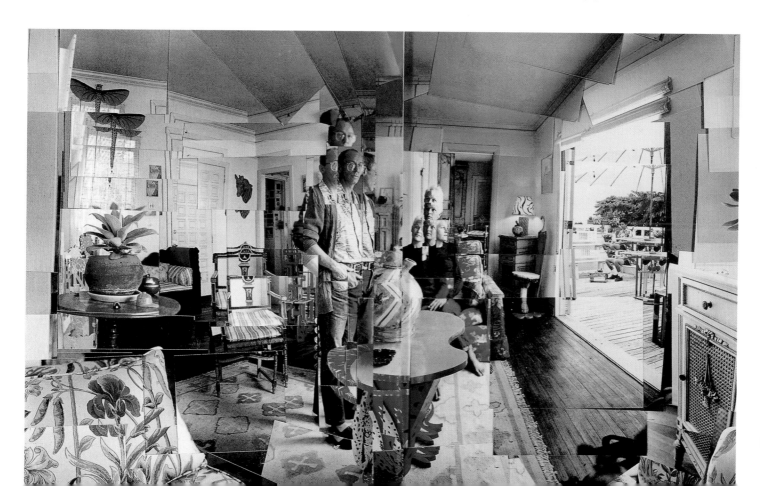

Los Angeles, April 1986

In April 1986 I returned to Los Angeles with a crew to shoot two, hour-long films on Hollywood in the seventies. I spent several evenings with David. This was my first introduction to his xerox work, which was being treated most suspiciously by his friends and business colleagues, gallery owners and the like. He had just acquired a small Canon machine and was excited by the fact that you could change the colour with ease. It was merely a matter of slipping out one cartridge, then inserting another. So it was perfectly possible to lay a background in black, change the cartridge and overlay a red area, and then do the same with a green. During my visit I saw his studio turn into an artist's impression of one of those large copy-shops, with people running around at breakneck speed as if trapped in an old silent movie.

One day we had time off from filming and I arranged to visit David in the early morning, around 9 a.m., so we could talk before he started work. I arrived to find him quite distracted. He woke in the middle of the night and couldn't get back to sleep. 'Got something on my mind . . .' he muttered, leading the way to the studio. I knew then that our interview was not going to happen, but I wouldn't have missed the day, because I was able to see him working flat-out on a complex, six-part photocopied piece. He began by sketching the design across six separate sheets of A4-sized paper, then he concentrated on one of these, using the basic design as a 'master' and feeding additions through the Canon photocopier so that the original was gradually overlaid. Thus a design was built up through a number of different 'states', not unlike conventional work on a lithographic plate, but at a hugely increased speed. He worked from 10 a.m. to 6 p.m. without a break, finishing each master design to his satisfaction, then doing an edition of sixty from each sheet. Three hundred and sixty original Hockneys, designed and printed in one day!

David believes that photocopying machines, and the next generation of laser printers, will revolutionize publishing and printing. Artists will be able to produce and edit work entirely from within their own studios, as indeed writers will be able to publish their work via desktop computers. The electronic age has caught up with traditional methodology, bringing the concept of the 'Global Village' one step closer. The artist in his ivory tower will no longer be isolated. Technology has brought the world to his workbench.

That evening we moved through to the newly constructed kitchen which now forms part of David's living room, by the terrace overlooking the pool. Any thoughts of relaxing and reaching for the tape recorder were soon dispelled as he flung himself into preparations for dinner. His approach to cooking, which he is very good at and enjoys hugely, has the same single-mindedness that he brings to any other task. His only moment of hesitation was over the broccoli. 'How long does it need?' he asked. 'About six minutes,' I replied. 'Right,' he said, thrusting a wicked-looking kitchen knife at me, 'get cutting!' I sighed, abandoned all thoughts about the meaning of art, chopped the broccoli and had one of the best dinners of my life.

Dancing Flowers, May 1986.
Home made xerox prints (6 panels)

PJ: Tell me, do you think that photography can tell us anything more about the physical world?

DH: Not really, it couldn't get close enough. I've no doubt that strong images will be made, although I must tell you that I was reading a review of a biography of Robert Capa, and I learned that the famous photograph of the soldier in the Spanish Civil War was posed. Well, something collapses there. The image is there, but a certain authenticity that made it into something has gone, hasn't it? Did you know it was posed?

PJ: I knew there was controversy about it, that some people denied it hotly and others said it was clearly fabricated. Yes, it always worried me, because I thought that Capa was a great war photographer and achieved magnificent results. But that took away the bite, the reality, what one thought was reality. It plays then with the notion of what is real.

DH: It's always the same thing we come back to, isn't it? But collage is happening, and I'm concerned about it being honest. It is happening.

PJ: Well, perhaps Capa's was an honest collage.

DH: Of course, the very fact that the image has done a great job leads you to ask why it matters whether it's real or not? I remember seeing a film with Marcello Mastroianni about the French Revolution, about two or three years ago. There's a scene where the French Revolutionary mob comes to attack. But the director and cameraman quite rightly don't spend too long on their faces because they don't look hungry, because they don't look like peasants who have nothing to eat. You might put clothes on which suggest that, but you can't make faces do that, and make-up cannot do that. If you saw a newsreel of the Revolution, even if you had posed it, if it was happening at the time with these people, it would be revealed in their faces.

PJ: Do you think that photography, in the sense of a portrait in its own time, has truth?

DH: Well, you can't escape your own time. No way. If I tried to make what I regarded to be an exact copy of a Rembrandt, even brushstroke for brushstroke, I couldn't help putting into it the twentieth-century view of Rembrandt. By the twenty-first century they would know that it was a twentieth-century copy of Rembrandt, just as we do with the nineteenth-century copies.

PJ: But looking back, particularly at photographs, it always strikes me that it's of sociological interest how a street looks, how people dressed, how they behaved one to another.

DH: Well, aesthetics aside, all old photographs *become* interesting, no matter who took them.

There has been no end of photographs taken, and the vast majority are of humble people. If any of them survive five hundred years they will be of great interest, not just to scholars, but to everybody. The future won't separate the pin-up from Cartier-Bresson. The first is attempting to depict the nude in a certain way; it's reflecting certain things about our time. *Anything* five hundred years old is of interest to us. We might think the nude is trash now, but the future will decide that.

PJ: I think of that great photographer August Sander, whom we mentioned once before, who did that wonderful series of portraits of Germans.

DH: In the twenties and thirties.

Spanish Loyalist at the Instant of Death.
Photograph by
Robert Capa, 1936

PJ: Yes, that's right. Well, are those going to be judged as masterpieces of August Sander in two hundred years, or are they going to be seen as a fantastic document which happened to be gathered by him?

DH: August Sander saw it as a document, and then later it's seen as the work of August Sander, but eventually, I suppose, it will be seen as it was meant to be, as a document that August Sander did. But what is interesting is the document.

PJ: Absolutely. It's a very interesting notion that photography can't escape its own time.

DH: No, it can't, no matter what it tries to do.

PJ: But, then, doesn't a Van Gogh escape its own time?

DH: Nobody does.

PJ: We still marvel at the Van Gogh because of something which is timeless about the quality, the vision of it.

DH: Yes, there is something universal there, and we will respond for ever to that.

PJ: I'm beginning to believe through all these conversations, David, that no photographer is going to survive a century hence, as a so-called artist.

DH: No, probably not.

PJ: Apart from an artist who picks up the camera, which is a different thing. And all this hoo-ha about them really tells us more about the paucity of art than it does about photography as a great medium of expression.

DH: The debate has never been settled – 'Is it art or is it photography?' I don't think it ever will be. There's a cutting here from Australia about my photographs, saying they aren't art.

PJ: They say that your work isn't art?

DH: It says, 'They are photographs, this isn't art.' As if you have to pay duty on them, or something! The Australians are very conservative. They think that a photograph has to be just a mechanical reproduction of reality, but art must be an interpretation. That's what they think.

PJ: If someone was about to pick up a camera, someone who you thought was maybe a promising artist, or had some special vision or gift, is there any advice that you would give?

DH: Ask questions. That's what I'd say. When problems arise, ask yourself questions.

PJ: And don't expect the camera to answer them for you? What you've shown, I think, is that the camera raises more questions than it answers. But, ultimately, they are questions about oneself, aren't they? They aren't questions about the world, or art. It's almost as if the camera points back at you, when you pick it up. What are you going to do with this? What do you see? Can you see where photography might take you?

DH: There will come a time when I'll suddenly decide: yes, I'll make another photograph. At the moment I've no reason to, so I'll wait till . . .

PJ: Till the moment comes?

DH: Yes.

PJ: What I've noticed in the photographic work, because that is the work that I've followed closely, is that you throw yourself into a piece, and then you stand back and think about it very hard, and then you do it again, and again, and maybe again. It seems to go through this constant process of throwing a punch and then stepping back to observe the effect before you move into action again. Can you see a time when the thought and the action might part, and you become all action?

DH: Well, that's happening now, apart from when I'm talking to you! Today and tomorrow I'm just working on painting. I'm not thinking it out; I'm just acting on ideas. It's with a brush I'm talking to myself now.

PJ: There's something about photography which is almost irrevocable, isn't there? You set up, shoot the picture, and that's it. Either you've got it, or you haven't. And if you haven't got it, you're fucked. For you making a picture is a process of getting to know, coming to terms with, moving around, exploring, relating to something that you're looking at. You have dispensed with the idea of the irrevocable picture, the one image that either captures it or doesn't. And I remember saying, in a piece that I wrote about you, that you could actually end up photographing the whole world because where do you stop? So that is the question, David, where do you stop?

DH: Well, you never stop. I never stop . . .

Paint Trolley, L.A.
1985. Photographic
collage

New York, September 1986

On 12 September 1986, I returned to New York for an opening of David's photographic work at the International Center for Photography. This could be regarded as the storming of an establishment bastion, and I had to be there to see it. ICP is run by Cornell Capa, brother of the late photojournalist Robert Capa. The opening was a triumph; my impression was that the American photographers approached the show with a greater openness than their English counterparts. They were genuinely interested, engaged and moved. This was a key exposure of his work not only to photographers, but also to artists, Madison Avenue executives, television and film people and, most importantly, the newspaper and magazine fraternity.

Next morning I was in David's hotel room for an 8.30 a.m. meeting. I'd spent most of the night working on the manuscript. All he had on were underpants, his hearing aid and a fag. We proceeded to talk about everything but the manuscript. He spoke of his growing disenchantment with England and the British. He had decided to abandon Pembroke Studios as any kind of working base in future and to use it only for a night or two when he had to visit London. He feels at home only in the North of England, when he joins his family for Christmas and other personal celebrations.

Our talk continued in the hotel coffee shop. In the corner, not far away, a throw-back to the sixties with long hair and paint-bespattered jeans sat with a sketch book in hand. His eyes lit on David's golden thatch and out came the crayons. I could see the 'artist' out of the corner of my eye, and sensed the possibility of an embarrassing incident. After a few minutes he sidled over and thrust the sketch under David's nose. It was truly dreadful, only the blond hair being in any way recognizable. 'What do you think, man?' David looked quizzical and concentrated hard on the drawing. 'Want to buy it?' David raised an eyebrow. 'It's for materials, man, they're sure expensive now.' Immediately David handed him a twenty-dollar bill. The guy nearly fell over. 'Hey, are you some kind of artist, man?' David nodded. 'Yeah, takes one to know one.' David held on to the drawing, and the guy reluctantly backed away. David placed the sketch under his chair. I said, 'It was the materials, wasn't it?' 'Of course,' replied David. 'We all need those.'

We talked another two hours away, until his 'limo' slid up to the hotel's entrance, and it seemed that we were still talking into the tape recorder as a phalanx of friends, relatives and assistants swept him into the smoked-glass interior.

PJ: Talking of your new work, you said something very interesting to me: 'It's changed again.' You didn't say: 'I'm seeing more.' You made it something outside yourself. I found that fascinating, as if you were an objective observer of what you're creating.

DH: Well, I don't make that many of these large joiners now. They are very slow and I only tend to

Hockney and Paul Joyce
in conversation. Photo by
Nathan Joyce

Hockney takes his 'Wagner Drive'
during which selected visitors
were driven through the Santa
Monica mountains to the
accompaniment of Wagner on CD.
Photos by Paul Joyce

do them if I can push them in some interesting way. Otherwise I'd rather paint and draw. Doing *Pearblossom Highway* [originally commissioned by *Vanity Fair*, then abandoned by them as being too 'difficult' and expensive to print] I realized that it had gone further than any of the other pictures. The picture of the *Place Fürstenberg*, which was in *Vogue*, took about four days' work just to draw the space. I thought at the time it was pretty complex, but of course the *Place Fürstenberg* is a small confined space.

But *Pearblossom Highway* shows a crossroads in a very wide open space, which you only get a sense of in the western United States. Obviously a large, wide open space is more difficult to photograph, and get a feeling of, than a small space. Slowly I realized what I was doing. Although the picture first seems to have ordinary perspective (in the sense that the space the picture describes seems totally believable), it becomes a little strange only when you start thinking about it and really looking at the image. Here is a picture of a wide open space that you can really experience, but at the same time you also feel close to everything, don't you? Close to the signs, close to the road, close to the shrubbery, close to everything – you can see the textures of things. You actually move to look at things. So the picture is dealing with memory in a different way from the previous pictures. Three of us drove out to Death Valley and back, taking some photographs on the way – not many – but we had the experience of driving out into the space. We got to Furnace Creek, one of the hottest places in the Western Hemisphere, where it rains once every four years. The day we were there it rained!

I remembered a crossroads we had passed, which I thought could be more interesting. That picture was not just about a crossroads, but about us driving around. I'd had three days of driving and being the passenger. The driver and the passenger see the road in different ways. When you drive you read all the road signs, but when you're the passenger you don't. You look at what you want. And the picture dealt with that: on the right-hand side of the road it's as if you're the driver, reading traffic signs to tell you what to do and so on, and on the left-hand side it's as if you're a passenger going along the road more slowly, looking all around. So the picture is about driving without the car being in it. The more you look at it, the more you realize it's about *driving*.

It took me, David Graves and Charlie Scheips a week to make this. We did the motel rooms at the same time but they're much simpler. I do think this kind of picture is getting more and more *painterly*, which is very interesting. I'd started using a ladder on a previous picture – one I made in Pembroke Studios at Christmas over a period of about three weeks. I realized that you do get fish-eye distortions in photographing a room, because you have to point the camera upwards. I started using a ladder so that I could at least point the camera just *onwards*. In the landscape we needed a ladder to photograph even the small signs. If you stood on the ground, and included the edges of the signs in the picture, only the sky would show behind them. But, in fact, two of the signs are completely surrounded by the land. The picture was very complex to make. For instance, the lettering in the roadway was done about eight times, with eight different sets of letters to try to get the right angle, the way it *should* look.

PJ: When you work on a complex piece, it sounds as if it might develop an organic life of its own, and turn out to be completely different from what you had anticipated.

DH: Of course, there's no one viewpoint. I can move things about if I want to. I can bring a tree in closer and things like that. The actual space, from one side to the other, is about five hundred yards, which is a considerable distance. If you stood near the yellow sign and took an ordinary photograph you wouldn't see the other two signs. Maybe I should take you up there; it's about an hour away. Having seen the picture it would interest you to see the subject.

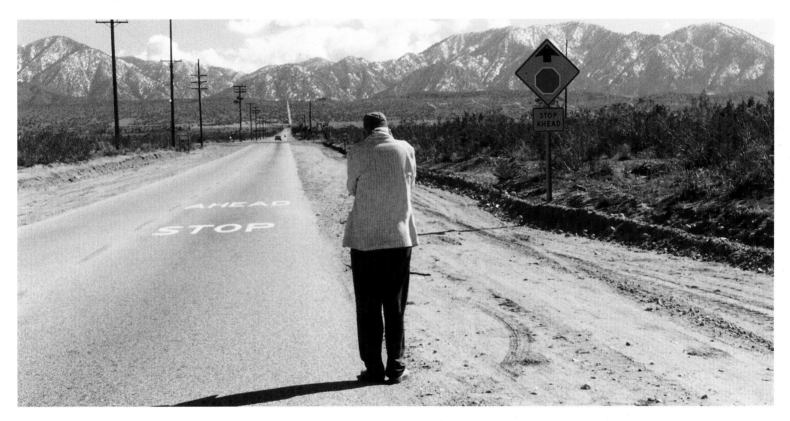

PJ: We should take some conventional photographs of Pearblossom Highway to contrast with what you've done. It's clear here that just as the individual images frequently overlap each other, so this reflects your own layering of time. Do you think an unsophisticated audience would appreciate this, perhaps even subconsciously?

Hockney photographing Pearblossom Highway.
Photo by Paul Joyce

DH: Yes, I think they would, without understanding how it was done. Obviously only people who are interested in constructing pictures are interested in the technique. Any viewer looking at the picture *knows* first of all, I assume, that the picture is intense, that there's a lot to look at. We deliberately chose a classic, American subject – a desert crossroad photographed many times. The

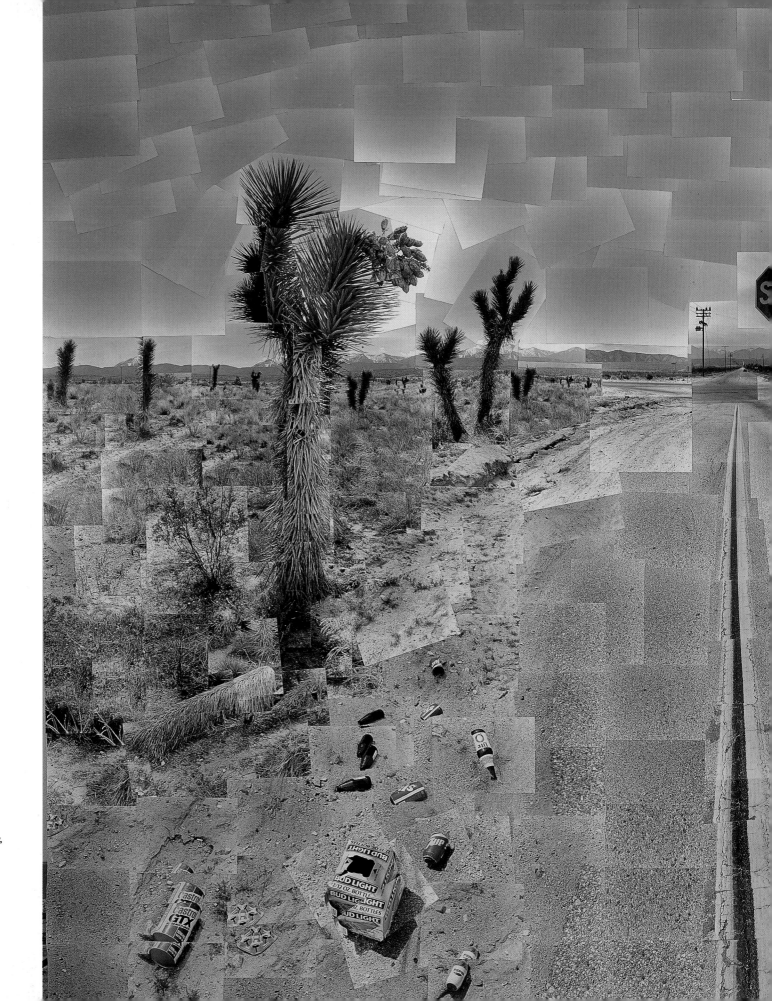

**Pearblossom Highway,
11–18th April 1986**
(second version)
photographic collage

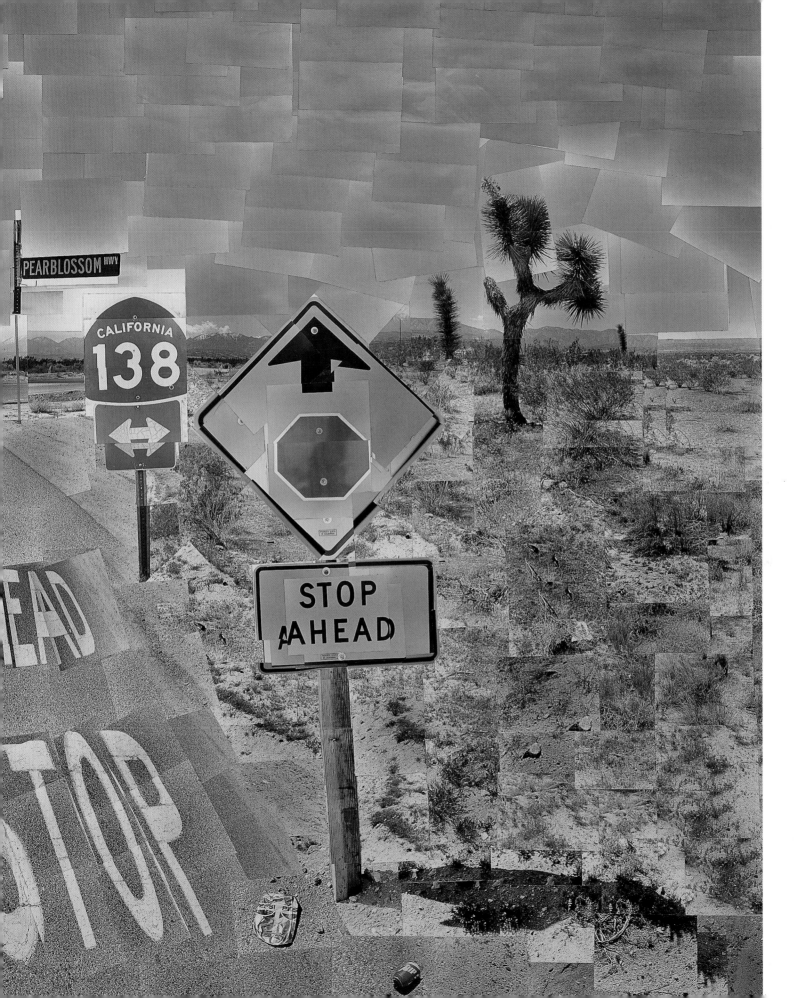

Hockney arrives at Pearblossom Highway. Photos by Paul Joyce

viewer is forced to wander around in the picture because I was literally wandering around the area. When you first look at it, it almost could be a conventional picture. It's only after half a minute that you realize it can't be and that keeps you moving in. I love the wide open spaces. I think they are good for the spirit. I love the feeling of taking a little walk in the wide open desert. The sky is massive and gives you a wonderful feeling. Somehow you feel the earth stretching for miles, without a vertical going up. You're aware there that you are on top of the earth – of course you are anywhere else – but somehow there you are more conscious of it. All of this was put into the picture.

PJ: I think the picture is about twenty-five years of driving across America. You've put the past and the present into it. But one thing I notice, almost in the centre of the piece, is a single, one-point perspective image. Perhaps you feel there is still room for a traditional viewpoint occasionally?

DH: In fact, right in the middle is a single photograph that is hardly covered up. You see the whole thing – a totally conventional road disappearing into the distance.

PJ: The picture which, in fact, anyone might have shot as their one remembrance of the place for their album.

DH: Yes. It's also saying that you don't just *dump* one-point perspective, but that it is merely a part of a more complex perspective, which we must move on to. Greater complexity is a natural progression. One-point perspective is only a half truth, we *must* realize that . . .

PJ: It's interesting that the AHEAD and STOP signs on the road, although fractured by images in a very complex way, actually read quite clearly. Not so long ago, you would have surely made a more graphic, less 'traditional', rendering of lettering.

DH: Those signs must have been done about ten different ways. What's happening is that you read both the signs written on the road and the actual road signs, and when you see the words on the road you know they are under your feet. You're therefore actually looking down. By the time you get to the crushed Pepsi can it's as if you have turned your head! Yet it all looks right, doesn't it?

PJ: Yes. It's an extraordinary picture in that when you confront it for the first time, it seems like a familiar view. The viewer is immediately engaged. Then one realizes that you, the artist, have actually looked *everywhere* and that each 'look' of yours is somehow reflected in at least one of hundreds of images. Surely this is the most complicated of your photographic pieces?

DH: By far, yes. It took us one week of going there to photograph *every* single day, then about

another five days back here at the studio. Hundreds and hundreds of pictures were rejected because they didn't make the piece look right.

PJ: Do you think it's always necessary to have something which, graphically, will strike people as being familiar, in terms of the photographic work? Or do you think it's possible to smash the realist barrier?

DH: Yes, it is; I think it's possible to smash the barrier. I'm approaching it somehow, but exactly how I'm not sure.

PJ: One difference about this new work, compared to earlier photographic pieces, particularly the Polaroid work, is that when you started to do the Polaroids you would have thought three or four hours taking the picture was an immense time.

DH: Yes, I did; that is a difference. I think the longest time spent on the Polaroids was about five hours.

PJ: And now, in five hours, you're just beginning to look.

DH: Yes, I wouldn't think that was much at all.

PJ: You have come to the point when you can say time can be built into these pieces. And once that is accepted and dealt with, that time can be as long as you want – it could stretch to months or years. You might work on a painting for three years or longer and come back to it again and again. Would that not be possible with a photographic piece?

DH: It might be now. It's certainly going that way.

PJ: Your photographic work is moving much more towards painting now. You started by saying it's like drawing. I think it's become more like painting. Certainly in terms of your later paintings and collages, there are amazing points of similarity.

DH: Yes, it is all coming together – painting, photography, prints, everything. You can see the links clearly now. The paintings are becoming collage, the prints are becoming collage, even the prints that I did at Ken Tyler's [master printer, of Tyler Graphics, Inc., publisher of *Paper Pools* and many recent lithographs by Hockney] were actually collage.

PJ: Has the period of four or five years of occasionally very intense work on photographic pieces

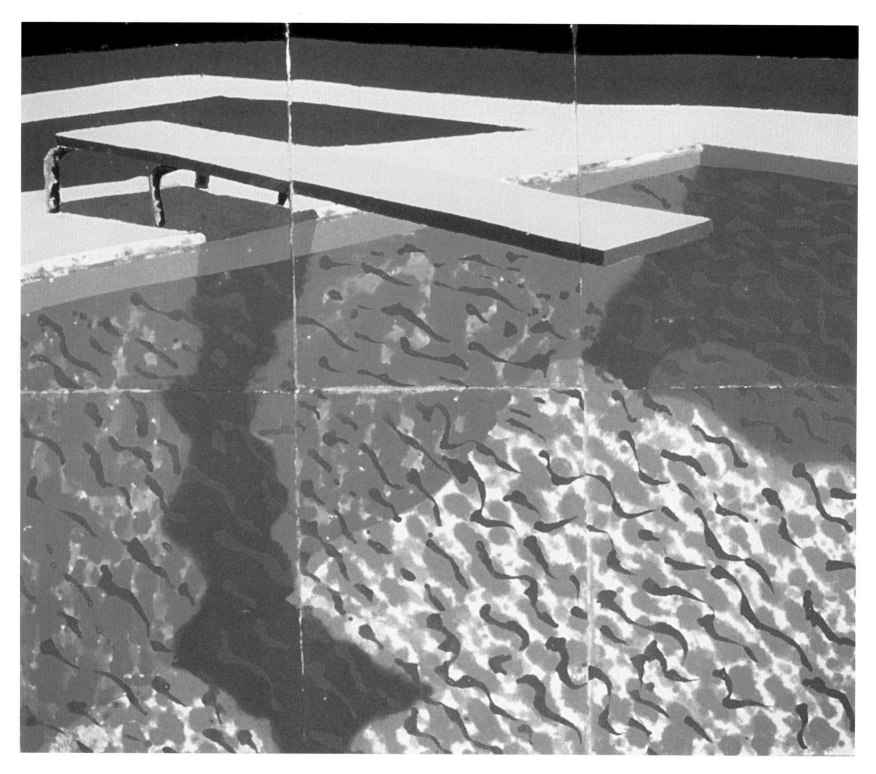

The Diver, 1978 (coloured and pressed
paper pulp from the Paper Pools series)

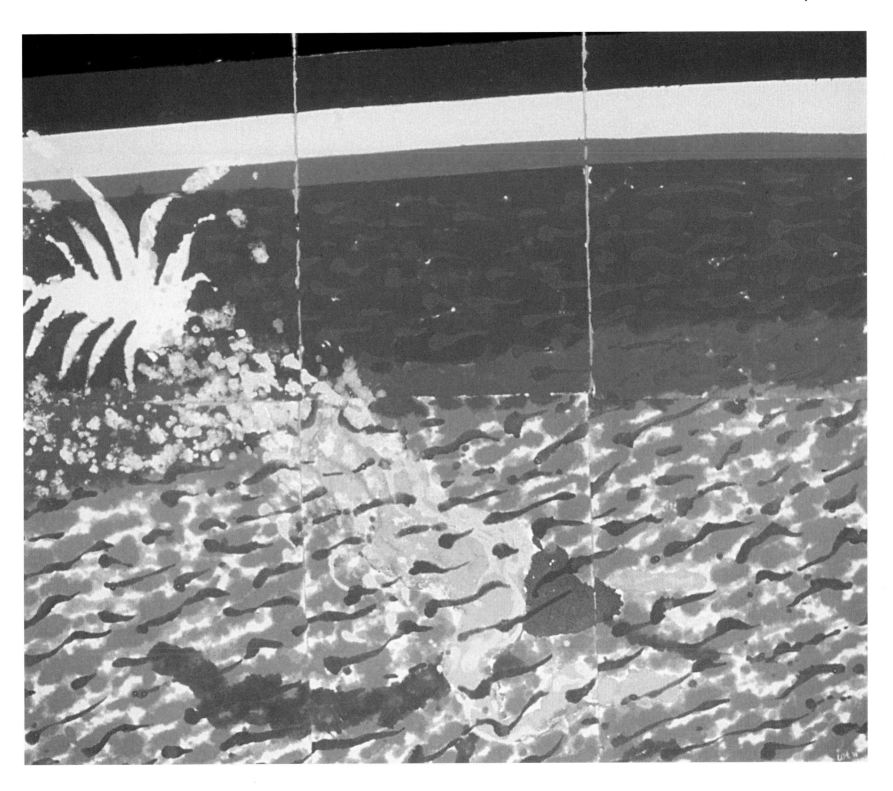

been necessary for a further advance in your other work?

DH: Yes, I do think so.

PJ: It comes back to that point of actually smashing through a barrier, doesn't it? You've actually got to break that apparently realistic surface and I think it is an aggressive act. One has to destroy it. It's too powerful to be dealt with in any other way.

DH: Collage is the key to the escape from the old way of seeing. There's something deep and very profound about the idea of collage, something very true. Collage acknowledges surface. It makes your eye realize that not only is there a change of surface, there's a change of many other things when one thing is glued on to another on a flat plane. What is lack of space, for instance? Its opposite cannot be empty space, its opposite is a theoretical flat surface. You can only have a flat surface, a two-dimensional plane, in theory actually. Collage makes space by acknowledging this two-dimensional plane and gets closer to our experience of reality. It's like the verse:

> *A man that looks on glasse,*
> *On it may stay his eye;*
> *Or if he pleaseth, through it passe,*
> *And then the heav' n espie*
> (George Herbert, The Elixir)

The idea here of levels of seeing, the eye deciding where to go, is happening in the xeroxes, isn't it? Glass is the theoretical flat surface. Heaven is space. I first read those lines when I was about ten years old and they fascinated me. It describes how your eye can look on a surface or ignore it and pass right through. The eye moves in space and it's that awareness that *makes* space for us. You begin to realize how foolish we've been to remain locked in the Western idea that the world goes on *without* us. I think this is deeply wrong. We are making *this* earth our consciousness. That is what I'm very aware of now. We could never prove it existed without us. When you get down to particle physics there's nothing there but energy.

PJ: I've had the feeling sometimes that there are parallel universes just a step away from us.

DH: Oh yes, they are here. There could be another Paul Joyce here doing something else. Do you remember, in Mexico City, I said that I felt there was far more *here*, right here? After that I began to read the theories physicists have come up with about alternative universes in the same place. Fascinating! It all seems far more likely to me than planets with other people way out there. That belongs to the old idea of moving and journeying to find other living things.

PJ: Tell me about the Uncertainty Principle that you told Kitaj about in your letter.

DH: The Uncertainty Principle has philosophical implications. It deals with notions of measurement, and the fact that everything isn't measurable, which goes against prevailing Western ideas. After all, we can't measure anything without being aware that we are making the measurement. We are there. This makes it clear that there is no neutral viewpoint. It was Heisenberg who made this discovery in 1927. He'd gone to the Island of Helgoländ – a rather misty place in the North Sea – for a rest because they told him he'd been overworking. He took walks, as physicists do, to think. And he thought out this mathematical formula about measurement: that you cannot measure both the position and momentum of a particle. The theory isn't about error but about the fact that it's just not possible. The implications are vast and, of course, one of them is that there is no neutral viewpoint. And that leads on to relate consciousness to reality – consciousness cannot be separate from it. I understand this passion for walking – when you walk alone you think, don't you? You go off in your head and think about all kinds of things. I used to walk across the moors in Yorkshire, always alone, and I've learnt since that all theoretical physicists do that.

PJ: Can you talk about the idea you mentioned before – how in Western art one-point perspective led us to Leonardo da Vinci's war machines and ultimately to the Cruise missile? There's something eloquent and intellectually appealing about the fact that a Cruise missile locks on to a target through a computer representation of a photographic image of the vanishing point!

DH: Yes, but isn't there also a link between the perspective picture, which excludes you from its space, and the Cruise missile, which would ultimately exclude us from the world? Only artists really go into this area – you have to be interested in attempts to construct representations of reality. Even the scientist, who is making a constructed picture of reality, doesn't link these ideas with the problems of the picture. We know that the picture has a powerful effect on us – it makes us see the world in certain ways.

PJ: Leonardo was working from a one-point perspective viewpoint but he was also dabbling in war machines and ways of approaching targets with his submarines and guns. There is an element of attack in the one-point perspective idea because you actually have to aim at a target, which might not exist in a particular picture, but logically those lines can be brought to bear on anything you want. And it's a very easy step from that to a projectile which is going to obey the same rules. What can we do about that?

DH: Changes happen slowly, as you know, even though we think the world's speeded up. I think the idea that people have understood, say, something that happened fifty years ago, absorbed it

Drawing for a Giant Crossbow
by Leonardo da Vinci

and now gone beyond it, is not possible. It often takes a great deal of time to *really* understand what the implications are.

PJ: What's the implication for the artist now?

DH: Well, you've heard people say: 'We've got too many images; we're saturated with images.' In one way it's true, and in another it's not. There are thousands and millions of images, but not very many are memorable. Most will just disappear. If we are to change our world view, images have to change. The artist now has a very important job to do. He's not a little peripheral figure entertaining rich people, he's really *needed*. When I realized that, it really thrilled me, because it means there's a purpose to what I'm doing.

PJ: Do you think that photography in some way mimics a pattern that the brain may have in recalling things? When we remember things – people, moments in our life – we have a tendency to stop time in our heads. Is there something actually built into the way we remember the world which seems to be photographic?

DH: I've always thought that Proust was very right. For instance, I was working on *Parade* and I went for a weekend to Connecticut to stay with one of the technical directors of the Metropolitan Opera. We went blackberrying. Now, as a child I used to go blackberrying on a railway embankment with my mother and brothers; we took cornflake boxes to fill with the berries. The sight of the blackberry bushes did not bring it back vividly, just a suggestion perhaps. But the moment I picked one and put it in my mouth, an incredibly vivid memory came back as it burst on my tongue. It was so vivid that it was as if that time became *now*. It was also Proust's story. You can't control the juices of the blackberry, or the madeleine. Something happens in your mouth and triggers something else which becomes incredibly vivid. It's of the past, but you're aware it's now.

I didn't get a great deal out of Proust at first, but there were things which absolutely fascinated me, particularly about memory. I have thought about the question: what is the memory actually like visually? Is it blurred? Is it vague? You are aware of a kind of long-ago murky memory that you assume you could bring back, just as you are aware that you have to forget to be able to remember. Have you come across any books by Rupert Sheldrake? People have been looking in the brain for the memory, but they can't really quite find it as a physical part. Sheldrake has a theory that there are fields outside our physical bodies, waves the memory can tune into. He opens up the possibility that there might be collective memories, which can be picked up. Some people suggested his theories were terrible bunk, but they do click a bit with me, and I'm not a scientific person.

Ultimately I think ordinary photography has made the world dull. There's *always* something everywhere, and it's always interesting. You make it interesting, even if it's not interesting in itself.

PJ: Your new xerox pieces, the *Home Made Prints*, do seem to me to be an absolutely logical progression from your complex photographic work.

DH: A two-dimensional surface is incredibly fascinating because you can put more and more dimensions into it. It has always fascinated me and it must be the same with anyone who makes pictures. I've noticed this is true in movies, certainly the ones I react to and watch over and over again. Jacques Tati made marvellous use of the screen as a surface to show you space. You make the space in your head from his suggestions on a flat surface. That is much more thrilling than any attempts there have been at 3D, which are silly. You have to acknowledge the flat surface, and the single photograph has a great problem here, because your eye glides completely over it. It can't deal with its own surface. On a television screen showing a photograph of something, your eye goes clean through it as if it's a window. I'm beginning to realize there is something very dangerous about this.

PJ: I saw you put together a complete xerox work from scratch yesterday, constituting six separate sheets. All the time you were reworking each individual sheet, sometimes five or six times, adding, subtracting. I can't think of any other printing process which would allow you to do that so fast and with such flexibility.

DH: The machine does what you want it to. And I've discovered that it can do far more than I thought. But the thinking process is similar to that involved with the photographic work.

PJ: As soon as you put two photographs together, in the way that you are now putting two xerox copies together, something has changed irrevocably, hasn't it? The machine is no longer seeing. You are fooling the machine.

DH: This little machine, the camera, has been used for a hundred-odd years in a very simple way. We just plunk it down, thinking that the camera sees what's in front of it. Well, it doesn't, actually. The most important thing that we feel and see – space – the camera cannot even record. But it is good for recording surfaces, and we can do something with that facility. I suspect laser printers are going to make the xeroxes look like old etching presses. Lasers could totally revolutionize the printing of magazines. After all, the half-tone process which enabled them to print pictures on newspapers only began about 1910 and only flourished after the First World War. With the new work, I'm drawing. If you just xerox a photograph it's not going to look like this.

Everything seems to be coming together now. I sensed it before but I couldn't articulate it. I don't know where the journey will take me, but it's very exciting. I plod along, I'm a bit of a plodder. But each step leads me somewhere else.

Los Angeles, March 1987

During the winter of 1986 and the spring of 1987 I kept in touch with David by phone. Although both our schedules were very crowded, we arranged to meet in Los Angeles during the last week of March.

By now I was used to finding organized chaos within the Hockney home. When I arrived David was sitting in a small lightproof tent in a corner of his vast studio with a scale model of his sets for Tristan and Isolde, *frantically fiddling with a miniature lighting rig. Jonathan Miller, the opera's director, and the conductor, Zubin Mehta, were due in the next day, and David had been working on the models for five months. Once again the tape recorder was set aside for another forty-eight hours. Soon after Mehta and Miller's arrival, all three of them retired into a tent for hours on end, and cigarette smoke billowed through the cracks and settled along the studio floor, reminding me of a Hollywood 'haunted house' set.*

In a couple of days comparative peace returned. By now David was physically and mentally very tired. The completion of the first editions of Home Made Prints *clearly marked another important chapter in Hockney's 'camera-related' works, which would later include the fax and laser pieces as well as work with the computer. But now he was committed to a major retrospective exhibition – in February 1988 at the Los Angeles County Museum. He had begun to paint again, much to the relief of gallery owners world-wide. Also, the arrival of Stanley (David's pet dog) had given him an inseparable companion and a new subject for his pencils and brushes.*

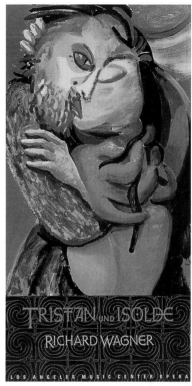

Tristan and Isolde, Opera model, Act II December 1986-87.

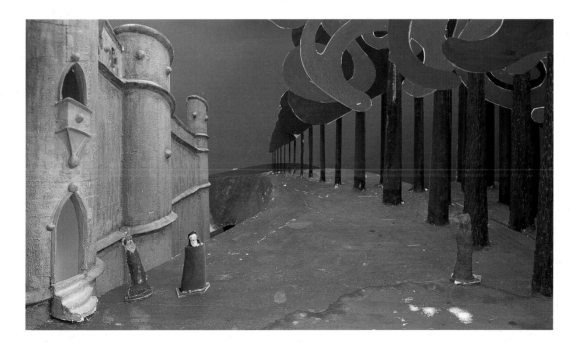

Opposite: **Hockney and faithful companion on the terrace of his Hollywood house.** Photo by Paul Joyce

Ian Watching Television, 1987.
Oil on canvas

PJ: Do you think you could have undertaken the *Home Made Prints* without having done the photographic pieces first?

DH: The *Home Made Prints* came out of work I did with Ken Tyler: I worked at Ken's studio for a year and a half, and all that work came out of the photography. The photography also drew me to the Xerox machine, because I realized it was itself a camera – one which confines itself to flat surfaces. The xerox work is collage as well, and I think collage is one of the most profound inventions of the

twentieth century in any way it's used. Although there's a playful aspect to collage, there's also a manipulative aspect. It's usually used for manipulative purposes. However, cubist ideas can save us from being manipulated, because in Cubism collage is seen to be collage.

One of the faults in the *Cameraworks* book is that the actual surface of the photographs is not shown. They were re-photographed in a conventional way. At the time it didn't occur to me that the re-photographing of them should dwell not upon the image but upon the surface. The image, after all, can take care of itself. The photographer, as it were, walked through the surface and not upon it. It would have been better if the corners of the photographs had curled up, or something, just so that you were aware of the surface. Perhaps there should have been shadows from the lumps of the Polaroid prints themselves. We should be able to feel that grid much more, and not simply have white spaces there. Shadows would have helped the eye to sense an eighth of an inch of depth, which can be very strong in a flat photograph. It could look almost real. I played with this idea on the next-to-last page of *Vogue* with the object upon the page.

Surface is important in our way of seeing. We are aware of it and every mark made on it. Why should you cover up marks in painting? In Western painting it's very common to cover up marks, but it's not in Chinese painting. However, in Western drawing the covering up of marks is not considered to be a sign of competence. There are a few reasons for covering up a mark in painting: perhaps you just didn't like the mark and want to eradicate it to put another mark there. Perhaps you wished to give the effect of volume to an object, and you used chiaroscuro, blending the shadows by using cross-hatching with a brush. Inevitably, some marks would get covered up in order to gain what you think is a feeling of solidity. People have failed to see that in very late Picasso this technique does not happen. He doesn't cover up his marks, and his work is more like Chinese painting for this reason.

If the marks are not covered, significant things begin to happen. In the oil painting of Ian Falconer [*Ian Watching Television, 1987* (see page 156)], I've covered up marks to make volume, but in the others I haven't, and if I've tried to make volume I've done it in a stylistic way. The painting of Ian was done three years ago. I wouldn't paint it like that now. In the painting of Stanley you can see all the marks, and you do in the xeroxes. Nothing is covered up, and for some reason these pictures work well from a distance.

PJ: The marks are actually more significant from a distance.

DH: Yes, you don't feel as if you've walked away from me, do you? The painting of Ian stays over there on that wall, but these later still lifes don't. You feel as if you are right next to them.

PJ: One of the first things you said to me about photography was how good it was for representing flat surfaces. But when you're making the joiners and the photo-collage work, you're not actually dealing with flat surfaces. The very nature of the collage means that it's not flat.

Self-Portrait, July 1986 (two panels)
Home made xerox prints

David Hockney with Jonathan Miller. Photo by Paul Joyce

DH: Well, there's no such thing as a flat surface: it's only a theory. If you really do get down to the surface of a piece of paper, you find it's full of bumps. So where are the flat surfaces? Are they just on the edges of bumps? The flat surface is a theoretical thing, and that's why it's fascinating.

PJ: As soon as the painter begins to paint, it ceases to be a flat surface, anyway. Surely, a photograph, a photographic print, is probably the closest, artistically, that you can get to a flat surface?

DH: Yes, it is, because it's all seen at once, and therefore your eye takes in the whole of the surface instantly. The eye can't do that in the collage, because collage entails another time existing there. When people make deceitful collage, Stalinist collage, they try to make it look as if it's all the same time. Honest collage deliberately puts another time there, so that the eye will sense two different times and therefore space.

In order to make a photograph like this, the photographer has to acknowledge his own presence: he is a participant in the events he portrays. Is Cartier-Bresson a participant in the events of the photograph we talked so much about?

PJ: In *The Informer* he doesn't participate in what's happening, but his commentary is surely deeply concerned with the event. If he had not been there, we wouldn't know about it, would we?

DH: We could read about it.

PJ: Not that particular event. We may have read about countless events like that, perhaps, but they haven't stayed in our minds.

DH: Do you know that I saw Cartier-Bresson at work on a Paris street? I didn't realize it was him at the time, but I thought: that guy seems to know what he's doing. By an incredible coincidence the very next day I met him in Claude Bernard's gallery. He had taken a drawing to them. I was impressed by the way he seemed to glide down streets, standing in corners so that he wasn't noticed. I saw him, but I'm quite observant.

It reminded me of the problem with the fly-on-the-wall documentary. The other day on a newsreel here they were talking about Los Angeles street gangs, and they showed a prison which contained a lot of gang members. There the prisoners were, banging on the cell bars, so that at first I thought they were an unruly lot. I then realized it was the camera that was making them react, and the moment the camera passed by they probably went back to sleep. But the average viewer, who doesn't consider how pictures are made, must have thought that these prisoners were banging on their cells twelve hours a day. It's the same in other situations. People react in an extreme way because of the presence of the camera.

PJ: But when you shoot photographs, there's never any attempt at concealment. In fact, it's completely the opposite: there has to be an absolute collaboration between the subject and you.

DH: Yes. At one time I put my feet in the picture, and then I realized I couldn't do that because I was walking about too much. It does have to be a collaboration. The point about the documentary photograph is: if the camera is there, it must be a participant; if it pretends not to be, then there's deceit.

I've gradually become aware that two very important surfaces – one paper and one glass – are continuously in front of us: the pages of the media, especially the pictorial pages, and the television screen itself. These surfaces ask us to forget them, to look through them. The television picture is behind the surface. The photograph printed on the page is below the surface, so that you're not aware of the paper.

I did a piece for the Bradford *Telegraph & Argus* recently, and they rang up to say how thrilled they were. They said: 'It seems to pop off the page!' I told them it had probably just popped on to the surface of the piece of paper, so that they became aware of looking at the paper, whereas they were not aware of looking at the other parts. That's the difference. If you're aware of looking, then you are aware of the surface as well.

PJ: But you also said there might have been a sense that work existed beneath the surface.

DH: I think we are aware of the surface of the paper because we're playing with it all the time, even with the surface of the photographs – leaving the rough edges.

PJ: One thing that strikes me about the work, however skilful and complex the procedure, is simply the very flat surface. It's the colour which makes the surface come alive.

DH: Of course, painters know about surface: only if you acknowledge surface can you go through it. We're aware of surface, for instance, on the cover of *Vogue*.

PJ: Very much so. You see the surface of the canvas, and the surface of the paint as well. What was the experience of doing this series of xeroxes so intensely? I saw you when you were just starting them.

DH: I was very thrilled to find a totally new medium, which nobody had explored. I was interested in the xerox as a printing machine. Most people who had played with it before had only used the reproductive aspects, and had assumed the printing wasn't too good. But there is no such thing as a bad printing machine. If the machine works and prints, whatever qualities it has can be used. It must have some good qualities so long as it actually works.

**A Bounce for Bradford
February 24th, 1987.**
A David Hockney 'original'
printed and distributed by
the *Bradford Telegraph &
Argus* in a special edition
on March 3rd, 1987

161

PJ: But beyond the actual printing, or indeed before and during the printing, you're making choices all the time about what goes on to that machine, not only what the content is but what the colour is, and so on. There is an element of the provocative about the *Home Made Prints*, quite apart from their content and the investigation of the process. They are a central challenge to the fine art establishment.

DH: They do that. They do challenge other things too. I have made the point, even with the black-and-white ones, that the machine can't copy its own layers. People do use the word 'copier' a great deal, don't they? I'm trying to point out that it isn't a copier, because there's no such thing as a copy, really. Everything is a translation of something else, no matter how it's done: it's a variation of time.

My work is never finished. It all leads on. The xeroxed work led me to devise a way of doing the pages for the Bradford *Telegraph & Argus*. Now that seems to challenge a great deal; for the newspaper, instead of reproducing my art and therefore commenting on it, made the page the piece of art. The page couldn't comment. Isn't that taking away an aspect of the newspaper itself? For instance, not long ago some prints of mine were shown in London, at the Royal Academy, but I didn't send them in. Later, someone posted me a cutting from the *Observer* complaining about the high price of the prints. They probably thought I'd be upset by this: they know I've always thought the art world was too greedy. But I wasn't unduly upset because I'd already figured out, if only vaguely, just where the xeroxes would lead. I'd begun to stir round in my mind the idea that somehow the page of the newspaper could have an original print on it, which, of course, would be very cheap. But the *Observer* haven't printed a page using this very cheap print I made for the Bradford newspaper. If it did, the *Observer*'s readers might think: 'Why can't we have one?'

New technology is enabling mass production to change, so that it is no longer about the possibility of making millions of identical objects, but about the possibility of making each one an individual object. Of course, this is a very great change, and, somehow, it must relate to this work. The newspaper's idea that it can only comment on art, that it's outside it, neutral, is a false notion.

I made a little edition with the xerox work, and since I do them myself the nature of the edition is quite small. I don't want to spend days and days making thousands of a similar kind, so I'd make a different one, and then a different one again. Sometimes I'd get thirty to the edition, but the most I made was sixty. I sold them at a certain price because of the relatively small number of prints.

What was more interesting for me was where it took me beyond the work itself. The xeroxes disturbed the print world because of the fixed idea of the craftsman on one side and the artist on the other. With these machines, the artist has to be the craftsman because he's part of the process. In etching and lithography, for instance, you work with a craftsman who knows a little bit more than the artist technically, but with the xeroxes you can't have someone who knows more than you about the machine because he'd get in the way: there is no room for him. But it disturbs a very small world – the world of the craftsman working with the artist – and it's fun to disturb things a

little! However, if you take the implications further, then things are disturbed far more than you would ever have thought.

Although all this work has come out of the photography, my ideas have changed and so our conversations have changed, because I understood things more clearly as I went on. When the *Cameraworks* book was finished, for instance, I was only just emerging to the perspective problem, which took me a while to understand fully. Issues of perspective are more wide-ranging than art alone, for all pictorial notions revolve around perspective. Slowly, the political implications dawned on me, as well as others, which I had never dreamed of before.

The very first photographic experiments I made were on a collage principle. Collage has been around now for seventy-odd years, but it took me a long time to realize how profound an invention it is. Yes, you can make pretty pictures with the Xerox, but I knew it could be much more than that. But I enjoy using pretty pictures to make something more profound. The knowledge that these pictures have a subversive side is deeply appealing!

I don't think this work is going to end here, but I do see why there might be strong opposition to it. There's a lot of vested interest in the neutral viewpoint.

PJ: Where is this opposition going to come from?

DH: From what we call the media, which is not quite what we think it is. The media still, to a certain extent, believes in the neutral viewpoint, whereas science has had to break away from it, and when it does it makes incredible discoveries. Well, there could be discoveries in other fields too.

People tend to think television news needs zappy pictures, so we are shown Rome burning rather than Rome being built. We are shown this because the way of seeing the world, and the mechanical instruments that we use, find it much easier to deal with Rome burning than with Rome being built. And, of course, Rome burns far more quickly than it is built. Destruction is always faster than creation – dramatic destruction, that is. We wouldn't notice slow destruction. It comes down again to a question of time.

Working out the implications of my experiments is a bit like working out the idea that if mathematics is consistent it cannot be complete. There's something fascinating about that idea, but it's not easy to realize the implications. The idea of the unknowable, which science didn't deal with for two hundred and fifty years, is now being confronted. It's a deeply interesting area, particularly for all kinds of artists. I think we're bound to see a great change in pictorial ideas because of this work, and I'm sure it will have a political effect, as well, because it's about images and how we respond to them.

PJ: It's intriguing that all the photographic experiments led directly to the *Home Made Prints*, which, in turn, led to the page of a newspaper, the simplest and cheapest and most easily available form of communication that exists in our society. You said that the newspaper piece was

**Two Apples & One
Lemon & Four Flowers.**
An original print from
The Independent

technically quite complicated. What exactly was the technique?

DH: It couldn't be done without the Xerox machine. I took away some processes that technicians had been doing, and returned them to the artist. I did the colour separations myself, but normally I would just have done the picture, with whatever colours I chose, and then the technicians would have processed it. In the end, all they had to do in Bradford was something very, very simple. They didn't even have to check their colours against anything, because I told them just to use their standard four colours. In fact, there would have been nothing to check their colours against, for the picture was the thing itself. I'd taken away layers that we thought, perhaps, couldn't be taken away that had to do with the processes of reproduction.

I delved into the printing process because printing is deeply connected with our way of seeing. The very word 'printing' has a lot to do with photography, because the photograph has to be printed, even if it's on a small piece of paper – as opposed to a transparency or a slide. If it can't be printed, it can't be seen by anyone, and therefore it won't have any effect. I'm aware now that we can change things, so I'm looking at all this with an amused eye.

I suggested many months ago that the catalogue for the Los Angeles County Museum should contain some pages made by myself. At the time I was thinking of the *Vogue* pages which I did, but now that I know how to use the paper itself as a medium, the exhibition can end by moving into the catalogue. My pages will be different because they won't be a commentary on the exhibition, they will be part of it, and all the other parts of the show will arrive at that point.

I've always been interested in reproduction and I know full well that if art is not reproduced or reproducible, then it's hardly known. For instance, I've seen more Picassos in books than I've seen in real life, partly because I've sat down and looked through the whole of Zervos [a comprehensive catalogue of twenty-three volumes reproducing all Picasso's work] three times. It would be an almost impossible task to assemble all those paintings together in one place, and yet they do exist all together in that book on the printed page. It is black and white; there's virtually no colour. But it is in itself a unique document.

I don't think printing is a side-issue; I think it's an important one. I must admit that sometimes I go down little side-lanes that turn out to be culs-de-sac, but sometimes they provide an angle which I can branch out from. Printing is an area which not too many artists think about. Andy Warhol is an exception. I think he intuitively understood a lot about printing as a medium, and his printed work is not very different from his so-called artwork. All his work involves printing and it's all just as effective in a printed book, which isn't the case, with, say, Picasso or Rembrandt.

PJ: But your work is very different, because your range and skill are much more extensive than Warhol's.

DH: Yes, but I just follow my intuition, usually wherever it leads me, and I'm aware that my work is

Poster for touring exhibition of Hockney's *Grimm's Fairy Tales*, 1994

known a great deal through reproduction. It couldn't be seen by nearly as many people if there were only the originals. You'd be surprised how few artists seem to take notice of this. An awful lot of pictures are reproduced once, and then they disappear, sometimes for good: a great deal of art does just vanish. When the first book, *David Hockney by David Hockney,* was done – the one I did myself – it occurred to me that bits of it might survive now. I don't know how many copies they published, but the book is spread far and wide.

PJ: Forty-six thousand copies were sold in the UK alone!

DH: Were they? Well, it was sold all over the world, so it must be well spread around. If there's a nuclear war, then perhaps some form of my work will survive, just in the shape of that book, as Picasso's would survive if all there was left was a Zervos. Of course, the great art of the past will survive, if only because it exists in so many books now; that is, if anything survives at all! We have to remember how much art has disappeared: art is a lot more ephemeral than we think. Rembrandt's work is still with us, but that's only three hundred years old – not that old, really. We just don't know what the situation will be in another thousand years. Nevertheless, versions of his work will exist in a permanent way.

PJ: I suppose the logical conclusion of this is that you will end up doing your own book.

DH: I'm actually thinking of that now. I'm thinking of making a book in the form of, say, that *Interview* magazine [December 1986 issue] where I did the page using so-called cheap printing, which we tend to think is not beautiful.

The first books I did were hand-made books. *Six Fairy Tales of the Brothers Grimm* was hand-printed, and therefore somewhat expensive, especially for a book. I think it sold for four hundred pounds – a lot of money. Although, considering the way it was made and hand-printed, it cost more to make than most books would sell for. Most people who bought it knew that.

I'd like to make a book which isn't simply reproductions, which uses ordinary printing machinery so that it would be cheap to make a lot of copies. I see, as I look at that *Interview* page, how I could do it, and how bold it could be. I will find a subject and I'm sure I'll do this book soon. We are already looking at printers, and I'm thinking of trial ideas for the four-colour process.

The book of mine occurred to me quite some time ago, but only now do I know, at least technically, how to start it. In fact, I think I'll make it on newsprint. There are different qualities of newsprint, and I'll probably pick the better ones because they will last longer. I'll do it in different ways, different forms, but I do want a period of painting first.

PJ: From what you've said over the last couple of days, it seems that the book we're doing could have something about it which makes it always living.

Front cover of the book, *David Hockney by David Hockney*, published in 1976.

DH: Everything dates after a while, and then comes back. Dating is just a process of change. There's the wonderful *New Yorker* cartoon of the man looking at Art Deco objects and saying: 'This is a movement we've got bored of twice.' Very funny, I thought! But with really interesting things, one begins to see them differently, and then they can settle down to being always there. I've witnessed that with Picasso in the sixties – when people thought his work had dated, was stuck somewhere earlier, while contemporary art had advanced somehow. Dating is about fashion, which does affect everything. There comes a point at which some things transcend fashion. Others fall by the wayside: ninety-nine per cent of it does. It has to. We couldn't deal with it otherwise.

I don't think the individual artist should worry too much about this; he simply has to go on with his research. It is the artists who make people look at the past differently. In that sense it's artists who make art history, not art historians. We tend to forget that. Even the historians forget it after a while! The past is constantly being re-evaluated so that it's kept alive. Art is either alive now, or it doesn't really exist, no matter when it was done.

PJ: Do you see the three or four years of intense work on photographs continuing in any recognizable form?

DH: I don't know. Certainly the intensity of the discoveries has worn off. I'm working more slowly now. For instance, my discoveries with the Xerox machine were very intensive at first. I worked very hard, and then I stopped for a bit. I might go back to the work and use it, but what you can never do is make the discovery again. *That* you can only do once. I realized that body of work had within it a subject that future work could not have: it had the *joy of discovery,* which, by its very nature, can't be repeated. I would only go back to photography now if I felt ready to push it in another way. *Pearblossom Highway* was a big advance on almost anything else. It was much more complex; yet it was a simpler image, almost straightforward at first glance. An awful lot of people probably don't realize just how complex it is, but it doesn't matter. That piece took a long time – virtually two months – the sort of time I wouldn't commit now.

I have noticed people using the joiner ideas in magazines sent from Europe. Most of them are not very good, but some are beginning to get somewhere. I'm sure the minute people started on the work, they realized how complex it was going to be. They think it's rather easy when they just look at my work.

I've noticed that older photographers tend to dismiss these ideas, or simply don't like them, while the younger ones seem more open to them. I suppose it's the same old story: we ought to expect that. It's the case with most new ideas. When Picasso and Braque experimented with Cubism it was the young who were excited, not the old. Nevertheless, there's a marvellous story about Matisse being told by Renoir that he didn't care for Matisse's pictures. Renoir was probably being very honest, but he was very nice to Matisse. I'm sure Cubism wouldn't have meant too much to Monet, either, and he didn't die till 1926. It was outside Monet's area. He would have thought

they were just young Turks doing something mad.

I noticed the criticism from older people myself. They were saying things like: 'You can't make good photography with a one-hour Fotomat. Certainly you can't make art photography.' Now, even in the art world they wouldn't say things like that; they'd know better. Nobody in the art world would say you can't make art from a piece of old wood, or a bit of plastic, or some trashy material, because they know perfectly well that it can be done. It seems to be the craft side of photography which is speaking here. The craftsman, who is not an artist, wants a beautiful piece of marble, whereas the artist knows perfectly well that if there's nothing else he'll use the old bit of wood – he has to.

PJ: I remember looking back on our conversations, and one thing you said really fascinated me. You said your photographic work was both a critique of and a commentary on photography, as much as being the work in itself.

DH: It is, but as far as I'm concerned, it changed photography for me. I get more and more letters now from people. They're mostly young, and some of them are very perceptive. They see the implications of the ideas.

The power of these joiners is that we know they are collages. Compare them with the photograph I showed you yesterday in which the view from the window and the furniture in the room had been altered by the computer, not the camera. That only works for the conventional, one-point perspective picture. Cubism can save us from this and, in fact, Cubism made possible the idea of collage, of the superimposition of one time level on another, therefore making the surface anything but flat. Of course, with Stalinist collage the picture is flat because the natural surface is taken away and replaced by another one. In montage, which is a slightly different thing, particularly in the work of the German John Heartfield [born Helmet Herzfelde (1891–1968), photomonteur and painter. He was a friend and contemporary of George Grosz, with whom he helped form the Berlin Dada movement in the aftermath of World War I. He created collages from cut and pasted magazine photographs, many intensely satirical and critical of Hitler's rise to power. He was a lifelong pacifist and Communist. He moved to East Berlin in 1950 and anglicized his name in a gesture of sympathy with the United States]. There's no deceitful attempt to make it look flat. We know it is montage, and there's no Stalinism. Quite the opposite.

PJ: And it was a political bombshell. Heartfield was vilified and his work was suppressed.

DH: It was done at a time when very powerful forces were against him, but perhaps that made him do it. We might expect that reaction.

PJ: He did create truthful images through that technique, projecting what might happen in the future.

Adolph the Superman Swallows Gold and Spouts Junk.
Photomontage by John Heartfield, 1932

Reclining nude 1932.
by Pablo Picasso

DH: There's another aspect here. It's difficult with photography to actually know what the present is like, because there are too many pictures taken. I made a suggestion to somebody at the International Center for Photography in New York for an exhibition. I said I had noticed over the years that in the photography of the nude there had been a movement towards closeness. If you looked through all the magazines showing nudes you could detect that movement, and make an interesting exhibition.

Of course, it ought to be the museum's job, to look at these developments in art and photography. Certainly some photographers are much better at depicting flesh than others are; that we can see. But they have got to the point where, with a single lens, they can't get any closer. If you got really close, you'd have to do a joiner like the one I did of Theresa Russell. That one was done as a commission, but I've often thought I should make one with a boy. I tend to like the bodies of boys, so it could be a turn-on – something more interesting for me, at any rate. But it would be about closeness first of all, which is totally impossible from any single viewpoint.

PJ: I rather think the work you've done, and the way you've changed photography, means that it's never going to be the same again. It's not going to be as self-absorbed.

DH: What I've done proves that photography is part of pictorial invention. It can't be treated

separately now, as it has been for so many years. The idea, the very words 'photographic realism', mean a very accurate perspective picture with everything in proportion, implying a certain kind of measurement. As far as I'm concerned, I've changed that, but whether I've changed it for others is hardly for me to say.

Many more people now go to photographic touring shows. I've no doubt that's because the shows attract the photography world itself, which is enormous. There are probably very few people like yourself, who are interested in theoretical aspects, and who also make pictures. There may be thinking people deeply interested in photography, but there are huge numbers of people who simply take photographs, who are attempting to depict what they think reality is.

I think we're living at a time when this problem about photography being seen as the ultimate depiction of reality is beginning to break down – partly through what I did myself, and partly because of the new computer technology. We don't know what photography will look like in two hundred years or so, but I suspect it will look different, very different. This is the exciting thing: photography has been brought back into the area that painting has always dealt with.

PJ: When people who don't know how these pictures were put together start to read this text, it might be illuminating for them to have some idea of how you approach a particular picture. I suggest we take the example of the British Embassy joiner, which you did in Tokyo. For a start, which camera did you have in your pocket?

DH: I think it was the Nikon 35mm. I was on a visit to Japan, mainly for the paper conference, but I was going to give a lecture about photography as well; the British Embassy was organizing a translator for me. We had been invited to lunch there, Gregory [Evans] and Paul Cornwell-Jones and I. Just before lunch we were talking to the British Ambassador, who was obviously something of a scholar and spoke very good Japanese. We talked about pictures for a bit, particularly Japanese art and the Japanese way, or rather the Chinese way, of seeing. He was talking about perspective, and the different ways of depicting space in pictures, and I told him I had been experimenting with photography, and wanted to make a picture over lunch of the assembled company at the table. He said that was fine, so I took the photographs over the period of the lunch. I tried to do it without intruding too much, so I never moved from my place at all.

When I put the picture together, it really did look as though the viewer was in my place at the table, having conversations with the other people. At that time the photography, the actual taking of the pictures, had always been done in one go. Later on the sessions began to spread over days and days as they got more complex. The taking of the British Embassy picture was probably spread over an hour, not a lot longer.

PJ: But it's clear you were watching all those people very carefully. Look at the way the Ambassador seems to have his arm wrapped around himself! Perhaps this is a little joke about the man, too?

Luncheon at the British Embassy, Tokyo, February 16, 1983. Photographic collage

DH: Yes, he seemed to be a very confident character, so I even had him putting his arm on his own shoulder!

PJ: Tell me, do you feel your theatre designs would be different if you hadn't been involved so intently with photographic images?

DH: Oh yes. I don't think I could play the games with space that I'm playing here. Just like the photographs, the viewer is totally drawn into the space, no matter where he is in the theatre. It's not a box that begins over there, which you look into. You feel you are actually on the ship, in the castle garden, on a clifftop, don't you?

PJ: Very much. When you embarked on this lengthy journey, did your instinct tell you that you would emerge richer from the experience?

DH: Yes, it did: within a very, very short period it told me that. These were discoveries. They may not have been new discoveries, but they were certainly profound discoveries for me with incredible implications, philosophical implications. These pictures are all spatial, and if they are spatial they must be complex. After all, spatial ideas take us to questions about our own identity: where we are, and who we are.

These ideas affected the painting immediately: I realized there could be totally new spaces in paint. It's only painting that can make these, not photography. I felt I'd taken photography to a certain limit. Photographers here, talking about the *Pearblossom* piece, said: 'It isn't photography; it's painting.' I could dismiss that as just something photographers would say, so that their work might go on undisturbed, but it is photography, even if I am, as it were, putting drawing into it. After all, the only instrument I used was a camera, and the only colours and processing used were photographic. True, I could change the colours, and I did that with the *Pearblossom* sky, but the medium remained photographic. The joiners do get close to painting because there is a different space made from the one the camera sees ordinarily. Once I'd got to *Pearblossom Highway* I felt photography was finished off for me. I know I could go on making more complex pieces, interiors especially, but I'm not sure I'll bother now. I'd rather do things in a more immediate way, through painting.

PJ: We've spoken about the xerox work, and I know you've done a lot of it, but it hasn't been shown.

DH: I have done a lot, but we just published thirty-two of those pieces. I didn't want to publish some of the first ones. Of course, this work took me a step further. It enabled me to do those two pieces for the newspapers – the *Interview* piece in New York and the Bradford piece. Printing in magazines or books is a much more interesting area to move into because the artist can use commercial printing now as a direct medium, and not as an aloof reproduction medium. This

means one can make much more interesting books, even though they're printed very, very cheaply.

I liked the opportunity of doing the piece for *Interview,* and for the Bradford newspaper. That is not a reproduction of the print I've made: it is the print. The process is therefore more direct, and looks more direct. You feel that straight away. Anybody opening the newspaper can see it. This is a fascinating area to have come out of photography. Here is a camera which deals with flat surfaces, the reproducing camera, the non-spatial camera, which is a Xerox machine as well. This opens things up to artists in a way they've not thought about. Artists have much too eagerly accepted the reproducing qualities of printing and photography, which, in many ways, distance the work from us.

If you look at some of my work in the eighties, you'll see that a great deal of it is actually about printing. It begins with the little book I did for *The Artist's Eye* in 1982, which is about printing, about reproduction. The exhibition was about looking at pictures in a room. In the introduction I was critical of photography in some ways, but most of the criticisms I attempted to deal with a year or so later. The *Vogue* piece was about printing: it was not just reproductions of my work. It is the work, the piece itself. The *Home Made Prints* catalogue is about itself, as well. It makes references to itself. And the *Faces* catalogue did that too. All this work came out of the photography, and yet moved quite away from it. If you just happened to see one of those catalogues, you wouldn't directly connect it with the photographic ideas. Although, if you had looked around, and you were intelligent, you would quickly connect them.

In this sense, the photography has not ended. It goes on and on, but I'd much rather go back to working very directly, and that means painting on canvas. I would now like to paint; that's what I really want to do.

Hockney painting in his studio.
Photo by Paul Joyce

Wave Tondo 1989.
Oil on canvas (round)

Los Angeles, 1988

During the mid-eighties, David's house in the Hollywood Hills became something of a Mecca for Hockney aficionados. The Hollywood artistic community, their friends and 'friends of friends' arrived daily on his doorstep. Being by nature good humoured and communicative, he managed to cope with this during the weekdays, but at the weekends, which he cherished as a time to relax and recharge, things became more obviously fraught.

In the mid-eighties David purchased a beach house and studio with a sea aspect that was restful and conducive to work. He decided to move his base of operations there. In Malibu he began a series of paintings of the sea, the house and its interior. He also began a series of intimate portraits of friends.

We spoke a number of times during 1988. It was becoming apparent about this time that David's deafness was advancing. Our previous somewhat intense dialogues gave way to a more expositional style of conversation. These informal interviews began in David's beach house with a portrait session. Our conversations continued over the next few months at various locations in Los Angeles.

Deck View 1989.
Gouache, ink, felt marker, crayon, xerox, collage

Hockney at his beach House.
Photos by Paul Joyce

DH: The beach house was owned by an old lady who had lived here for decades – an amateur painter actually. She'd built a small studio on the hill at the back of the house with an electric lift to get her into it. I enjoy using that lift too, and so do the dogs! She must have seen the whole of this Malibu beach area develop around her. What attracted me to the house was not just its charm, untouched since the twenties or thirties, but the fact it has a double-length deck. Anyone else would have divided that space and sold half off. To be able to walk along that wooden deck with the water at your feet gives you a feeling of real connection to the sea. Here I'm on the edge of the largest swimming pool in the world – the Pacific Ocean! Beyond me is nothing but sea. I've become something of an expert on local tide charts. Studying the movement of the water sends one into a profound meditative state. When you live this close to the sea, where it literally comes up and splashes the windows, it is not the horizon line which dominates, but the close movement of the water itself. It's like fire and smoke, endlessly changing, endlessly fascinating. I've noticed that the dogs don't look out of the windows in the hills, but here they'll sit and watch the sea with me for hours. I go to sleep and wake up to the sounds of the sea.

The studio here is one of the smallest I've ever worked in, and this limits the physical sizes of the canvases I can use, but it is one of the nicest I've known. I love it, and I notice that many other people do too.

PJ: I'm sitting here, having my portrait painted, and it's one of the most relaxed atmospheres I've

ever been in with you. Tell me how it has helped in the work you are engaged on now.

DH: I began to paint small flower studies here. They were for friends, friends who had died actually. I've lost a great many of them recently.

PJ: They have a sadness to them, I can see that.

DH: Also pictures of the beach house itself. I am experimenting with different kinds of perspective, relating to domestic interiors. Also painting like I am now, intimate portraits of friends. I try to complete the portraits in a single session, anywhere between two and three hours. I wanted to look again at my friend's faces and render them quite quickly, but not flatteringly. I might be charming sometimes, but I'm not a flatterer!

PJ: Tell me something about your experiments with the copying equipment; you always seem to get your hands on the latest gear.

DH: Although I've always had a lot of high-tech gear, I'm actually a believer in low-tech. To a gadget freak the hand must be the lowest tech of all. I've always believed in the hand, along with the heart and the eye. That's what we've got over machines and I suspect always will have, however

Second portrait
of Paul Joyce, 1988.

179

40 pix of my house with a video camera.
Colour Xerox prints/fax art post 1988

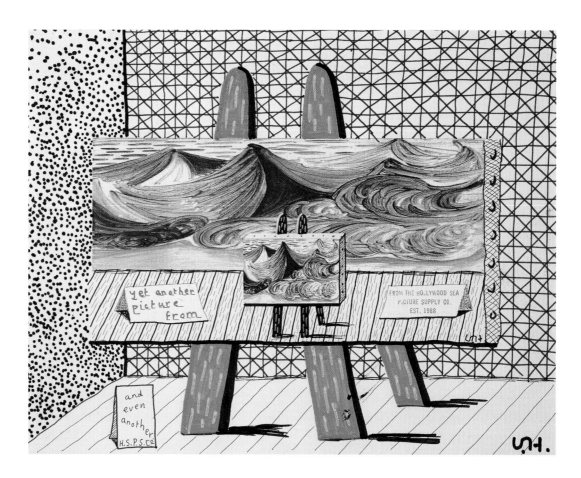

Even Another 1989.
Xerox, marker, ink

sophisticated they become. Nevertheless, I do acquire quite a lot of gadgets, cameras, computers and so on, but there are times when I feel that a machine might have a function that no one else has investigated. Against the advice of some of my friends and actually of my assistant, Richard Schmidt, I've just purchased for $40,000 a Canon colour copier, which can reproduce, one to one, up to a maximum size of 10.5 by 16.5 inches. Then I ordered dozens of canvases the same size because I had experimented with a copy of Henry's portrait and became very excited by the result. The colours from the Canon machine were intense and very, very close to the originals. But what was it, this copy? A photograph but not a photograph? A copy without a conventional camera, but I suppose a photocopier is just a different kind of camera. However, unlike a colour photograph, where the colours seem to exist below the surface of the print itself, here was colour which sat on top of the paper, giving it an incredible luminosity. What were they then? Not 'home made' prints, because there I made the images in stages via the machine. So they are not copies, but originals in an unlimited edition, just made by using a copier. I wasn't sure what to do with them, or where this would lead, but I knew instinctively that it would lead somewhere. So I made a lot of prints and gave them away to my sitters.

PJ: Tell me about your work with the fax machine.

DH: Well, there's another example of a machine which no one has thought about making art with. As a matter of fact, I call the fax machine 'the telephone for the deaf'. After all, the fax machine is just a printing machine. It occurred to me that it could be used in a beautiful way, to make beautiful things. It also struck me that you can send as many sheets as you want, literally hundreds, which could be assembled at the other end to make a work just as large as you wanted. So I started with sixteen sheets, making a complete picture. Over the six months or so that I worked with the fax, this expanded to twenty-four, then upwards to one hundred and forty-four and finally, the largest of all, two hundred and eighty-eight pages.

PJ: That would block a phone line for a couple of hours at least!

DH: As people became aware of what I was doing, they would call and ask me to send the latest fax. First I would send a detailed plan of how the pages should be pasted together, followed by the work itself. My phone bills became enormous! Then I realized that people have different kinds of fax machines at the other end – old ones and new ones. The old ones were incredibly slow sometimes. Once I send one to an old machine they rarely get another!

I did two exhibitions of faxes during this time, or rather one was a show and the other was more of an 'event'. The first was at the San Paolo Biennale, through Henry Geldzahler, who was the curator. I thought it might be amusing to send the whole show to them by fax, and never appear in person. The whole exhibition just travelled down the phone lines, materializing at the other end to be constructed according to the precise dimensions of the exhibition space which we had details of in advance. Some people thought it was a joke, faxing a show. They chose to ignore the serious side of the work.

The second, the 'event' was when we faxed one hundred and forty-four pages to Salts Mill in Yorkshire. Jonathan Silver had called me, asking me to send it in a couple of days' time. He organized for film crews at both ends to record departure and arrival. Here it was just me and a few assistants, quietly working at sending it out right. I had no idea there were five hundred people at the other end, all getting excited and drunk, but I remember asking them to quieten it down a bit when I spoke to Jonathan on the phone. 'We're trying to work over here, you know!' That fax still hangs in Saltaire, in large perspex boxes. Jonathan carefully preserved it on museum-quality acid-free mounts. If you don't copy the fax sheets on to proper paper and take trouble with them, the originals turn yellow and just crumble away.

PJ: A truly ephemeral art.

London and Los Angeles, November and December 1992

In 1992 David came to London to oversee the production of Die Frau Ohne Schatten *at The Royal Opera House, Covent Garden. I was extremely keen to record the final stages of rehearsal and the first performance. The BBC agreed to finance a film for ' The Late Show' . However, owing to intense pressures of time and, beyond that, finance for the technical rehearsals imposed by Covent Garden, this project was aborted at the last minute. My conversations with David began in London.*

At about this time David was experimenting in a serious way with his own Hi-8 video equipment. I visited him when he returned to Los Angeles to view his tapes and watch this work in progress. He had by then acquired a small version of the Steadicam system which enables a camera operator to achieve extremely smooth tracking shots by means of delicately balanced counterweights attached to a harness around the camera. Armed with this new technology, David circulated around his beach house, recording an extraordinary fifty-minute video over the course of a single day: Malibu, February 22nd 1992. *He was now keen to talk about these video experiments, as well as* The Very New Paintings *which seemed to me to relate to his work in opera design and particularly his representation of theatrical space, including multiple perspectives.*

DH: The time I've spent with Hi-8 and still video cameras has been intense. I would carry the video camera around a great deal, both here and on my travels around Europe. In the US I taped our excursions to Monument Valley, recording sunrises and sunsets and an extraordinary electric storm which crashed around our heads. The camera was also useful for practical applications such as taping our studio rehearsals in order to check lighting cues on models for the opera sets.

PJ: I've just seen your Malibu video, which I think is your best work on tape so far. It is, if I may say, a very eloquent essay on the theme of personal isolation.

DH: Well, you know, these things must reflect the way you are feeling at the time. There are a number of ways that film could be interpreted. I was shooting a lot of material around that time. A piece about Daumier's exhibition in Paris of his *Parliamentarians*; Dachsunds in Paris with a street musician; and a short film at The Café Voltaire.

PJ: I love that one. You just leave the camera running on the table to record anything that happens. Proustian almost!

DH: Well, I was in Paris.

Henry Geldzahler and Stephanie Barron, September 5th 1990.
Still video composite

Detail from 112 L.A . Visitors 1990-91
Colour laser printed still video portraits

PJ: Can you tell me about the portraits shot with still video equipment?

DH: In 1991 we bought a Canon RC 470 still video camera which can store twenty-five pictures on a floppy disc. It's a camera without film, which intrigued me. In a sense film is one of the problems with photography. Here was a totally automatic camera from which we could print colour images via our computer and laser photocopier. No need even for the one-hour Fotomat! I shoot full-length portraits, moving the camera vertically in stages down the bodies of my subjects, usually ending up on my knees, taking about five or six different portions which we'd then paste together. In this way it was possible to make images approaching life size. I would grab anyone who came close to my studio: friends, workmen, interviewers, plumbers, framers, car cleaners, opera producers and art dealers. We made quite a big show of these which went to The National Museum of Photography at Bradford (May–September, 1991). The colour of the laser prints was quite unusual and intense – unlike any other kind of photographic reproduction. By shooting so close to the subject one avoided

The Eleventh Very New Painting 1992.
Oil on canvas

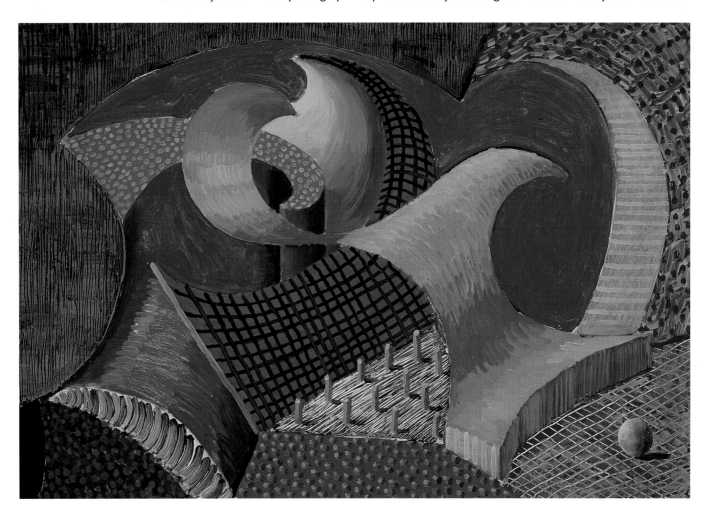

the grainy effect caused by atmosphere between camera and subject, which is often characteristic of ordinary colour photography. All these experiments with cameras of different kinds, both moving and still, left me with an intense desire to once again depict my subjects in oil paint. Almost all the work I do apart from painting sends me back to painting in the end.

PJ: Let's talk about *The Very New Paintings*. They are unlike anything you have done before, although they appear to have developed from some of the ideas in your opera designs.

DH: I have been working intensely on the stage designs for *Die Frau Ohne Schatten*, which in turn followed on from *Turandot*, meaning that my studio had been taken over by models for nearly two years. I had nowhere to paint! Someone pointed out that as soon as I've finished a big project, like an opera, I retreat somewhere and paint. Well, I did retreat down here, to Malibu, and I deliberately left everyone behind, including my assistants. An artist *can* do it all himself; all he needs is canvas, paint and a room, and this is one of the most beautiful rooms I know. I suppose the *Very New Paintings* came out of many things, but one aspect is the continuing struggle between representation and abstraction.

PJ: Are these paintings an attempt to reconcile the two, then?

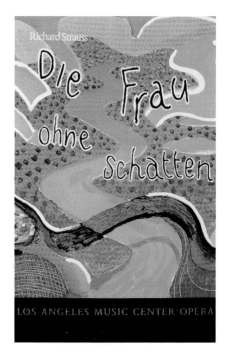

DH: I believe that representation and abstraction are not mutually exclusive, each must contain elements of the other. I've always believed this. Panofsky in his book *Perspective as Symbolic Form* speaks of perspective in terms of symbol or metaphor. What he's saying, in simple terms, is that there is no one 'true' perspective. How can there be in pictorial representation?

Someone said that *The Very New Paintings* are abstract narratives. Certainly a great deal of thought and feeling have gone into them. For example, here at the beach I am between two great forces, the mountains and the sea. The mountains were made by a great force of nature, a thrusting force, which calmed in time, leaving them here, grand and peaceful. While below the other thrust continues, the endless movement of the sea. These forces are present, I believe, in the paintings. They are also quite sexual – or so I'm told. But I know that! These things were on my mind when I was painting them.

Perhaps these paintings seem a jumble to the viewer at first. They take time to unfold. They're a bit mind-boggling, but they are meant to be. The viewer can roam freely within them, finding his or her own space. That's why there are no figures in them. You construct your own space mentally.

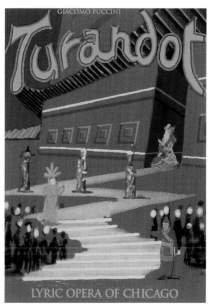

The life force is in everything, but has particular resonance in great works like *Die Frau*. At the end of the opera, when the golden river transforms into the tree of life, then into shapes which suggest human sperm, we are not just dealing with the making of children through a loving union, but with the force behind this which drives us all. I feel it as well. It drives me onwards in the work that I do.

Top: **Poster for Los Angeles Music Centre Opera production of *Die Frau Ohne Schatten*, 1993, featuring a detail from 'The Golden River'.** *Bottom:* **Poster for *Turandot* at the Lyric Opera of Chicago, 1992.** Computer generated laser print

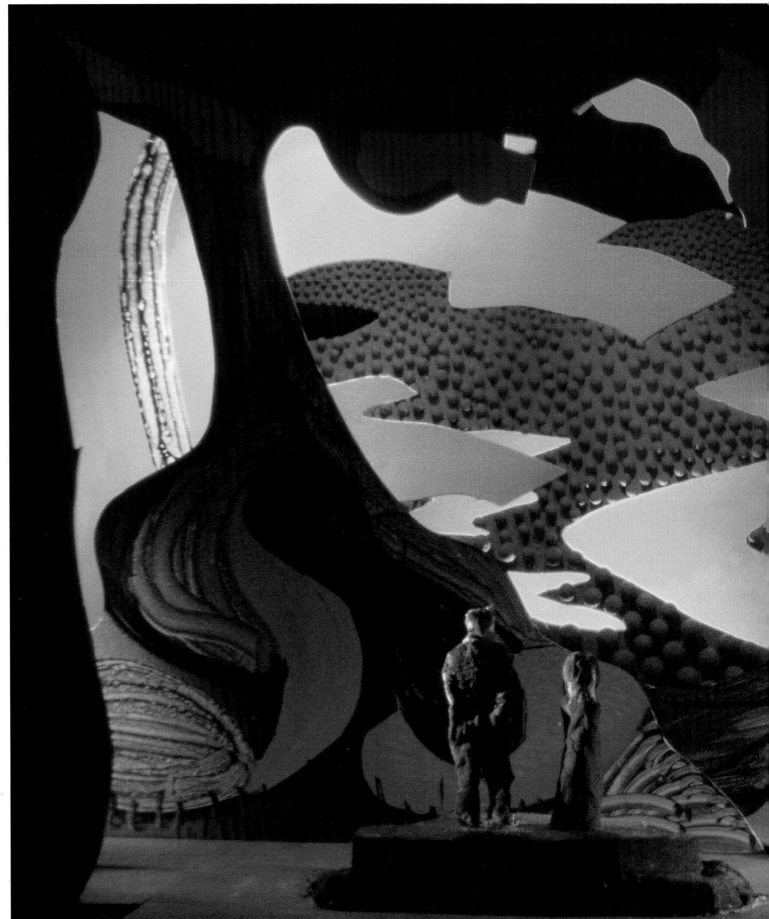

Die Frau Ohne Schatten, 1992. Act 3 scene 4. Scale model

Los Angeles, March 1994 and 1995

Between 1994 and 1995 I travelled frequently to Hollywood, directing documentary profiles for my company, Lucida Productions. Amongst other subjects, I tackled Marlon Brando, Kris Kristofferson, Robert Altman and Stanley Kubrick. My schedule did not always dovetail with David's, but I visited him as often as I could. On some occasions we met in his large studio–storehouse–office complex in West Hollywood.

Hockney's discreet, unmarked and completely anonymous studio façade on one of the wide Los Angelian boulevards hides a complex of vast storage areas and offices linked by slung metal stairways and catwalks. This rambling infrastructure conceals spaces unexplored even by David himself. One massive room, used in part simply as a storage area, David decided to open up as a workspace. Like his studio in the hills, this room is bigger than a conventional tennis court. Initially he used this space to hang the multiple portraits of friends in such a way that they could be viewed from a distance as a single work. Indeed, having done so, he decided not to sell the portraits individually, preferring to wait – presumably for a museum purchase – so that all the images would remain together as he had arranged them. Once he had opened up this area, and realized that it could be used creatively, he conceived one of his most extraordinary works to date: Snails Space. This shape-shifting painting, principally about twenty by seven feet but spilling on to the floor as well, demanded to be recorded. I organized my Hollywood cameraman, Biff Bracht, to come with a Digital Betacam camera for a day. Here we carefully framed David's creation on a widescreen format as a permanent record of an entirely new and highly original piece of work.

DH: In 1995 I decided to experiment with photography again, in a completely different way, and this time I used our studio 8 by 10-inch plate camera* which we basically keep for recording works on large-format transparency colour film before they leave the studio. I realized that it would be possible to construct interesting images in my [Hollywood Hills] studio by carefully placing objects within this large format, checking compositions all the while by means of a Polaroid back. Only with an 8 by 10 camera can you get an incredible amount of detail when you blow them up. Thirty-five millimetre just goes grainy. Using it was quite interesting, you have to move everything else but the camera – not the usual way for me with photography at all. Composing takes quite a while. You have to move objects just here and there a little bit, shooting Polaroids to check you're getting it right. They were very carefully composed, and they play games too, about what we see and think we see. In the case of *The Studio, March 16th 1995* you just see two paintings and a floor. There is an easel holding one painting and some objects on the floor, but it is just a floor. It might take you a little while to see that, I suppose. I needed to compose extremely carefully in this way as I was playing with reverse perspective by using grey masking tape stuck to the studio floor. This not only gave the illusion of shadows, but also conveyed the impression of solid objects where none

The Studio. March 28th 1995.
Digital Inkjet print

193

actually exists – at least not in the way you seem to be seeing it. For instance, the box construction apparently framing *Near Bruges* in *The Studio, March 28th 1995* is actually just tape marks on the studio floor. This took some time to line up correctly through the camera, which of course gives an inverted image on to its ground-glass focusing screen. There was certainly an element of playfulness in these works.

PJ: Not to say that they were in any sense inconsequential, or just done for fun.

DH: Some people thought I was just game-playing with a camera again, but they are the ones who usually neglect or misunderstand the serious side. I usually do things for a purpose. I guess I worry away at some things, but I learn new things all the time. For example, this work gave me the chance to experiment with new colour printing techniques. The images, conformed via a computer, were printed by means of an ink-jet printer directly on to archival watercolour paper – Somerset heavyweight textured actually. This is the most beautiful printing of photography I have ever seen. The colour on the paper seems almost physical, and the paper's surface is really beautiful.

When people ask how long these works will last, I reply: 'Colour is fugitive in life as it is in pictures, much more so than line.' Dimming room light immediately alters colour, it does not alter line.

PJ: *Snails Space* goes beyond this though; it deals with changing colours through time.

DH: Well, during the period I was making these photographic images the painting *Snails Space* changed quite a bit. The original painting is on two canvases measuring 84 by 240 inches, but I decided to continue the painting on to the floor immediately in front of it, so we constructed a three-dimensional extension using real cubes, cones and cylinders. Then I decided to experiment with computer-controlled lighting, the type they use at pop concerts, to physically change the appearance of colours within the painting. It demands a dark room to start with; we then arranged a computer programme of subtle light changes lasting around eight minutes. I called it *Painting as Performance*, meaning if you put a sequence of lights on it, it is passing through time, which in turn means a performance. From when it begins to when it stops, it is theatre and painting combined. It will be seen publicly for the first time at the André Emmerich Gallery in New York, but it's a very expensive piece to show, due to the cost of the lighting hire as well as the computer programmer who oversees it. That's why we had it videoed on to widescreen DigiBeta.

PJ: You did say, or imply, once that your work in opera had led you to a notion of how you might make a film or video yourself one day.

Hockney's Hollywood studio. Photo by Paul Joyce

DH: In the end I'm too bored with the video picture. I can't get beyond it. Obviously other people

Snails Space with vari-lites. 'Painting as performance' 1995-96. Two canvases. Oil, acrylic on canvas covered masonite, wood dowels

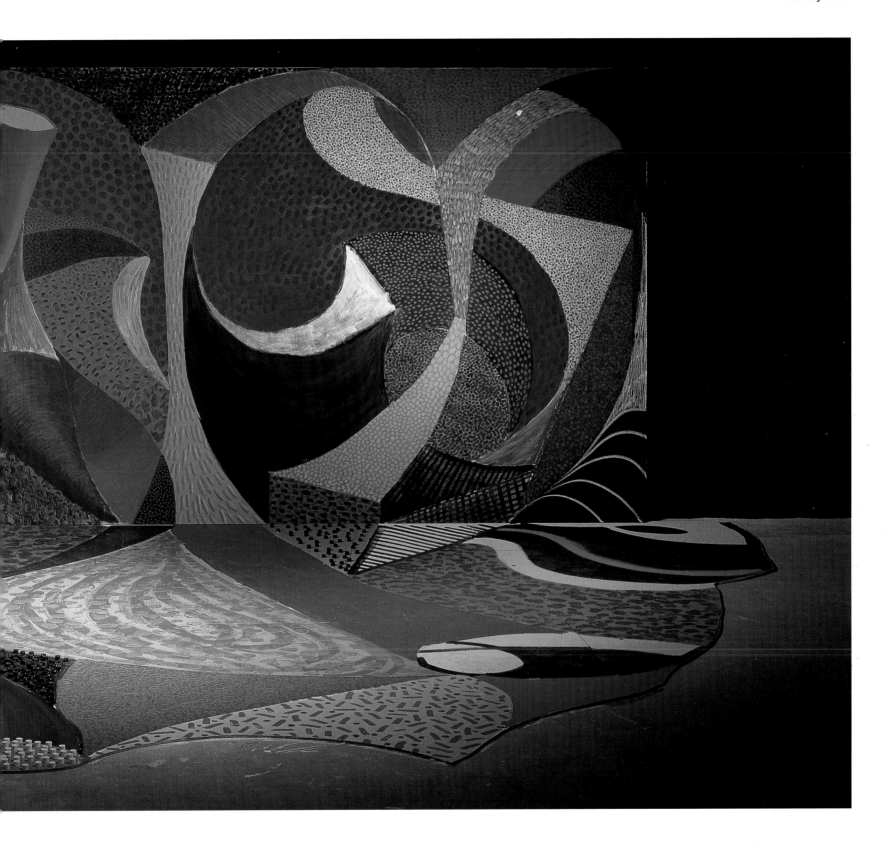

can, but I can't. I tend to see this picture and feel it's not very good, not very interesting. I suppose it's the way you look at the world, isn't it? I think we are becoming aware of the way things look in photographs. We tend to think this is very close to the way they actually look to us. But I suspect it's doing something to us, making us separate from what we see, and in the excitement of it one never thought about those problems. I don't get involved any more with video experiments because it's an art of time. You have to deal with the physical length of the tape and all that involves. With painting you don't.

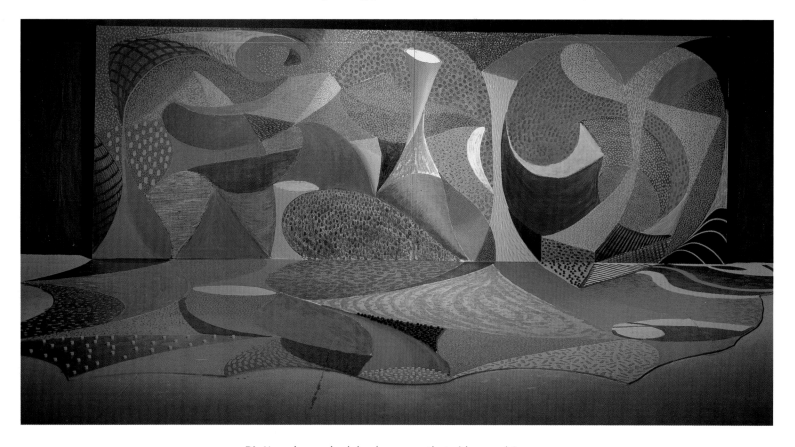

Snails Space with vari-lites.
'Painting as performance'
1995-96. Two canvases.
Oil, acrylic on canvas covered
masonite, wood dowels

PJ: How do you look back now on that video work?

DH: Not many people will have actually seen them. I began to ask myself: 'Who is going to look at all this stuff, even if you label it right?' [*laughs*] I mean you can put the tape over there on a shelf, but after you've got ten you realize that's ten hours! The same time as the Beethoven symphonies! Well, am I even going to look at them, seriously? I began to doubt that, and I thought: 'Do I really need all these hours of stuff? No.' So I put the video camera down and picked up the brush.

PJ: What did you learn from the video experiments?

DH: It heightened my awareness of the fact that I didn't want to do any more video work. I pushed it away. I decided I'd explored it enough. You have to look at things another way, if you're looking through time, and that's not what I wanted to do. I got quite amused about the problems of art in time, but obviously not too many people take the trouble to think these things out. Is it possible to see *all* these videos, tape after tape? If you have these kinds of questions flying about in your head, it becomes a kind of nightmare, doesn't it? I decided I didn't want that kind of nightmare; I'd prefer something else.

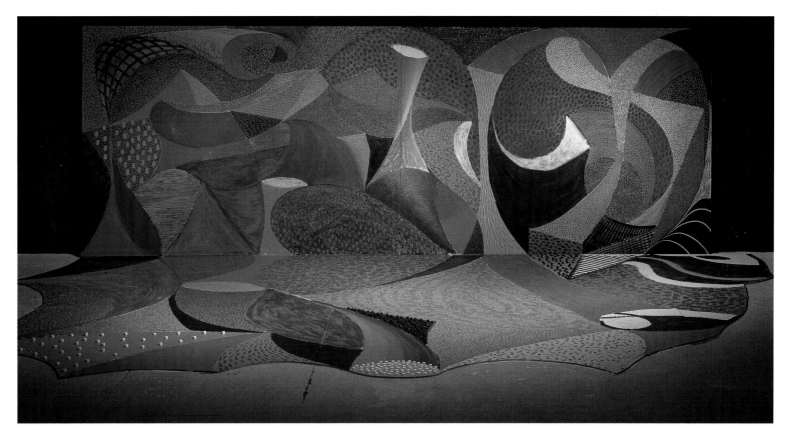

[The lens throws an inverted image on to a ground-glass screen which is traditionally examined by the photographer underneath a dark cloth in this upside-down form. When the composition is deemed to be correct, a plate of the same size (8 by 10 inches) is inserted into the back of the camera and in front of the ground-glass screen. With the lens cap on, and with the dark cloth still in place, the cover of the plate is removed, or the shutter released, depending on the age and sophistication of the lens. Once exposure is complete, the plate cover is slipped back in place, and the plate removed so that the negative may be processed.]

Snails Space with vari-lites.
'Painting as performance'
1995-96. Two canvases.
Oil, acrylic on canvas covered masonite, wood dowels

Los Angeles, February 1997

In February 1997 I flew to Los Angeles at David's invitation to attend the final performance of his production of Tristan and Isolde. This had effectively become his production because he had not been happy with the previous version, directed by Jonathan Miller. Indeed, his input into the designs and beyond that the overall lighting of the piece gave any director, let alone Miller of all people, extremely limited parameters of movement. Although there was an additional technical director credit, to all intents and purposes David took final responsibility for everything but the musical direction of this revival at The Armanson Theatre. It was clear from watching his studio rehearsals that the music actually had the effect of transporting David on to another plane of consciousness, enabling him to achieve great insight into the nuances of emotion and psychology within the opera.

After the final performance, at which I sat transfixed for over four hours, he was ready to unwind and talk about this production, and reactions to it. Now, due to his ever increasing deafness, he was communicating in considered and lengthy statements, which I did not feel it necessary to interrupt too frequently.

He also wanted to talk about his recent visit to the Monet retrospective in Chicago, which affected him deeply. During my week or so with him he began to put forward theories about the 'information overload' of television culture, which he later gathered together in the form of an article published by Modern Painters in their Summer 1998 edition.

Opposite: **Hockney in his L.A studio with the theatre model of Tristan and Isolde**

Tristan and Isolde Act 1, 1987
Stage set

DH: Even the fucking music critics kept talking about *Tristan and Isolde* as if it was a long piece. Four and a half hours of ecstasy, well, you don't usually have four and a half hours like that. Most periods of time like that are frankly forgettable. If I'm telling them to go there's a reason. I wouldn't tell them to go if it was boring. Some people wouldn't go out of fear. Some have told me: 'I never thought I could sit through a whole Wagner opera.' But how can I comprehend that? Frankly, *Tannhauser* and *Lohengrin* are easy by comparison with *Tristan*. One hundred and thirty dollars for a seat was frankly a bargain for what they got. A fucking bargain! There were only eight performances. The dress rehearsal was the first time this opera was put together with an orchestra. Compared with a musical such as *Sunset Boulevard* with, say, thirty previews, we are at a disadvantage. Each performance simply got better. The last performance which we saw tonight was musically by far the finest we've achieved. That's the nature of an art of time. It's not *La Bohème*; it's at another level.

The only other opera I'd consider doing is *Parsifal*. *Parsifal* has spectacle built into it with the music. In the first act there's a change from a lake and a forest into a cathedral – in front of your eyes, with music! Wagner said in 1878 that with *Parsifal* time and space are one. Thirty years before scientists said that! Incredible intuition. Time and space then were seen as absolutes. Music is an art of time, and I deal with space. Sometimes in a mad kind of way I can make time go backwards, but you have to make the effort as a spectator to see this. It demands concentration. At the very least, time sometimes stands still.

I've had letters from people who saw the production and who talk about the 'fantastic space' we created on the stage. They think it was a fantastic space, but actually they're looking at an object, a physical object, on a small space that is an illusion of a bigger space, that is in space itself. The figures are the first thing I put on the stage, even just as a stage model. Everything has to be geared to that. If you don't put them there first, the rest won't work. Ultimately, though, the music is the key; it covers everything. For example, at the beginning of the third act, Tristan is in a bleak place, a ruined castle in Brittany. The music begins slowly, richly, gloomily, and paints first a picture of the place, and this in turn changes his internal emotions. This is how and why it works so powerfully.

When you see the second act gradually revealed, with the row of trees, you figure out that it's in a real space, but it's an illusion. It's been made in front of you. Then you accept the spatial illusion because you want to, don't you? The piece calls for it. I pointed out that the ending is not a tragedy. There's a lift up. It's religious in a way. There's a kind of hope at the end when they are joined together in spirit. Only music can describe emotions; all you have to do is feel, just through hearing you feel it.

I'm a painter. I make physical objects. *Tristan and Isolde* wasn't a physical object. So it's gone now.

PJ: I know there are very few painters that you admire enormously, and I also know that Monet is one of them. Tell me a little about the Monet retrospective in Chicago you attended last year.

Fisherman's Cottage on the Cliffs at Varengeville 1882
by Claude Monet

DH: Actually I went to Chicago just for that Monet exhibition. I stayed overnight and spent maybe six hundred dollars – only because of the Monet exhibition. A million people did. Everyone spent at least five hundred dollars. So *five hundred million dollars* went into Chicago. Every taxi driver knew about the Monet exhibition! I went with a friend who lives in Chicago on a Sunday morning and he said it was the biggest number of people he'd ever seen in the gallery. When we left there were huge queues around the block. And I see why they went.

You don't need an art critic to tell you Monet was a great artist. You can see it yourself; you absolutely can. I came out of that exhibition and it made me look everywhere, everywhere intensely. That little shadow on Michigan Avenue, the light hitting the leaf. I thought: 'My God, now I've seen that. He's made me see it.' Most people don't see things like that. They can't get pleasure like that, can they? Monet gives it to you though, for he was a generous spirit, and you can then take pleasure

in looking at things freshly. A great artist, a very great artist. Very finely painted, superb condition now. What? A hundred years old? He knew exactly which paint to use and his work remains in marvellous condition. I had to look at every single painting. I couldn't just walk by one.

If you come from a northern climate and are used to looking at the weather – and after all England and Northern France are much the same – you know how truthful they are. I've seen a riverbank in the mist just the same way. And who else painted it like that? Nobody. I came out absolutely thrilled. I see why a million people went. You don't need a big book or a guide. You just need your eyes. Monet painted unbelievably direct things – as direct as Van Gogh. He used his eyes and looked. He painted them mostly outdoors, perhaps finishing some in the studio. You never see one that's wrong. The balance, the colours and tones, perfectly pitched. The range of colours in the shadows, particularly, just marvellous. Colour photography has the greatest difficulty with shadows. It simply doesn't see colour in the shadows. Monet saw colour there and if you look at Monet you start to see it for yourself.

I bet you in the end that show didn't really cost them that much money. Of course it cost a lot to get the paintings there – you don't just put a Monet in a Fedex box – but millions of dollars poured into the city because so many people visited that exhibition. You can't put on shows nowadays that nobody goes to see. The City of Chicago would have been aware of this. It was a great big event. I know people from all over the world who went there. You weren't going to see it ever again. It wasn't going to Paris or New York. You had to go to it; it wasn't going to come to you.

PJ: You mentioned that after seeing the show, you began to see the world again, almost through his eyes. Can you give me a specific example of this?

Hockney's living room and terrace, Hollywood.
Photo by Paul Joyce

DH: When you fly back to California from England you wake up very early – about four in the

morning. So I came here into this room [the lounge at Montcalm Avenue] and I sat here [at the dining table, opposite the picture window overlooking the famous pool] with a cup of tea. Just me and a cup of tea. *The New York Times* had arrived, so I began to read it. Then I noticed that it was beginning to get light outside; I switched off the lights inside and just sat here with my cup of tea watching the dawn come up. We're fairly far south here, so the dawn breaks quite quickly. Every minute the light changed: dark blue, then a lighter blue, then a whole range of greens, then the redness before the sun. A whole palette of colours. A living Monet! It remains here, in my head, that image. I'll never forget it. Then I realized why I live in California – for this quality of light. You'd rarely see this in England except for a few days in the summer. What would I have painted in England if I'd stayed there for the last thirty years? Who knows? But I do know that I'm imbued with the characteristic 'Gothic-ness' of the north. Bradford is steeped in it. No wonder, with the constant English cloud cover. And it's so thick. Months would pass in Bradford without a hint of the sun.

When I went to the cinema there, as a child, I noticed that the films always had strong shadows, even in the inside scenes! So I thought, that's where the sun shines all the time, in California. That's why I came here really, chasing the light. I realized then too, watching this Monet painting in front of my eyes, that I've probably (with luck) got about fifteen active years left. So I must use this time with care and make my own choices. I must not be forced into situations where I feel obliged to step in on big projects only to exhaust myself making sure someone doesn't cock something up. I can make my own projects here, in this house, and here, in my head. I've never been short of a big project of my own – provided I'm given the freedom and time to think of it. That's what I intend to do from now on.

I'm perfectly happy when I'm just painting. I'd rather do that than anything else. It's a long time since I've been able to paint for three months without having to stop. I always have to stop for something, to re-do an opera or something like that. And that's really the time when I shouldn't be interrupted, because I am pushing and extending the boundaries all the time. Look at this new series of portraits. Slowly, slowly, I realize what to do – develop the palette. They get stronger and stronger. I just need time. Now if someone says, 'Stop, come over here and re-do *The Rake's Progress*', I'll say, 'Oh, fucking hell, I don't want to do it. Get someone else to do it. I don't really care any more.' But with the *Tristan* I had to care. It had only been done once, and I live in Los Angeles, and it was to be re-done here, so I said to Richard [Schmidt], 'We can't not do it.' But now I'm free of all those great big, big projects. Doing those operas, they were enormous pieces of work. Enormous. They are major works of mine but they only exist when they are performed. They're very ephemeral. Only twenty thousand people saw *Tristan*. That's not very many when you think that with my drawing show at the Los Angeles County Museum you'd probably be talking in terms of hundreds of thousands. Now with *Tristan,* however successful it is, there is not even the remotest possibility of another performance.

It's now clearer and clearer to me, in the midst of all the other things I've been doing, that photography isn't what they thought it was. They said painting was dead but it is *photography* that

View from terrace to pool.
Photo by Paul Joyce

Girl with a Red Hat by Jan Vermeer

is being altered and painting is the cause. Even perceptual painting is perfectly valid and the idea that it had gone seems rather naïve now. Look at the flowers and faces, subjects I've been working on concurrently. Both fragile things. Faces last a bit longer than flowers but they're both fragile, aren't they? Somebody asked what the connection is between the two subjects and I said, 'It's where nature and artifice meet.'

They will do *Turandot* in San Diego. It doesn't need me. It's been videoed. There are records of that production. I may go down to see it, but not to work on it. I won't take on another big commission from outside. I want to think about myself and what *I* want to do and that will put an end to it.

PJ: But you always return to painting in the end, don't you? How did your recent visit to the Vermeer show in The Hague affect you?

DH: What so impressed me about the Vermeers was the condition and the vibrancy of the colour. Every other picture in that museum looked dull in comparison. How can these paintings glow like this! He put the paint on so carefully, in transparent layers so you get those vibrant blues. Stunning! Most things painted five hundred years ago don't have any colour left in them.

He was above all a very, very good craftsman, making things which he knew would last. He took great care, and they have lasted. They're in incredibly good condition. That view of Delft – all right, it's been cleaned, but it looks like it could have been painted a year ago. There are tiny cracks, but you have to look really really closely to see them.

I've learned a lot about transparent glazes in oil painting over the years; I've made it my business to. Seeing how Vermeer handled the paint, and beyond that how he controlled the light on to his subjects, sent me back into the studio with tremendous energy. In fact, I decided the best place to paint the flower studies was at the far end of the studio, at the top of the stairs, just outside the loo. It might seem a bit peculiar, but that was where the north light came down in just the correct way, at a certain time of day. That's where I worked on many of the flower study paintings [shown at the Annely Juda Gallery in London].

When I start painting I get into a good routine. I'm disciplined enough to concentrate for hours. I love it!

It's terrific when I really get painting: squeezing the paint out and using it so it doesn't even have time to get a skin on it; working in the evenings where I'll set something up; and then continuing on it first thing in the morning. And as soon as I get going, I develop. I'm never short of what to do. Just give me enough time and I'll work it out.

I put all that effort into an opera and it only exists for thirty hours. It is an ephemeral art – not a physical art. It may exist in your memory if you've seen it. People think it's automatic, redoing it. You just press a few buttons or something. I certainly don't want all that responsibility with the singers and everything. I won't face that again. Not when I can be quietly painting some bluebells

Maurice Payne,
March 15th 1997.
Oil on canvas

Blue Hydrangeas
1996.

Cactus with
Lemons 1996.

here. I'll be sixty in July so I guess the next fifteen years or so can be quite healthy and active. I'd like to have it my way now. My way.

PJ: I know that you watch television now only very occasionally, but you spend a great deal of time thinking about it, and the implications it has on modern society.

DH: Around Christmas [1996] I read some pages in *The New York Times* and immediately realized here was a very significant thing. They announced that in two years' time the television picture we know will change. An agreement was reached between the manufacturers so that production could begin on what will be a new high-definition TV system. Now I saw a demonstration of high-definition TV about twelve years ago and the thing is, that as soon as you see it – as anybody sees it – the old version will be gone. It's simply another format altogether. There are four times as many lines as the old system, carrying much more information. So many more textures are visible, long shots come properly into focus, a profoundly different picture. But there's also something else they announced. The reason the system didn't change ten years ago was because of the invested interest involved in conventional TV. It was agreed that the picture would also be a *computer* picture.

The Internet screen is part of a new enormous network that exists independently from the vast capital investments of ordinary television. You can tap into it and make contact with someone, somewhere, who has put together everything there is to know about Gulf War Syndrome or whatever you choose. You don't have to rely on CNN. You can pick a story and delve into it through your screen. This will take away the power of Ted Turner and his people.

Now they are all scrambling to make 'all news' programmes for television, aren't they? They're *scrambling* to do it. Even Microsoft. Because they know that the only TV that they might put out that you're going to watch is either a movie for which you probably pay extra, or live television into which they can drop commercials. Otherwise they know, you can fast-forward it. The only thing you can't fast-forward is live television. Live television is only any good if its dealing with sport or disasters – nothing else. Consequently, that's all there will be on TV. This means that automatically a pessimistic view of the world will be built into it. Bad news is taken a lot more seriously than good news. The change is very profound.

Advertisers don't know where to advertise. That's why newspapers in England get thicker and thicker with advertisements. It tells you that advertisements are not working on television because people aren't watching them. 'Click, click', they are fast-forwarding them. You can deduce this. Instead of reading the newspaper just look at its thickness. Think of it as a physical thing. Weigh it, and that will tell you something. It's news nobody thinks about.

Now the point about 'Cubist Television' isn't in the physical picture, but the fact that some images and information come your way but you can tap in to see what's around the corner. And another view, and another view. You can do it. It's Cubism, isn't it? TV's been cubified! Like painting

was in the early twentieth century, all the paintings were cubified in a way even I didn't think of until this. Your tapping into the Internet is twisting the picture, is it not? You are in effect creating your own picture, seeing around the corners, extending the ordinary view. Now people say, 'Oh, they won't want to be tapping in all the time'; well, that's our generation. Everyone else younger does. Profound long-term effects. A whole new generation will have a very, very different view of the past. It might even be an ignorant view but that in a sense is a permanent thing, isn't it? Nevertheless the age of the mass media is coming to an end.

When there was only one TV channel, everyone watched it. The more TV channels there are, the less you watch. The VCR made it unnecessary to watch at any given time. It slowly took the immediacy away. Television will not dominate any more, for if it's a computer screen as well, you won't be watching what Ted Turner tells you to. He chose before, now *you* can. It's a fundamental change. There will be a good side and a bad side; there's bound to be. The good side is the spreading of power, taking it away from the few. There is bound to be a bad side, but it may take time to emerge.

Radio was invented in 1926, and the first thing Hitler did when he came to power was mass produce a cheap radio – for everybody. Then he made speeches on it and they couldn't get anything else. Dr Goebbels thought that out, then Stalin did it, and Mao followed on pretty soon after. Yugoslavia is the last example of where they kept control of the media, everyone went mad and killed each other.

At the same time the veracity of the photograph is totally collapsing, faster than even I thought. Mention this to any newspaper picture editor dealing with documentary photographs and they know it. They can just move anything around that they want on the computer screen. Move that building over there, to here – perfectly possible, and it still just looks like an ordinary photograph. Ex-documentary photographers, some of them at least, are now called artists because they do things like this. All this is fascinating, and I'm watching it quite carefully.

PJ: One of the reasons you abandoned your video work was because of the sheer weight of accumulated material. This must surely become a global problem, mustn't it?

DH: People in the art world don't realize, they don't observe images enough, but there will be a return to the still image, eventually. The still image can tell you more, has a greater depth to it. It may take a long time, but the other way – video, television, more and more and more programmes – gives us too much information. There will be an information overload.

It's not an accident that out of all the music composed in the nineteenth century probably only a small fraction survives. Finally the same will be true of movies and television. All this stuff crowding in, jostling for a place in this torrent of information. But what they forget is *your* time. You still have to deal with real time and, frankly, we simply don't have enough time to give to it. So it will all rush on by us and most of it will be forgotten forever.

Disturbances in Yugoslavia 1991. Photograph by B. Bisson.

Cologne, London and Los Angeles 1997

1997 marked two major events in Hockney's life, one personal, the other professional. Jonathan Silver, the extraordinary entrepreneur who had acquired Salts Mill at Saltaire a decade earlier and had transformed it into a bustling arts centre, died after a two-year battle with pancreatic cancer. He was forty-seven. Jonathan was one of David's closest friends and his death came as the most cruel of blows after the loss of so many others. David said, 'I thought he would be there with me, for twenty-five years more. He really understood my work, and I listened to what he had to say – and now he's gone . . .' The Yorkshire landscapes which David painted at this time simply would not have existed were it not for Jonathan's fatal illness. The paintings gave David (and Jonathan, who never lived to see them all) a reason to go forward even in this, their darkest hour. Doctors later told David that his presence in Yorkshire extended Jonathan's life by some weeks.

Almost immediately after Jonathan's memorial service, David flew to Cologne to honour a long-standing commitment to oversee his first major photographic retrospective at the Museum Ludwig. The curator, Dr Reinhold Misselbeck demonstrated his innate understanding of the intimate relationship of David's photographic output by cleverly intermingling the photographic collages with selected paintings and drawings, immediately showing the correlation between different media. David told me: 'Now Jonathan's gone, and he knew my work so well, then I fly to Cologne after the funeral and find that Reinhold understands it too. It was a wonderful surprise to find, so to speak, Jonathan's spirit of enthusiasm and perception alive in Reinhold. I was thrilled.'

In December 1997 I flew with a documentary crew to record the opening of the Cologne retrospective, beginning what I hope will some time emerge as the filmic complement to this text. We spoke together in Cologne, London and later in Los Angeles.

Jonathan Silver, January 3, 1997
Oil on Canvas

PJ: Although your recent photographic retrospective in Cologne has preoccupied you, I know, painting too has been much on your mind recently, hasn't it?

DH: Painting, after all, is a craft as well as an art. You can find things, of course, by trial and error, trial and error, trial and error. You eventually come up with something, but you could save a lot of time if somebody told you, well, really, do it *that* way. Frankly, that's the ethical way, and you might save three months of trial and error. Most painting was taught by the apprentice method for centuries. Every painter had apprentices to grind the paint. They did all that, so they were learning all the technical side. They even had to make brushes. Mainly they watched the master paint. Well, can you imagine what it would have been like, watching Rubens paint a face? Anybody who was sharp, and wanted to do it would have picked it up very quickly.

PJ: That great tradition appears to have died out. Is painting now entirely private activity?

Opposite: **Photography is Dead: Long Live Painting, 26th September 1995.**
Digital inkjet print

Chinese boy artist's painting of a cat is inspected by Hockney's dog.
Photo by Paul Joyce

DH: Well, I remember when I was in China doing *China Diary* with Stephen Spender, at Kweilin, I was taken to meet an eight-year-old artist, an amazing child! His father, like Picasso's, was a hack artist, doing these boats on the river, but the child was a real artist. Tang A-hsi was his name. That's his cat on the wall over there. I had these coloured pencils he wouldn't have been able to buy then – although he might now. You could put water with them, and so on. I was near the end of my trip, so I thought I'd give them to him with a big pad of paper, and I took them with me. When we got there, they said the child was tired. I thought: 'Poor kid. They drag people over to see him and he thinks, "Oh, here we go again"!' Well, I know what it's like. I understand. I said: 'I've got these crayons I'd like to give him, and I'd like to demonstrate how to use them.' So they translated this, and he said, 'okay'. So I drew his bicycle which was just outside. Well, the moment he saw me beginning to work, he actually grabbed my hand and watched. I used every technique that was possible to show him, and I could see his little eyes light up. He realized I was an artist, not just anybody. He was dying to get his hands on the crayons! When I had finished he was beaming, and he held my hand, and then got out his paints and painted this cat for me.

When I got home I sent him a lot of art books on European artists who were influenced by Chinese things – Dufy, for instance, and Picasso and Matisse. You couldn't get those books in China then. And he was obviously a little genius. His father knew that! The child's placement on the paper was perfect. The Chinese guide asked me, 'What should we do with the child?' They realized that he was a prodigy. And art prodigies are rarer than music prodigies. It's not a prodigal activity, actually. It's usually a slowly learned skill. Picasso was a rare prodigy. Cezanne was not a prodigy, his art was a hard-earned skill that took a lot of time. Long after he died people said that his drawing was crude. With a very great artist like that you might think there was some facility for drawing.

I was just reading about John Singer Sargent. Anybody who paints like Sargent – well, the luscious brushwork, it's a skill not many people have. It might be flashy, but who cares? I don't. I remember looking at a Sargent, in Chicago I think it was, and thinking: 'That's fucking good.' Then I went round the corner, and there was a Van Gogh portrait, and then I realized this is something else. This is another level, really. With that comparison you know that Sargent is flashy and Van Gogh is not. Van Gogh touches you a lot more. It's a deeper thing. But Sargent by the 1950s was being dismissed. But frankly the paintings are too good, and you pay a lot of money for a good Sargent today. Marvellous flesh, marvellous skill and brushwork. You know the one in the Metropolitan Museum of the American Consul in London with his wife? She has a boater hat and a long dress. Now the rim of the boater hat is one enormous brushstroke filled with paint – like that – done! He may have done it several times, because you can wipe it out on the wet paint. It's not easy, but nevertheless, that one stroke, you can't help but look at it. It's gorgeous! It's just a gorgeous way to represent that hat. That's a great skill. Anybody who paints can see that. And it's not gone away. Why doesn't anybody paint like this now? Lucian Freud doesn't paint like that. His strokes are much stiffer. He's a marvellous painter, but not in that way.

Ena and Betty, Daughters of Asher and Mrs Wertheimer by John Sargent

Self-Portrait.
by Vincent van Gogh

PJ: Lucian's is fluid painting.

DH: Yes, it's fluid.

PJ: And it's hard work!

DH: Yes, it is. And Lucian Freud has an incredible visual scrutiny, and as he's got older he's got better. It's a marvellous case of an artist who didn't just sit back. He has become better and better. How old is he now, seventy-six or seven? And he's doing his best work now. It's not fading at all. Nobody would think that. I've known his work for a long, long time, ever since I was a student. It's a certain kind of painting, a scrutiny, a perceptual method, and not many people can do that, in fact nobody I can think of. He obviously has students who take up the method, but he has special eyes that can scrutinize.

PJ: I know you have been looking at the new Thomas Moran catalogue, as I have. I didn't know he was so prolific and so brilliant. He also painted the Grand Canyon, as you've been doing recently, and in fact he was born in the same neck of the woods as you, wasn't he?

DH: Well, he was born in Bolton, Lancashire, which is forty miles from Bradford exactly a hundred years before me, in 1837. But he was brought to America by his parents. They had heard a lecture by George Catlin, who had seen and painted the American Indians. Moran's father was a hand-loom weaver, and there was so little work in Bolton that he decided to go to America, to Philadelphia where there was employment for textile workers. Thomas Moran was trained in the Art School in Philadelphia, but then he did go back to Europe, and was very aware of Turner. Well, Turner died in 1851 so he would have known of him, even if in those days you only had black-and-white engravings. He travelled across the Atlantic quite a bit. You had to in order to see the old paintings. There wouldn't have been that many here in 1860 or '70. Turner was a very famous artist in his day. Everybody admired him.

I went to see the Moran show in Washington. Peter Goulds [David's art dealer in Los Angeles] recommended it. I had seen a review, but you have to know a little bit about the nineteenth century to know his name. Albert Bierstadt [nineteenth-century American landscape artist] is more famous, but he's a different type of painter. I went to Washington and they had these big pictures Moran had done of the Grand Canyon in about 1870. He came out West when they were building the railway and the government sent scientists and geologists to look at the land, and in those days they actually sent artists and photographers too. It was the beginnings of photography and it would have been very craft-oriented. You would have had to know a great deal about the technical side. So the first real photographers of the West came on those expeditions. Thomas Moran as a trained painter picked the spots for the photography. He obviously knew how to compose things,

whereas the technical photographers knew all about the silver nitrates or whatever it was, without necessarily understanding composition. [The photographic process was a collodion wet plate process. It was cumbersome, messy and dangerous.] Moran describes the expedition: I read the catalogue. I thought the watercolours were remarkably fresh.

The first early engineers in the mid-nineteenth century were good draughtsmen. You had to draw a picture of the engine if you wanted to make it, not just a plan. They must have been good draughtsmen, which would have meant a bit of training, probably drawing human figures as well. The human figure is the most complicated thing you can see. That's why it is rather hard to draw. The engineer would have been trained that way until the early twentieth century. They would have needed a few lessons in chiaroscuro if they wanted to make a cylinder appear lifelike. They would have needed chiaroscuro to show the volume. Today the engineer would not do drawing lessons. Now there is the computer! But most objects begin life on the drawing board, don't they? They are drawn, even today. The drawing board might be a computer screen, but it's just the electronic equivalent of the old drawing board. In some way it's still drawing. I'm told now that at CAL Arts the only drawing classes they have are in the animation department.

PJ: That's rather sad!

DH: Amusing, but sad, yes. Animation for films is a certain kind of drawing, and it has changed. If you look at early animation, early Disney, the drawing in the twenties and thirties, when they did Mickey Mouse, this would have been done by European-trained artists. CAL Arts was started by Disney to train craftsmen. They are still drawing movies. You still need draughtsmen. After seeing the film *101 Dalmatians*, I did point out that when you watch a drawing – an animated film of dogs – what you are seeing is someone's statement after observing dogs. Someone has looked at dogs very carefully, watched every movement. Before you begin to draw them, you have to watch them, and then you make an account of your observation. The cameraman isn't doing that. Part of the delight in watching the movie is in knowing that a human being has closely observed how those little puppies move and has now shown it clearly. It would look wooden otherwise.

My whole point about photography is that it's being altered by drawing. The feeling of things in space and how to place them in space is a *drawing* skill. We'll feel that loss. It might therefore come back, but it will take a long time. Skills and knowledge have been lost in the past. I'm going to keep my books, even though everyone else is putting their stuff on magnetic tape. How do we know that there might not be a sudden great magnetic storm which comes near the earth and *whoosh* everything's wiped out? There have been great losses of knowledge in the past. The Library in Alexandria was burned, for instance.

PJ: You started this speculation because you felt that teaching was important, but when we were looking at the new Grand Canyon piece you said it was about painting as much as anything.

Painter working, reflection (detail).
by Lucian Freud

A Miracle of Nature, 1913
by Thomas Moran

DH: I'm well aware of all the arguments about painting being either dying or dead, and frankly I never believed them. I believe it will survive in spite of indifference. This situation has arisen perhaps because painting is not taught. Frankly if you didn't teach children to read, then within a generation or two countries would be unbelievably backward. It is essential to pass knowledge on. Each generation has to be taken seriously. Universities are there for a reason. You don't have to pass knowledge on to everybody, but at least to the more curious and the more intelligent. And each group looks after itself. Musicians would not have made the mistakes that were made in the art schools, letting them get on without teaching fundamental skills of drawing and draughtsmanship. If some educational theorist had come in and said, 'You must teach them to play the piano *after* they have passed their GCSEs', the music world would have said, 'No, it's much too late. You start training them early, especially with the talented, very early indeed.' Very few

composers did not start very early. In the past all painters did, with one or two exceptions. Matisse, for instance, was not a child prodigy like Picasso. He took it up much later. He trained as a lawyer.

PJ: And Bonnard started late as well.

DH: They quickly realized their fortés. There are schools somewhere where they are training people properly, but not as many as there were. Many people say that painting is an old man's activity. Look at what I said about Lucian Freud. He's got better and better, but he's also better because he knows more about life. Some activities, like the discoveries in mathematics, are usually done by people in their twenties. You do get mathematical prodigies, very young people who can do mad things in their heads that nobody else can, and they do it easily. Heisenberg was about twenty-six when he had his insights. In mathematics they say that you might be over the hill in your thirties. Well, you're still of *some* use to stimulate and train the younger ones! Certainly, mathematics goes on. I did point out once that Bill Gates, now the richest man in the world, is a mathematician. Mind you, he's clearly a very hard-headed businessman as well. In the past, the mathematicians were always the priests because the priests were the people who followed the stars and predicted where the moon would be at a certain time. Anyone who could do that was in a position of power.

There was a piece in *The New York Times* saying there is a limit to what you can see. The physical limit at present is thirty million light years away, and then there's a horizon with nothing much beyond. There is something, but it's the unknowable at the moment. It's a mystery, and that mystery obviously won't go away. If we discover that, then there will be another layer, and so on. When science acknowledged the unknowable, it made vast discoveries, in a sense. In fact the scientific part of Marxism is the part that failed. It isn't scientific because it didn't accept the unknowable. The nineteenth century didn't accept the unknowable. It was only with Heisenberg that the unknowable is accepted. If we know the position of the particle, we don't know its velocity. You cannot know both. That's a profound discovery in itself, isn't it? So I suspect space isn't what we think it is. It's a very difficult thing to grasp if you're seeing that far away, you're seeing backwards in time. It's a very difficult concept to grasp. The quasars might be exploding this way and that, but that was thirty billion years ago and the light's just reached us. What's there now? What *are* we looking at? It might be some fantastic golden paradise full of people. We don't know. It isn't there now. That light's only just reached us. That's the interesting part of space to me.

PJ: When you ask those questions, how does it affect what you're doing as an artist? Over the last ten or fifteen years you've been asking these questions and reading about quantum physics. How has it changed your work? It has changed dramatically over this period.

DH: I've always been interested in space. Anybody who can draw, who has the ability to render volume and mass and place it in space, must have a profound curiosity about the appearance of

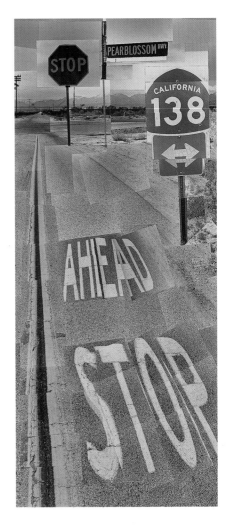

Pearblossom Highway (detail)

things. I don't know whether it is instinct, knack, or what it is, but some people are certainly better at it than others – or their curiosity about it drives them to it. I've always been interested in these things. You can see that in my work going back a long, long way, all the way back to art school. I could place a figure in an illusionistic space that you could believe in. That might be an innate skill. It's what I want to explore in painting now, not photography. I explored it in photography for a long, long time, and did at least prove to myself that the space in those joiners was different, more exciting somehow. For instance, when they put up *Pearblossom Highway* at the new Getty Museum, they told me that it became quite an attraction. People do look at it for quite a while. In fact, people wanted to touch it, so the museum had to put a guard next to it, and a little rail round it. Someone said that they would put up a shrine to *Pearblossom* next! Of course, it's not framed under glass. As far as I can see, the difference is that when you look at it you are a participant in it, not a spectator. That seems to me to be quite a big difference. It affected everything, everything I did. People will take a while to see it, though I do think it is now visible in the work. It was also the first of the photo-collages that you could see across the room. In all the others you saw the surfaces of the collage from across the room, the pieces of paper stuck on other pieces of paper. From a distance, you only saw the shape of pieces of paper. When I went to see *Pearblossom Highway* at the Getty, I was quite amazed. I could see it through two dimly lit photography galleries. I could see it from far away. In fact, it looked like a big painting. Any collage previous to that would not work that way, and they weren't done that way either. This was by far the most complex of the pieces. Actually I've never seen one like it since. It's a very complex construction. You are moving all around it. I was moving all over the place, not just in one spot making a panorama. You are an active participant. That's what draws you in. It was first shown in New York, at the International Center for Photography in 1986. Later it was shown in the retrospective at the Los Angeles County Museum, where they have interesting facts about exhibitions – mostly about how many people attend. People spent longer looking at *Pearblossom Highway* than almost any other picture. I said I think I can understand why. I suggested that photography is a medium everybody knows and understands. The processing was absolutely ordinary. Everything was printed in the one-hour Fotomat. But it took me a while to work out that the reason they were looking at it for so long was that they had become a participant in the picture. What would you say?

PJ: I remember when we spoke about it at the time it was first shown, in 1986, you said, 'I don't even know what it is!' You said that it was not like a photograph at all. It was more like painting or drawing. And I thought that too. I thought it was the greatest photo-work you had done. You'd already stretched the bounds of photography, but this took you somewhere else.

DH: *Pearblossom* certainly finished off my period of playing with photography. It's a very plain, ordinary subject, the crossroads, but I'd done it in a different way, with a camera. It does occur to

me that if you ever photograph a desert road again, *that* has to be taken into account. Through the way I represented the space, an ordinary desert crossroads became a commentary on the experience of travelling for hours, days even, across the Western deserts. That's why people spend so much time looking at this work. Everyone has shared the experience of observing details of landscape whilst driving. Even if the response is unconscious, I do believe it gives the work its power to engage. People often stand in front of it for a very long time. Why? People instinctively know, although many things in it are recognizable, that something *different* is happening.

PJ: That must have to do with the depiction of, and control of, space within the frame. One has a great feeling of space, standing in front of *Pearblossom*, but does the space we seem to see actually exist in the form you show it? It's recognizible but slightly alien too, like a language we only half understand.

DH: It comprises eight hundred separate images. Many are overlapping so only a sliver remains. It took two weeks to construct. It therefore dealt with space and time. But what is it? What would you call *Pearblossom Highway*? It hasn't been exhibited much, it's now ten or twelve years old, and it was exhibited in a few places, but not that many people have seen it. We did make an excellent poster of it. I insisted that was done very carefully, meaning a very careful photograph of it with good printing, good paper, and so on. We printed five thousand copies. I think they have all gone. Now the Getty have made another. They did tell me in the bookshop that it is a good seller. I always said that more people would see the poster than the original. Now that it's not up, people do ask, where is the *Pearblossom Highway*?

PJ: It's probably in the vaults. It must be an archival nightmare!

DH: *Pearblossom* did, in a sense, lead me back to painting. It took a while, it didn't lead me back immediately.

Look at this painting of the Grand Canyon. I'm basing it on a photograph I made in 1982, but I'm also basing it on my memory of many, many visits. I'm always going to the Grand Canyon. It's only a day's drive. I've taken many people and gone at many times of the year. It's some time since I've been down into it. I have been down to the bottom, but that was thirty-odd years ago. You can go down on mules or you can walk down, and it's different when you go into it. To me it's very beautiful from the rim in the sense that it's the world's biggest hole. The sense of space you feel from the summit is unbelievable. The space seems to me not horrifying but invigorating. There are descriptions of when people first went to the Grand Canyon and they realized that it was vast, a vast abyss. It was when they were coming West and some people described it as a 'terror'. Of course, that was the age when you had only a man on a horse. It's only a hundred years ago, but we were still exploring by foot. There are old trails and they are still used.

Poster for Hockney's respective exhibition at the Tate Gallery, London, 1988

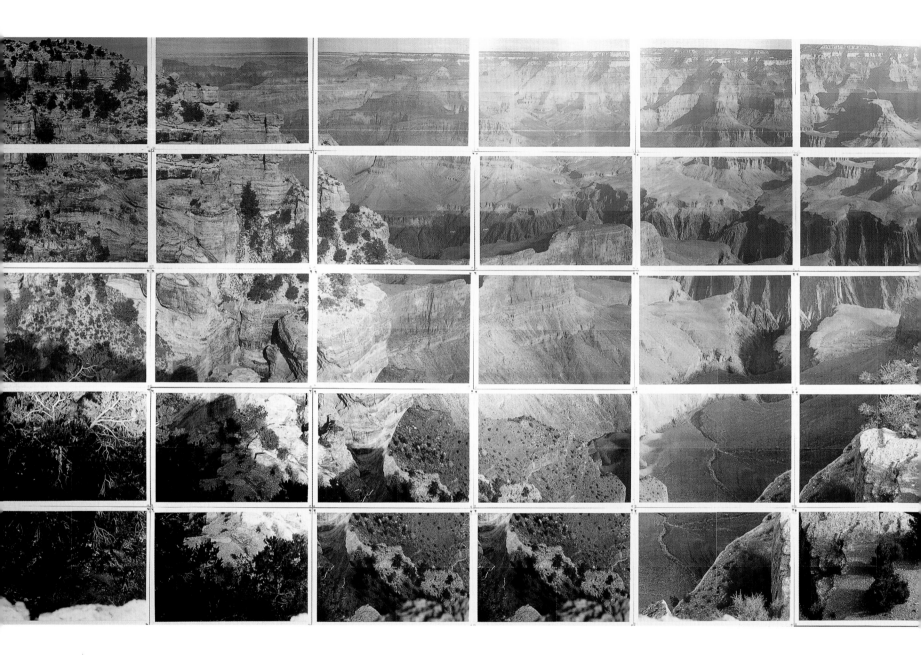

**Grand Canyon Looking North II,
September 1982.** Colour laser printed
photographic collage (60 prints)

PJ: It could have been a sacred place for them.

DH: Yes, of course, I'm sure it was. And it's dramatic, even the weather is dramatic. When I went to photograph it in 1982, I rushed there because I thought I'd found a way to photograph the unphotographable: the Grand Canyon. I first went there in 1964. I might have taken a photograph of it, but most little snaps do not tell you anything, cannot give you the feel of that immense space. 'Unphotographable,' I always used to say. Yosemite, too, which was photographed by a great

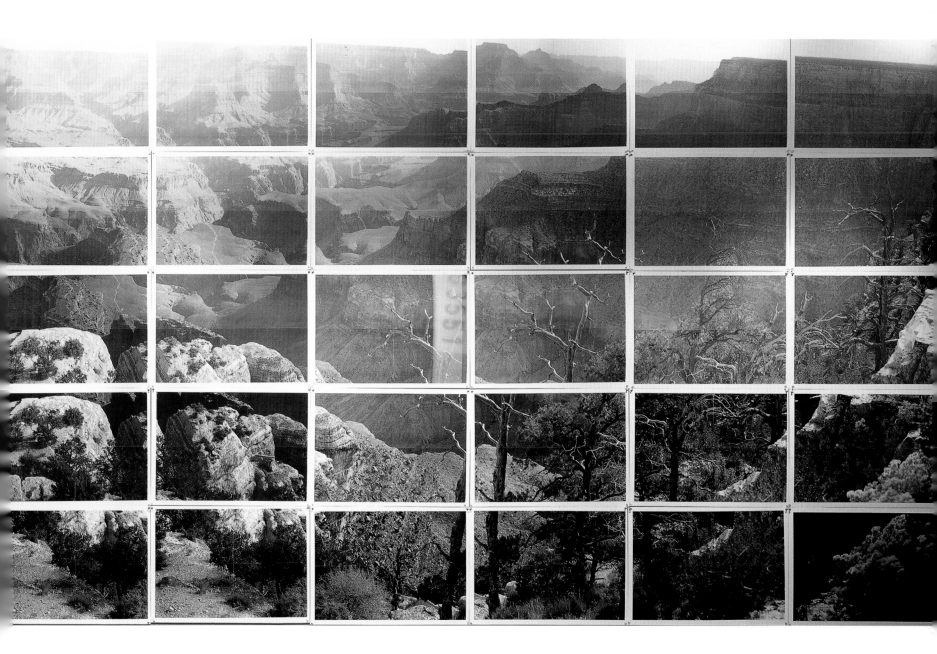

photographer, Ansel Adams. Those photos were marvellous, but they don't prepare you for your first sight of Yosemite Valley. It's a spatial thrill, or it is to me. Standing on the edge of the Grand Canyon is a spatial thrill, and the camera just can't capture this.

PJ: Tell me then about your first serious attempts to depict it.

DH: I made my first attempt in the late summer of 1982 with a 35mm camera, not a Polaroid. I could

223

not watch the picture being constructed in front of me; I had to take the photographs and then wait a few hours before I could construct the picture. That meant I had to train my eye and retain a very good visual memory. I remember I'd just bought a red Mercedes convertible. I wanted an open car because I like to really see the West. I thought I should try the Grand Canyon. I went alone. I thought it would be better alone. I think I was out there a week, maybe more. I knew I would have to stay there, partly because it's always changing. It was late September, when it was not as crowded. The children had gone back to school. I realized the best time for shadows was early in the morning or late in the evening, not midday. This is elementary stuff. I remember I took quite a few books, as I would be spending evenings alone. I would get up at dawn, at 5.30 a.m. to watch the sunrise. It was quite a good one. I sat there, with one or two other people, watching that great drama of the sun lighting up that space. That's simply un-filmable. You have to see it. The photograph was made an hour or two after the sun rose. You can tell by the length of the shadow that it's still not high in the sky. On misty or cloudy mornings you might not see the sun. I used just two rolls of film of thirty-six shots each. It took maybe half an hour, because I didn't have a motorized camera. I had to move the camera slightly to turn the film advance lever on, and remember what bit I'd looked at. It's five rows in depth, and it starts on the left. You can see this if you look at the sequence on the negatives – quite amazing that when it comes to the trees. I'm still terrifically accurate with the framing, each edge of the picture leading on to the next with just slight overlapping. When I'd finished I sat there for quite a long time still looking. You can look at it for a long, long time, it's such a marvellous experience.

I remember at the North Rim I might have been the only person in some spots, but I like solitude, I like myself. I remember my shoe is in some of the pictures because I was sitting with my shoe like this [*stuck out in front of him for balance*]. I was excited. I thought: 'These will work!' But of course I didn't have them developed then. I just numbered the rolls and put the pictures back in the envelopes till I was ready. I might have done ten. They take a while to sort out. I think that I only made two versions, one on the Rim and one in which the horizon would be seen, curving in shape. That's all I made, and I put them together, gluing them myself. I did them here, on the lounge floor. I also made one smaller one which we labelled 'Made for the ICP Exhibition in 1986' and then we put it away. It was way at the back of the storeroom and, because it had never been reproduced anywhere, we kind of forgot about it. This is an example of how things can simply disappear!

PJ: But that piece came to light in a curious way, didn't it?

DH: The reason we found it was because we now regularly put all my work on to a computer – tens of thousands of images – photographs, drawings, paintings, everything. It was about the time that Reinhold [Misselbeck] was planning the photographic retrospective for December 1997 at the Museum Ludwig. I had been to Cologne, and he had showed me that vast room with a gallery which

allowed an audience to look down at the walls beneath. He had said, 'Well, you could use this room.' Then I did think: 'It's like looking into a canyon. Why not try great big versions of those photographs of the Grand Canyon?' We had the laser printers here which could make the large photographic images, two sheets for each 35mm frame, if needed. The technology existed in 1982 to do the same thing, but it would have been an incredibly expensive operation. Now the costs had dropped dramatically. I said to Richard [Schmidt]: 'Let's do this. Let's try.' He had his lap-top computer, so I said: 'Let's look through my archive of images. I think I remember one which would look good for this, printed big.' I had to describe it to him.

When Richard came back to Los Angeles, he looked in the records and realized that we had made a bigger version for the International Center for Photography in 1986 - we found it way, way at the back of the storeroom, dug it out, and made a big version. But it was actually very dark. Far too much black had been used in the printing. I said, 'Well, we'll do it again.' Both my assistants groaned a bit: 'Oh no, all that cutting up . . .' I said, 'Don't worry. I'll do the cutting out if need be.' I won't ask people to do what I won't do; I know these things are chores. So we did, and that's the one in Cologne. Well, we thought it looked pretty good at that size. Gives you a real sense of scale of the Grand Canyon. When I got to Cologne I was pretty impressed; for a show of photographs it was impressive. You always have problems showing big photographs. They get flatter and flatter as you blow them up because the eye is moving and time is not. Not a great deal of luminosity, but not bad. After the Cologne opening, before I came back to Los Angeles, I watched your film with David and Anne [Graves] and I realized your camera simply didn't pick it up. You could see me talking in front of it. That was okay, but behind me there were just sixty squares. You couldn't read it and I was a bit disturbed by that. It's not that good on television. So I got back here at the beginning of January, and I thought: 'It doesn't read across the room.' The paintings read in your film, but not many of the photographs. Remember the painting of that chair I'd given to the Van Gogh Foundation? How you saw it two rooms away, whereas you didn't see the others? It was as though you were next to it. Your camera would have picked that up.

PJ: It did.

DH: From way over there it picked it up.

PJ: Luminous colour.

DH: Paint, oil paint, not photographic dyes. Most printing is film, a thin film of colour. I then became convinced that I had to paint it. It's *painting*. Here it is, absolute final proof that you'll have to do it in a painting. I began some little ones – nine canvases together at first, then one of fifteen. Then I said to Richard, 'Let's decide exactly what scale this should be' and we worked it out. Here I admit that I took into account the size of the wall at the Pompidou Centre for the exhibition there in January

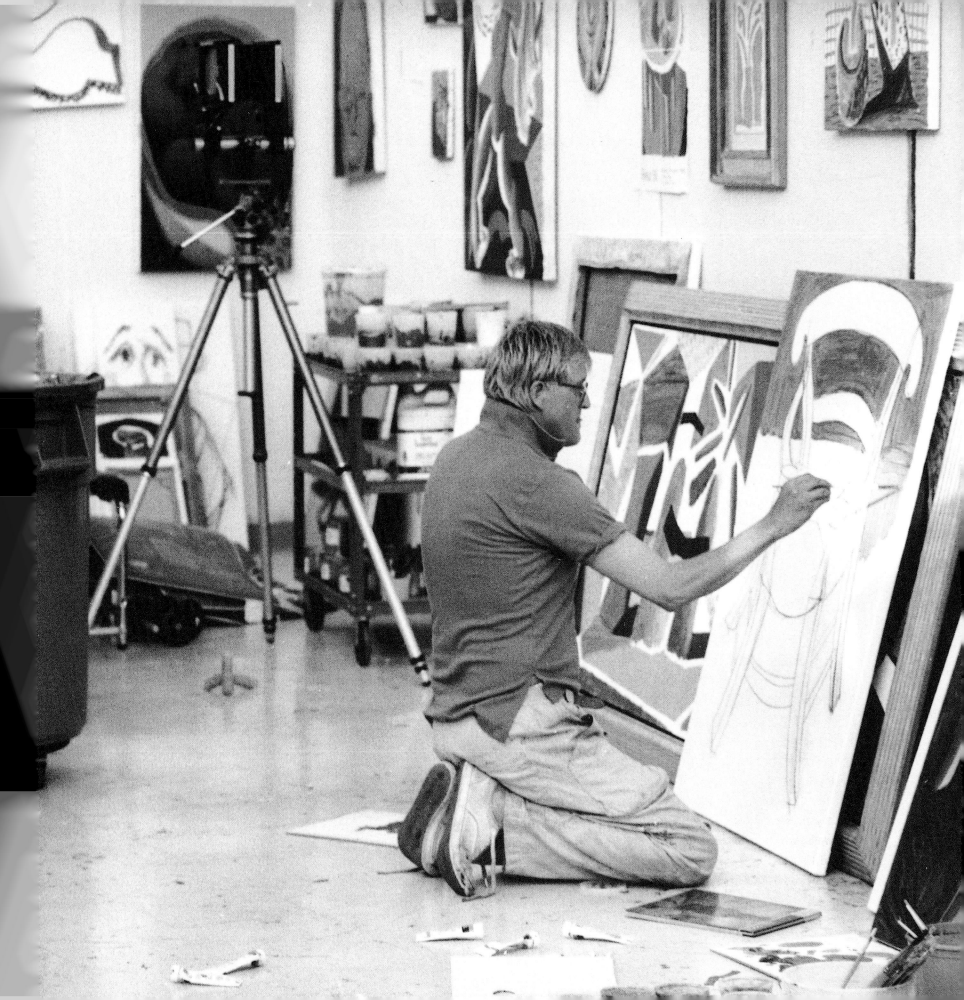

1999. We'll do it on sixty canvases. Richard has devised a way of hanging them on the wall. We worked out the scale and I said, 'Order one hundred canvases, because I'll need sixty and that leaves forty spares.' I can always swap them, if I don't like one; just take it out and put another one in. Oddly enough it gives me a lot of confidence to work that big, because if I don't like something I don't have to scratch it out, I just toss the canvas away and put a new one in. I'm now going to work from memory. I have a good visual memory. I've been to the Grand Canyon many, many times.

PJ: Weren't you tempted to go back one more time, before you tackled such a big painting?

DH: I deliberately decided not to go again before I did it. It was January, not the best time to see the Grand Canyon. There would be snow around the rim, even on the South Rim. There might be a lot of mist and I'd see nothing. I might as well be looking at Bridlington. So I decided not to go. I didn't want to be influenced by atmospherics. I wanted to paint it how I remembered it, with real colour and pigments, strong pure colour put on right – meaning the colour will stay there, you will read it. It was planned quite carefully. It's actually the largest painting I've ever done, four feet longer than the *Mulholland Drive* painting. Then I did a study, that's now in Boston, to select the palette of colours I would use – how to use them and how to paint the deep shadow and one big mountain. Though the mountain is in deep shadow, I wanted to put detail and colour there. The violet that I wanted had to be done in layers of glazes because if you put white paint into cobalt violet it goes dull, chalky and dull.

PJ: And opaque, too, David, surely.

DH: Yes, it had to be carefully planned. Then I decided on a somewhat limited palette. Working long days, every day. Terrific. Once I'm started, I'm gone! I did do a little etching at the same time, because often when using glazes I need to leave them to dry before putting the next layer on. In fact I only just finished it when Celia came at Easter.

PJ: You'd promised her a special trip, hadn't you?

DH: She wanted to see the Grand Canyon! Also Didier came from the Pompidou Centre in Paris – because we had made a model in Los Angeles of the room in the Pompidou Centre in which we'd be showing the work. He saw it and was very impressed. I said, 'Well, you'll be able to see it from twice the distance when you approach it from far back in a room.' I like the idea of that, being able to walk slowly towards it. I did think of putting it in Saltaire but it is really too big for any of their walls, which is why I'm doing a smaller one. I might send it to them in the summer. I then realized I have to do this in painting. Painting simply is best, because it seemed to me to be a statement about landscape painting on a very grand scale – which is frankly utterly out of fashion. Not that that would put me off; in fact it would attract me! When I told people that I was painting

Hockney in his studio circa 1986.
Photo by Paul Joyce

227

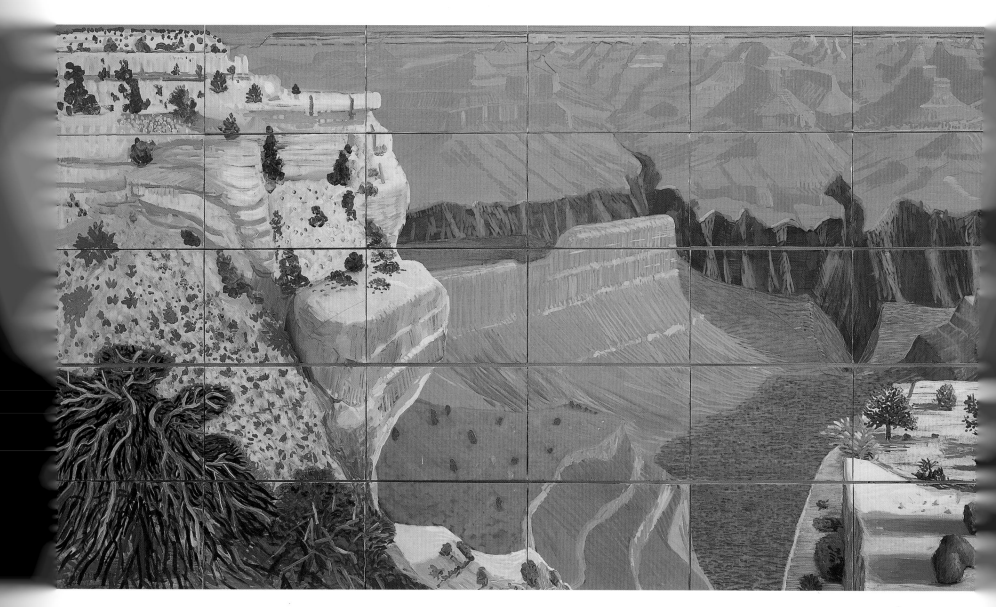

A Bigger Grand Canyon 1998 Oil on 60 Canvases

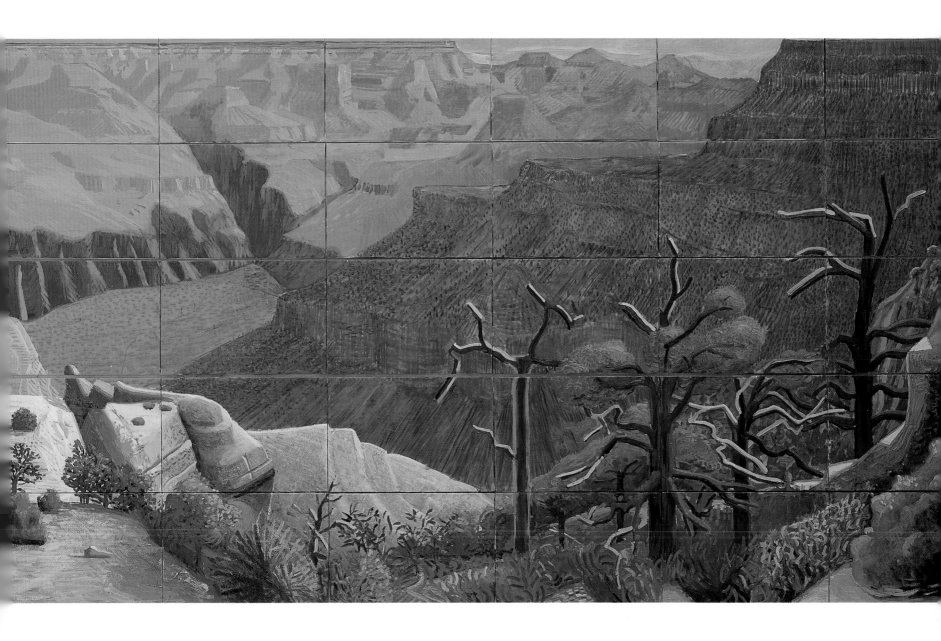

the Grand Canyon, well, I saw the expression on their faces! The only witty comment was from Ed Ruscha. One evening I excused myself early by saying: 'I'm painting the Grand Canyon.' He immediately replied, 'In miniature, of course!' Good comment that. He has a natural wit, doesn't he? You can see it in his work.

Celia and I went to the Grand Canyon – a marvellous tour, spectacular natural vistas of the West. We drove straight to the edge of the canyon for a sunset. It was April and there was still quite a bit of snow around. That night it began to snow quite heavily, and it continued to snow all night. We drove back along the South Rim; apart from the snow, it was absolutely full of mist. Mist and snow until we had gone quite a long way, descending by about two thousand feet. It was beautiful to see it that way as long as you had seen it without the snow the day before. Then we drove a couple of hours to the mesas of Monument Valley, where there is just a dirt road and a Navaho reservation. I was in the eight series BMW, a long, low car, too low really. I wanted to be looking up at all this in Monument Valley. I said, 'Let's hire an open jeep.' Celia said, 'Well, it'd be quite cold', as we hadn't really been prepared for such conditions. We knew it would be cold at night, but not during the day. The guide said, 'What do you want to go in that for? Look over there! That's coming over here.' 'That' was the snow storm we'd left behind in the Grand Canyon. So I said, 'Oh well, let's just go in the jeep.' It was a rickety old jeep; they would only allow it on the Navaho reservation, not on any real road. The guide obviously thought we were a bit mad. So I said to Celia, 'You go in the front. It is covered up a bit, and we'll sit in the back'. The snow caught up with us. The few others in cars going out were laughing at us. But Celia said later, 'You were right to do the jeep.' I said, 'Yes, it was a great idea of yours to make us go in that jeep!'

The land is unbelievably red, a deep orange red and so snow falling against this, white snow falling on this deep red earth was marvellous. It's not the kind of landscape – red earth with not much growing on it – that you'd expect to see snow falling on. The monuments looked like hazy cathedrals. I did take a few snaps.

PJ: Will you paint them?

DH: Maybe from memory. I've got it in my head. It was marvellous. We spent the night at a motel right in the valley, with spectacular views, called Broadings Trading Post – it's where John Ford stayed when he made *Stagecoach*. I must have seen it when I was a kid. When I came West I thought that all the West would have these great big mesas, but it's only in Monument Valley that you see them – mesas which look at times like vast buildings, although you know they are rock. Not too many people go, because there are not many hotels; it's mainly Europeans who go.

PJ: Probably because of John Ford!

DH: I've no doubt. He was the first to actually film it.

PJ: You told me that you were planning such a painting, before you had made the large photo-work of the Grand Canyon for Cologne.

DH: I was really, yes. I was planning a great Western landscape. I would take the drive to Santa Fé and back. Twelve hours from here, and I did that twice in three weeks as well. People in Santa Fé thought I was crazy. Well, I said the drive was the marvellous bit of it. Twelve hours of intense visual pleasure.

PJ: So really all those experiences have gone into the new Grand Canyon paintings?

DH: Oh yes, yes! Now I was planning to do a Western landscape on a big scale, by using memory, meaning not one view but many views as I drove. Now, what is this collective space, that I got from twelve continuous hours' travelling, in my head? I wanted to make something of that, do you see? But then I found myself, instead of that, crossing the Yorkshire Wolds.

East Yorkshire is a remote area. Not many people travel there just to sightsee. There is a geographic reason for this: East Yorkshire is protected by the Humber River to the south, and it is only relatively recently that a proper bridge into Hull was built across it. Consequently people would simply by-pass the region, travelling north on the A1.

West Yorkshire, on the other hand, is relatively accessible, and has easier routes to the traditionally picturesque places. So Thomas Moran, Turner, Tom Girtin, and other artists visited there with some frequency, making historic topographical studies which in turn increased the popularity of the western areas. No one has painted East Yorkshire. I must be the first one to do so! The roads there are as empty as the desert roads in California and Utah; you can go for miles without seeing another car. There's an occasional truck, that's all. Just the same in East Yorkshire! I would take small roads from Bridlington to visit Jonathan, when he was very ill, and not see another car. Even the villages don't have shops any more.

In a sense those Yorkshire paintings came out of the ideas of the great spaces of the West, but it did occur to me straightaway that Yorkshire is one place where you have enormous vistas. It's not like, say, Cornwall. A drive in Cornwall, well, you've got tall hedges. You don't see over them. You've got to get out of your car and climb up a hill. Here you can see everything as you drive, from Bridlington to Wetherby, just east of York, down Garrowby Hill and up it again, and I realized here's a subject and here's a way to paint it. Jonathan was urging me all the while to 'paint Yorkshire'. I had never stayed this long in Yorkshire. I was forced to see it afresh. With agricultural landscape, the surface changes a lot. When I arrived there were still golden fields, they'd cut the corn, I'd see these big machines doing it, then I'd see brown earth, then the winter wheat coming up, unbelievably fresh and green.

PJ: But you're putting a whole experience of three months into a single painting, mixing all those colours and changes of weather and texture . . .

North Yorkshire
1997. Oil on Canvas

DH: Well, David Graves says that I'm becoming like some old countryman, noticing all these differences. Driving in an old car, driving quite slowly actually. I'd worked on this land, harvesting in 1952 and 1953, near Sledmere, cycling all around those roads and into Bridlington. They've not changed; the roads are still the same, really tiny. So they have a relationship to the American West.

The last two Yorkshire paintings I actually did back here. I'd painted Saltaire, for Jonathan; I wanted him to see it as I see it now, and also for him to know how I remembered it as well. *Salts Mill* is about time and the history of the place, and many places like it. By that I mean, for instance, the rows of houses to the right of the Mill never came down the hill like that. You would actually have to be *inside* the Mill looking out to achieve that perspective effect. But I grew up in Bradford in small terraces jammed together just like that, and I remember Saltaire as a busy working mill – literally the hub of the whole community. The workers' houses crowded down towards the mill. It was the focus of their whole working lives.

One other painting I did about the same time of a wood stretching down the hillside reminds me – but no one else I suspect – of Grimm's fairy tales. As a child I thought a witch would live in such a wood. I would not even want to go near it. In that sense these paintings, as much as anything, are about my childhood and the things I remember from it.

I then felt I'd like to finish the series I'd planned of Garrowby Hill. In November I'd started this picture of the Wolds late in the year, when the harvesting had been done. There was more brown in the ground. I put in rich purples to emphasize this soil colour.

PJ: The ones you did here, in Los Angeles.

DH: Yes, I started them here in December, one a large double-canvas, which when they published it in The *Observer*, they only printed half of it, not realizing there were two parts to it! It still works just one side, but it would have been better with both. Then in January, as soon as I got back from Christmas in Bridlington, I painted the Garrowby Hill picture. Although I had a few photographs of the plain of York, it was really done from memory. You can't photograph the landscape from any position to accord with the painting. I painted it, finished them, then I said, 'The next painting has got to be of the Western landscape, and we'll start with the Grand Canyon.' The Cologne piece was okay, but it was powder, powdery colour . . .

PJ: Toner, from a cartridge.

DH: Yes, toner. It's essentially thin, and cannot read like paint can. So that's the history of the latest painting, I still have others, planned in my head. So I've got another two hundred canvases. [*General laughter.*] I said to Richard, 'Get them in, have them made up so I can do them.' Then I started a smaller version, a detail of the Canyon from memory.

PJ: You must do those mesas as you describe them. I can almost visualize them in the mist. I would urge you to paint them.

DH: Well, if you can almost see them, that's how I would do them. Of course, in the mist, you don't get that extraordinary sense of space; you don't see as far. But as long as I can see them . . .

PJ: The one thing that remains from the photographic piece is that the painting is constructed on a grid pattern, many separate images making up a single whole.

DH: Well, for example, the painting of *Salts Mill* is ten feet by four feet, which is simply two five-foot by four-foot canvases. I couldn't have got a ten-foot canvas into the room where I painted it, in Bridlington. I can simply take each canvas down the stairs when I've finished it. So there is a practical reason there. But here, I think there is a deeper reason: the grid makes you look from side to side. I also realized it must have sixty vanishing points as in the photograph – or a *minimum* of sixty vanishing points. A picture could have two or three. Well, there's at least sixty there; certainly

The Road to York through Sledmere 1997. Oil on canvas

The Road Across the Wolds
1997. Oil on Canvas

not one! Somehow or other that must have an effect, because I am not using atmospheric colour at all. There's no attempt to do that, and yet you do feel the space. The big space.

PJ: So it's the vanishing points which are giving that feeling, that effect?

DH: Must be. I'm only just thinking that out, and now going into it. But it's certainly fascinating, what it does, considering the colour has nothing to do with traditional aerial perspective.* I deliberately did not use them. Although there is a perspective, in fact there are multiple perspectives. It must

have an effect. The grid also makes you look at each one, which means you journey through it, as the eyes would do anyway. That's the way you see the Canyon [*A Bigger Grand Canyon, 1998* (see page 228-29)]. You're forced to move your eyes, just as you would if you were there.

Aerial perspective is a traditional rule of landscape painting which dictates that foreground objects are rendered in bold, dark colours as they reflect the strongest light and show darkest contrasts. Distant object are painted in lighter tones, and should reveal little detail so they seem to recede into the distance.

Garrowby Hill 1998.
Oil on canvas

Salts Mill, Saltaire, Yorks 1997. Oil on 2 Canvases

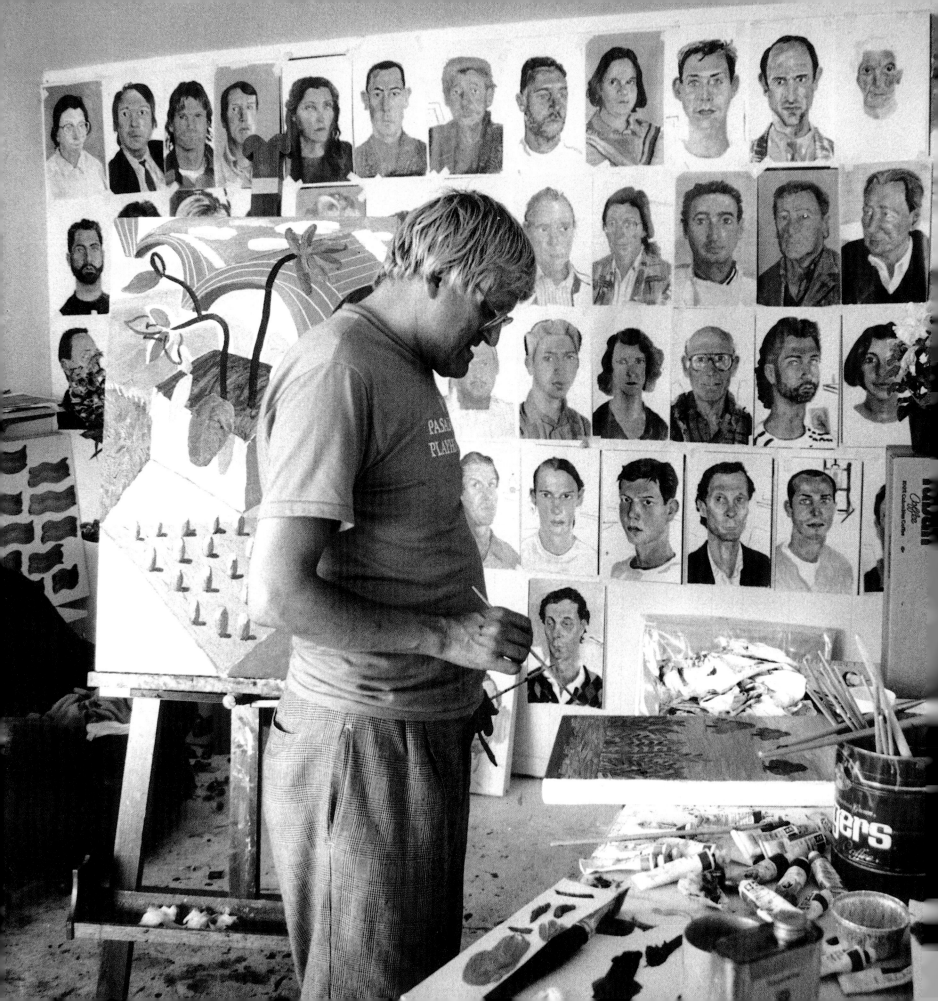

Los Angeles, June 1998

In June 1998 I returned to Los Angeles to stay with David for a few days to continue our conversations before finalizing the text for this book. Although very excited by the new paintings and lithographs, he confessed to exhaustion due mainly to a retreat into work following on from the deaths of Henry Geldzahler and Jonathan Silver. On the last evening of my visit I arrived at David's house in the Hollywood Hills for dinner, as arranged, to find no visible evidence of dinner but much of etching procedures. David and Maurice Payne, his master printer of thirty years and more, were locked in silent communication, unshaven, grimed and ink-stained. I had to stay and watch this.

Maurice by now had been living in the house next door – also owned by David – for five months or so. During this time he had set up and equipped a fully functioning etching studio and adjoining workspace: the first carved out of the garage, the second out of the living room. Maurice's tenacity in keeping David's nose close to a sheet of copper almost exceeded my own in getting this book finished. Indeed, Maurice and I would occasionally exchange looks when frustrating interruptions crossed our respective paths. Two hoary old pros trying to get the job done. Together they had produced, through various complex etching 'states', twenty stunning and completely different images which David framed and put around the house. It was perfectly clear, even to someone like me who is basically ignorant of the finer points of this process, that these would be major works when editioned. Maurice clearly felt this and was trying to get the series completed, but David still pressed on, experimenting with and extending the possibilities of the medium.

The tools of the etching trade look quite intimidating, all sharp pointed metal objects, laid out – in Maurice's extraordinarily neat procedure – and looking as if only some unfortunate body were needed for dissection to begin. I'd certainly never seen an etching plate prepared and a print 'pulled' – if this is the correct technical term. David told me later that amongst the tools were some he had designed himself, in particular two or three 'brushes' made out of different thicknesses of wire which allowed him to achieve stunning effects of cross-hatching which would have been virtually impossible with a conventional single point.

The image David had been working on was a near-lifesize head of Maurice, in half profile. David was still unhappy about the amount of hard line detail, particularly around the mouth and eyes. This meant that he had to physically attack the plate with a burnishing tool, flattening lines by carefully gouging out surrounding layers of copper. This took a great deal of strength in hand and forearm and, although David is not over-muscular, he is wiry and extremely strong. He worked hard on the plate for about ten minutes and, apparently satisfied, he told me that this was the third 'state' or working of the plate, and it would probably go to six or even seven before they were finished.

The thin copper plates, lacquer-backed after being worked, then bathed in acid for a couple of

Hockney in his Malibu beach house studio. Photo by Paul Joyce

hours, have a great intrinsic beauty. The shine of polished copper on closer inspection reveals a surface fragmented by delicately traced abrasions, which in turn will mingle with viscous black printing ink and a dab or two of French chalk. First, Maurice drew the ink – about three or four dessertspoons full in culinary terms – across the surface. He then spent at least the next ten or fifteen minutes working the ink into the plate, then wiping it down, working in more ink, wiping it down, and so on. All the while the wiping away process reduced the ink until you could not believe there was any left, but there was indeed, deep inside that fine tracery of lines. There followed more evidence of the crucial importance of the hand when Maurice took tiny portions of French chalk and, working with the ball of his palm, dusted off the surface to remove any excess ink. The process was mesmerizing, like some kind of ancient Japanese tea ceremony, each tiny process leading to the next, unhurried yet inevitable.

When at last the plate was prepared to the satisfaction of both, Maurice selected a sheet of heavyweight paper, full of water and resting between sheets of blotting paper, wiping off the excess moisture and placing it beneath a cloth facing the plate on the printing press. Then he turned the heavy press slowly but incredibly smoothly, like an old fangled clothes mangle until plate and paper had travelled right through the drum mechanism. Voila, an artist's print!

After dinner, David took a freshly waxed virgin copper plate into the lounge. As his dogs, Stanley and Boodgie, fell asleep on their respective cushions in front of the open fire, he began to draw each dog, working on the plate with his special brushes. I looked with fascination at what he had done, examining the copper plate carefully: the dog's short hair had been beautifully realized with those special brushes, a myriad delicate lines traced into the waxed surface.

Later Maurice told me that the most he could achieve on a good day might be ten prints worthy of the edition. I left the house with a greater understanding of the reason why great prints, whether etchings or lithographs, can approach the prices of oil paintings. Even in an edition, it is perfectly apparent that each print pulled from an etching press has to have its own individuality, one which directly results from two skilful pairs of hands. As David said, watching Maurice, 'No machine could ever be programmed to do this, ever.' In this respect etching is truly a 'hands on' process – the basis for all great art.

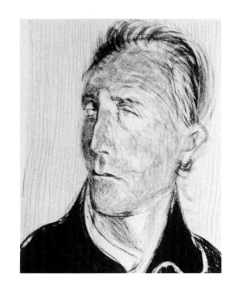

Maurice Payne sitting in the etching room at Hockney's Hollywood home, surrounded by tools of the trade.
Photos by Paul Joyce

2/80 *v dm wmey* 95

Small dogs, 1995.
Etching

DH: In the world of images which I've always been fascinated by – which is separate from the world of painting – in that world photography has been a very dominant thing, and it still is. But it's about to change. I anticipated it quite a long time ago and nothing has happened to make me think I was wrong. On the contrary, it's confirming what I thought out then. I've been doing so much painting, drawing and lithography, that I haven't done much photography since Bridlington last summer, when I did those big pieces for the vast room in Cologne. Otherwise I was too absorbed in the painting. Why would I bother? But it probably made me take those photographs seriously. It's a time in my life where I have to arrange things; after all, events force you to, events control you a lot of the time, don't they?

PJ: You've got a big operation here, David, you have to ensure it runs smoothly.

DH: I'm well aware of that. I'm an active professional artist and I've no intention of being anything else for quite a while. It's an active studio. I have to show. I have to participate. I have to respond. When the Museum Ludwig first approached us I thought: 'Well, it won't bother me much. All the photographs exist. Let them look at them and just do the show.' So I go along with it to start with, then I usually realize that I've got to be more involved because I'm an active person.

PJ: It did make you produce substantial new pieces.

DH: Well, in that sense I'm an opportunist. I take the opportunities, and I understand that pressures like that are often good for me; they stimulate, and I can usually cope with them very well. I've worked in the theatre and I know perfectly well the deadlines are real even if I think the work is not yet good enough. The curtain goes up and the show goes on. That's the way it is, and those deadlines make you do it. But it's difficult at the moment. I lost Nathan, Henry and Jonathan. Only one of them was slightly older than me. They were three people I was very, very close to and who were also very active with me in my studio.

You know when I questioned where photography was leading to? Well, I do believe there is a kind of anarchy coming. It will happen as the Internet proliferates and with all these television channels, what does it mean? Advertising is split up; people are split up. You know there has been a series of long articles here in *The Los Angeles Times*. I could even have written the same things myself. They mentioned the TV show 'Seinfeld'. Apparently, it was one of the last programmes that a lot of people watched – except me!

In the 1950s and '60s everybody watched 'I Love Lucy' with Lucille Ball, *everybody*, from the professor at Harvard to the housewife. In a sense they all saw the funny side of it, and most importantly the audience covered a vast range of people. Well, it doesn't now; the audience is much more split up. Maybe it was always like that. We might be going back to an older system, before the mass market when people were in smaller groups. If that's better or worse, it's not for me to say, is it? It hardly matters; it will come. There's a side of it which gives me pessimism, and there's a side which gives me optimism. On the other hand human folly . . .

PJ: Means there will be a downside.

DH: Very likely. Human folly doesn't stop.

PJ: But in your article 'A Wider View' you indicated that the coming information revolution would mean that people would have access to more kinds of information; that if people wanted to find it, they'd be able to.

DH: I don't think I was quite saying that. I was describing, using a word, 'cubification', suggesting that it had pictorial parallels. A lot of people wouldn't know it was Cubism anyway, wouldn't see it that way. They would just think – well, that's the way the world is. The consequences of these things seem to me to be reasonably obvious.

PJ: You're usually one step ahead, in putting it into words. But this cubification you talk of, is it to do mainly with a multiple viewpoint of events occurring now? Is this the parallel with painting? Then look at Cubism, it seemed to lead nowhere . . .

DH: It did seem to lead nowhere. Cubism didn't look as though it was lifelike, for it was dealing with such difficult concepts. For example, do we see with memory now? Most people don't sit around thinking about stuff like that, really.

The moment the movies came along, Cubism was marginalized; these new pictures, moving pictures, were far too interesting. After all, I was brought up as one of the last generation without television in England, meaning movies were big events. Now children can see movies twenty-four hours a day; they are not necessarily big events. You have to make a movie about potentially a large subject – *Titanic*, even in name. At least they had the sense to put a love story there, because there's nothing without love stories, is there? Nevertheless film doesn't thrill you like it did in the early days when a train rushed into the station and people threw their hands over their faces in terror. Even a child wouldn't do that now. Okay, in *Mr Bean Goes to Hollywood* there's a sequence where audiences are thrown about in their seats – some kind of simulated virtual reality. Frankly, that would just make me sick. I can't really believe that people think they are actually there when the volcano erupts or they're swept away on a jungle river and the seats move up and down.

It's interesting, living here in Hollywood, in the middle of it. You can ignore it, really! After all, when movies began, there weren't any film schools. It emerged as a new medium which people found incredibly exciting. I remember watching Kevin Brownlow's documentary series on the history of the silent movies [*The Parade's Gone By*]: utterly brilliant, and an example of something that couldn't be done in a book. It had to be done through time, and video is perfect for that. I bought the tapes, watched them, and realized that here is a sympathetic scholar who tracked down all those people who were still around twenty-five years ago, survivors from Hollywood's silent days. When movies began, you didn't need some old scholar; there weren't enough movies to study! But there will be scholars in the future. Kevin Brownlow's just one of the first, a good one, who obviously has a scholar's mind but edits brilliantly too. He must have looked at hours and hours of material and, in so doing, probably saved things which would otherwise have been lost. If nobody loves something, it will be the first thing to disappear. Kevin Brownlow's love of movies and for Hollywood as it once was motivated him. I'm sure he was paid well, but that wasn't the motivation, it was love. That will always be the same.

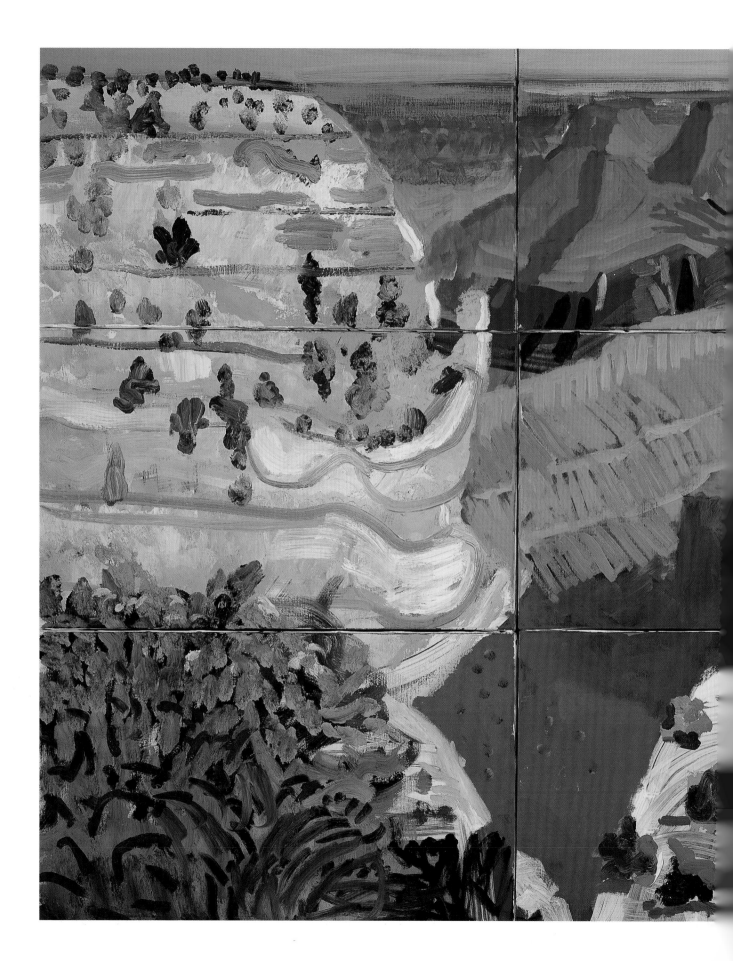

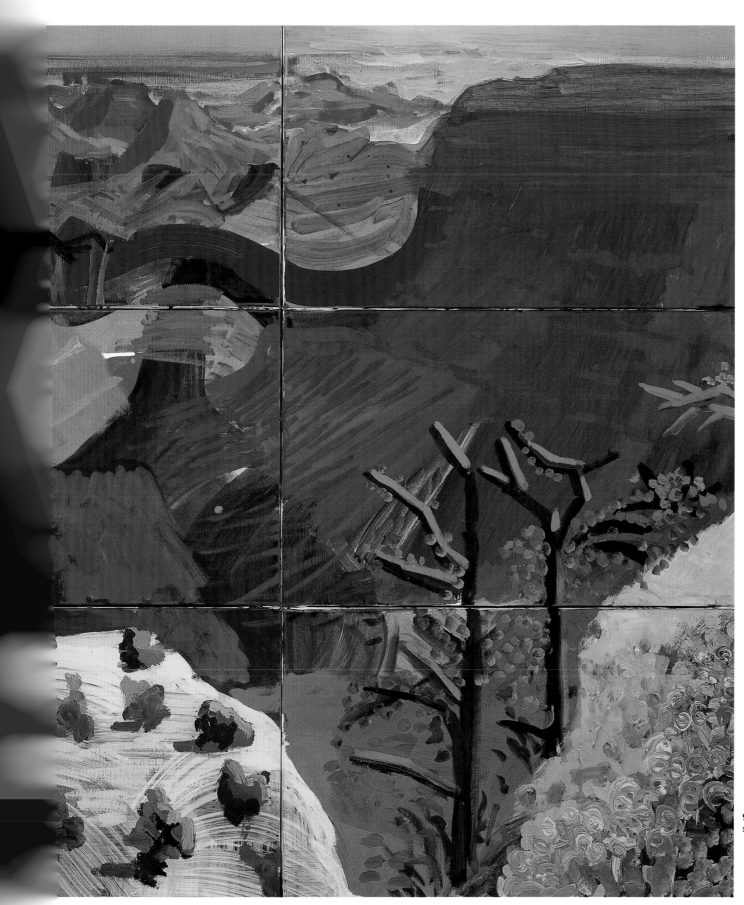

9 Canvas study of the Grand Canyon, 1998. Oil on 9 canvases

PJ: Love can extend both to the subject matter, and the medium in which you choose to depict it.

DH: The recent paintings of Yorkshire and the Grand Canyon are to me vast improvements on photography, which is the only thing they could compete with, isn't it? These are landscapes that we look at and enjoy for different reasons. I think that's why I realize that I have gone *through* photography. You look around; I do look around a great deal, and enjoy looking. Can I give a better account of that subject, a more realistic account? Isn't that what my photography was trying to do? We don't see that way, we see more *this* way. If we're more truthful about how we see, it would lead us to make fresher, newer pictures of the world.

PJ: So you are saying that by moving beyond the apparent realism of traditional photography, and by embracing painting full time, you have discovered a new way of depicting the world in a more realistic way?

DH: I've got to the point now where I'm painting what appears to be the visible world, meaning images that everybody recognises. It's only in fact comparatively recently that people can see *that* many images. Remember Felicité in Flaubert's story *The Simple Heart*? I've always loved that story and the vision of 'abroad' by the servant girl Felicité. She'd never been abroad. She'd only seen one picture of abroad, in a book, and that was of a monkey carrying off a girl. That was her notion of abroad, monkeys carried girls away. You wouldn't think that *now*. Now there are pictures galore, but of course most of them are not that memorable. When they're thrown at you all the time, you're not going to remember too many. On the other hand, I tend to observe that most people predict the future quite wrongly. All it needs is one other discovery and everything's changed. Life is a mystery and that mystery I assume will always be there. What was that headline in *The New York Times*, 'Secrets of the Universe About to be Discovered'? I would just laugh at that. Highly unlikely, really.

My experiment with photographic imagery lasted about fifteen years. It took me from the first images in 1982 for some years when I wasn't doing much else, slowly changing and developing. Fifteen years, well you wouldn't know when you began, that it would take that amount of time to sift through what it was suggesting to you. Then I went to painting with a renewed vigour, because now I realize the photograph does not compete with painting at all.

PJ: But you had to go through that. I mean, you surely couldn't have painted the new Yorkshire pictures without that fifteen years of photographic experimentation?

DH: Well, without Cubism I couldn't have done it. You know, there's a remark of Juan Gris that I discovered some time ago: 'Cubism isn't a style, it's a way of life.' Rather good that. Quite something to say, meaning that Impressionism could be said to be a style. If you look at the history of pictures and images you have to take photography in as well; it's not separate. In my way I dealt

with it. It led me into an exciting area, a very exciting area. I remember telling Peter Fuller [(British, born 1947) was one of the most intelligent and influential art critics of the 1970s and 1980s, and founder and editor of the journal *Modern Painters*. He died in a car accident in 1990.] a long time ago that 'slowly the photograph will lose its veracity', and he said to me sadly, 'Oh, if only that would happen.' I replied, 'It will, but don't think it necessarily will make things easier. It won't do that. I'm not being judgmental here, actually; I'm just stating what I think will happen.' I don't think he had given it that much thought, but he is the kind of person, were he still alive today, who would have been extremely interesting, because he would have noticed these things, he would have become more confirmed in these views. And in a way, making that great big photographic piece of the Grand Canyon in Cologne last year finished it off for me. I was re-doing a 1982 picture which in 1982 I couldn't make that way because it would have been too expensive – three hundred dollars for each image whereas now it costs maybe four dollars. Why would I spend that if someone wasn't taking it on?

PJ: But there was an element of disappointment, wasn't there, looking at that large photographic Grand Canyon piece?

DH: There was, I admit that. It wasn't that luminous, but then nothing printed is that luminous. Would it have been better as a lot of slides with light behind? Not necessarily. I told you it was when I saw it on your television screen and I thought, 'Nobody would know from this what the Grand Canyon was.' Your camera, through space, picks up lots of pieces of paper with printing on which don't glow like paint does. I mean it was a private disappointment; most people were thrilled by it. I realized that looking at your film, and that television isn't a good medium for all this. It's a moving picture, not very good for still pictures. When *The New Yorker* printed the two Yorkshire landscapes, it was better than being seen on television by twenty million people. On television as soon as you glimpse it, it's gone. *The New Yorker* is a physical object. People can touch it, pick those pictures out, pin them up, keep them and look at them in *their* time. So when you wrote and told me that Channel Four didn't want to continue with the film we were doing together, frankly I didn't give a damn. You might, but I didn't. I don't think they really grasped what was going on.

There's a side of me that's getting a bit more pessimistic, then I shake myself, for life goes on and people are more resilient than you think. On the other hand, change is constant, isn't it? The only constant thing is change; that's the paradox.

PJ: I remember saying to Wendy [Brown] that I long for stasis, and she said: 'Stasis is death. What do you want that for?' Of course what I meant was that I long for peace.

DH: I was just writing to André [Emmerich] and I said I like a quiet life but I realize I'd never have it because I ask a lot of awkward questions. It would be much better if I didn't ask, it would be easier.

Unfortunately I just keep asking questions. I have from an early age and I won't stop now! It's in my nature to question things. You can't really have a visual art without a physical object. You need to look at *something*. You could have art without it, but not what you'd call visual art, the pleasures of the eye and the mind. After all, you could have the pleasures of poetry without ever seeing a physical object; you could have it recited to you. I was even brought up that way a bit, people did that. The pleasures of people reading aloud, I used to do that myself. I knew that the the rhythms of the words were also part of it. Playing with them on the page, and especially the way they're said is important too. If you think of Eliot: *A Painter of the Umbrian School, Designed upon a Gesso Ground*. When you see it on the page there are a lot of 'gs'. There's a 'g' in designed, which is not pronounced. And the 'Gesso Ground'. Lots more 'gs'. Well I'm just pointing out there are many pleasures here – the pleasure of seeing them on the page and the pleasure of saying them. Very good, isn't it? Like the word 'abyss'. I was pointing that out in relation to the Grand Canyon the word 'abyss' is also bottomless. What I'm saying does bring this to a kind of temporary stop. Nothing stops really, but I'm saying it has brought me back to painting but it's also brought me forward to it. It's a forward motion, not a backwards one. I could defend my position rather easily now. I've thought out what photographs are really.

PJ: You mean defending your position about returning full time to painting?

DH: Yes, why one has to paint.

PJ: How would you put that concisely now?

DH: Well, you don't have to put it concisely in words, you have to make the painting, and I just did. That's what it's telling you. Nothing else. After all, the only competition to it I've already made – the big photograph of the Grand Canyon. When you put them side by side, one may have come out of the other a bit, but I could make a landscape now without that photograph. I can now. To defend painting you have to paint. I'm saying that only in painting can I show the grandeur. I am deeply attracted to those great big spaces which keep me in the American West. I find it thrilling and absorbing to be close to these spaces. It puts me in *my* place. I get more and more claustrophobic. I don't like tiny spaces at all. I notice people's reactions to the paintings of the *Grand Canyon*. Quite a few people have been up to see them. Nobody's indifferent when they see the big space. They don't say, 'What is it? What's going on?' It's quite clear. This is where it's all led me: not to make movies or videos, not to make computer games, not to make photographs, but back into painting with conviction. I see now *how* to go back into it. And then take off! It's just beginning, now, which is quite exciting. I actually do feel I am a step ahead of quite a few people, yes. *I've* thought it out, and I know a lot of people haven't. And I think there, for the moment, is as good a place to end it as I know.

15 Canvas study of the Grand Canyon, 1998.
Oil on 15 Canvases

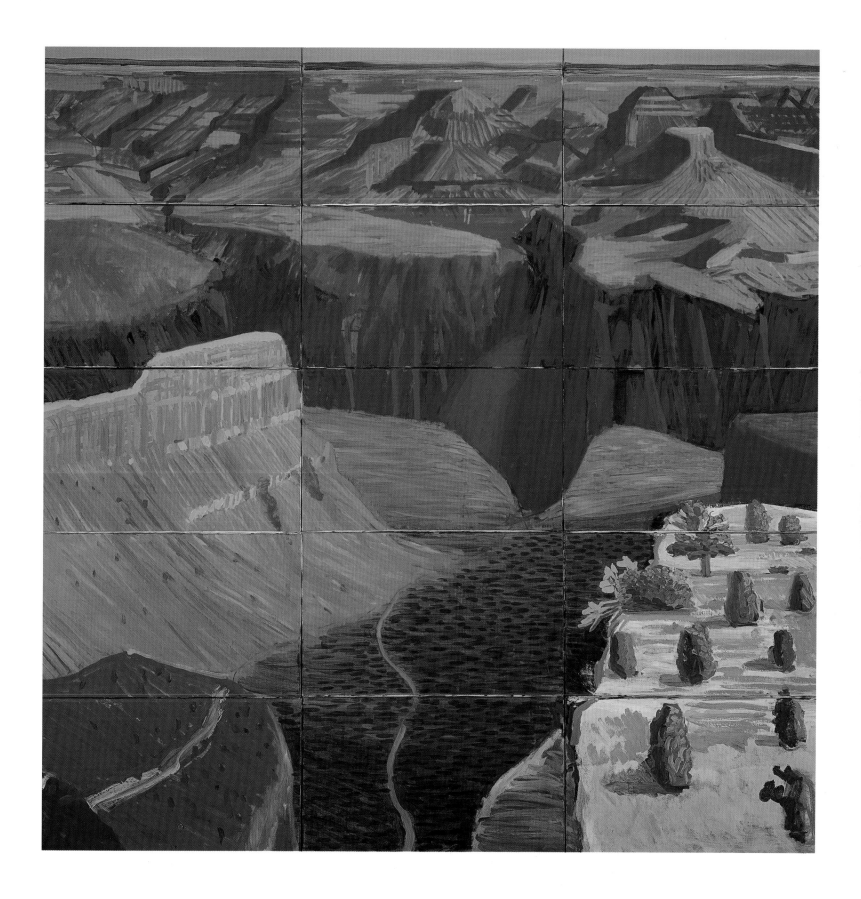

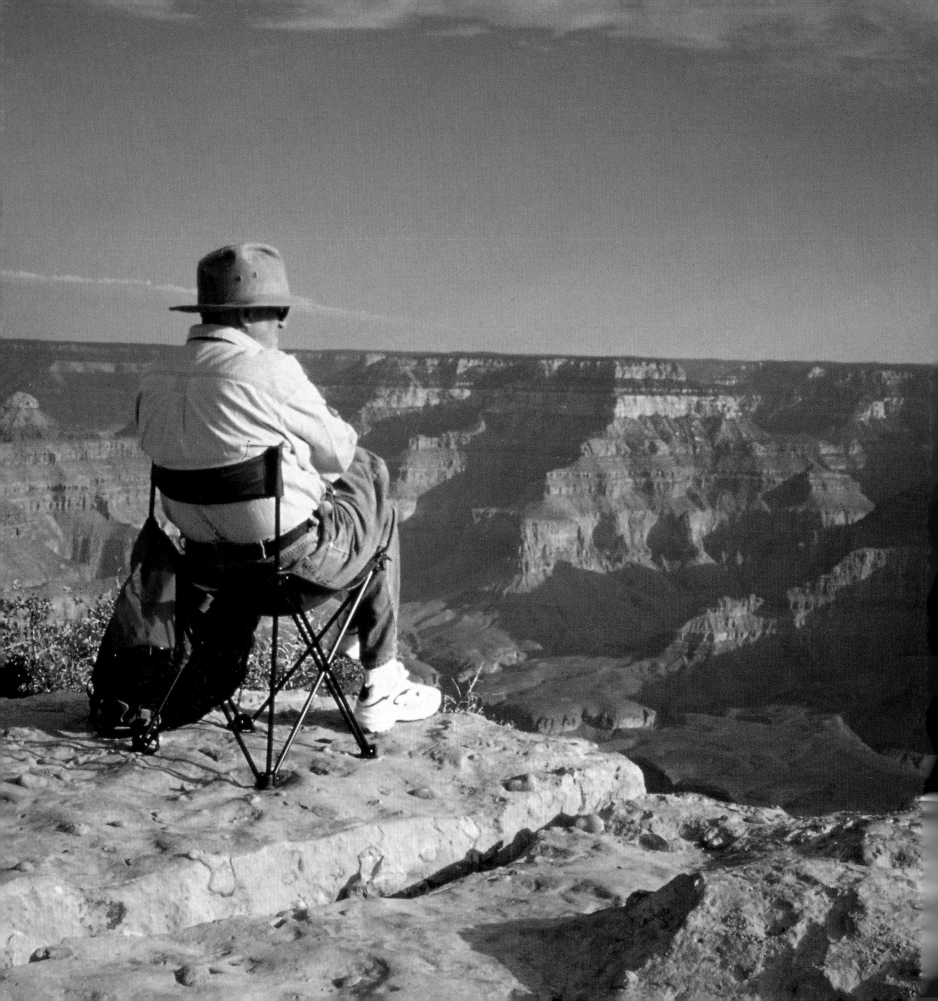

Paris and London, June 1999

In January 1999 I travelled with my cameraman, Jeremy Stavenhagen, to Paris to attend the opening of David's show at the Centre Pompidou. In fact, we bumped into David as soon as we arrived, outside his hotel, and we repaired to a bar where he consumed three bottles of Guinness and talked non-stop. Unfortunately, we did not have our camera or recorder with us, for this was effectively the only time we spent with him. After this he was pursued by journalists, curators, hangers-on and friends to the point of utter distraction. We spent time filming the installation of the show, and the mini-retrospective which accompanied it, including 'A Bigger Splash' and 'Mr and Mrs Clark and Percy', which we would never have been permitted to film in such a leisurely manner in England. After this, seeing David's increasingly drawn and worried countenance, we cut our losses and headed back on the Eurostar to London. I realized that my ongoing film about David would probably turn out to be a lifetime (self-imposed) assignment.

In May 1999 David returned to London to supervise the installation of the Grand Canyon series in the Royal Academy. Both Sir Norman Rosenthal on behalf of the Royal Academy and Sir Nicholas Serota (Director of the Tate Gallery) had spent some time in Paris looking at David's work. In the event, it was the Royal Academy who were prepared to make space available to David at the Summer Exhibition. In an unprecedented move, they offered him the largest room, which had just been used for Monet's Water Lilies. Here, David, working with his old assistant David Graves, decided on an installation of the Grand Canyon pictures which included four large mirrors, set in each corner of the room. These mirrors produced curious optical effects as one walked around the space; not just a reversed image but one which juxtaposed one painting with another. The effect was overwhelming and an instant crowd-puller. As I watched him transforming the Royal Academy space, he turned to me and said, rather gloomily: 'You know this will double the audience figures.' I replied, 'You should get a percentage of the take, like Steven Spielberg.' He laughed, realizing the joke has a barbed tail. 'They do make a lot of money out of me, you know,' he replied.

I had managed to get my camera crew into the room a day or two before the show opened and now we were able to do the interview which had proved so difficult to achieve in Paris. It was with something of a shock that I realized we were to bear some responsibility for the beginning of his great Grand Canyon *series . . .*

DH: When I watched your film rushes (unedited material) from Cologne, I realised that you couldn't read the *Grand Canyon* at all, not on the TV screen, and that was partly because of the printing ink and the flat paper we had used in making that giant photo-collage. It simply wasn't very physical. When I got back to L.A., I knew that I had to paint the Grand Canyon to make the picture work as I wanted it. I did two: the small pictures are studies for the two big ones. The first was based on the photographs that formed the big photo-collage in Cologne: sixty-four separate viewpoints on sixty-four canvases.

Hockney contemplates the Grand Canyon, September, 1998

I visited the Grand Canyon just before I started it, but I painted it in the studio in Los Angeles Then, I visited the Grand Canyon again last April with Celia, and my immediate reaction was: 'Oh my God, everything is closer to you in real life.' That's what the photography has done: it's pushed it all back. I pointed out in the Van Gogh illustrations which the *Royal Academy Magazine* published in their summer issue, that the drawing for *Harvest at La Crau* has a more compressed effect, whereas the impression of distancing in the painting is closer to the result a camera might achieve. In fact, the painting does not seem to have been done from the drawing at all.

I think this one, the second and biggest Canyon painting of all, with the sky above, is quite different. At first most people think the paintings are rather similar, but they are not. I added the sky right at the end, which you would have done anyway. After all, it's the most fleeting aspect of the scene. But the further you get back the stronger the space seems to be. Just as the photograph disappeared into a rectangle, these don't, which is why I've put the mirrors up, so you can see them reversed, and at quite a distance as well. I'm not sure why the reverse aspect is so interesting.

Normally, pictures are not necessarily that interesting in reverse. My only explanation at the moment is that the Canyon landscape itself is of something that took an enormous amount of time to make. The evidence of time is there in front of your eyes. It took millions of years to make that landscape with water. It's highly unusual to see that in front of us. We don't normally feel that we're looking at millions of years of something, but here you are very conscious of it. Probably when it's reversed, it's like running a film of a waterfall backwards, which is like a joke in a way. Here you are seeing what the water did, but backwards, a great force of nature. That must play a part in it, but I don't know enough about optics, really. I do notice that it works with the big pictures, but with the smaller ones it doesn't really make any difference. That's why, in the end, I put the mirrors up. It was my idea. I painted them in Los Angeles with a great big mirror at the back of my studio so I knew what the effect was.

PJ: When you made the big photo-collage pieces, the Cologne pieces, you were dealing with a lot of atmosphere between you and the far distant Canyon sides. With the painting, obviously, you cut the atmosphere aside, don't you?

DH: Yes, that's deliberate. First of all I wanted to read the atmosphere. If I tried to paint the atmosphere, maybe dilute the colours with white, the atmosphere would stay there, it would not move with you. After sitting there for a week, I'm not sure about atmosphere. Sometimes, after sitting there for an hour or so, I would think everything I'm looking at was absolutely flat. At other times, it would seem very powerful. Is it space or is it flat? You can go from one to the other in your mind. I did not want to use normal atmospheric technique, known as atmospheric perspective. To make the illusion and not use that technique is difficult. The moment you see the distance you know it works, that's why the mirrors are there.

Opposite: **Hockney in his L.A. studio painting 'A Bigger Grand Canyon' 1998.**

PJ: When you were sitting at the edge of the Canyon for days, watching the light come and go in this enormous space, how did your thought processes about representing it alter and develop?

DH: You realize it is constantly changing there in front of you. Even if there were no clouds in the sky, you notice the shadows. If I was drawing, I'd be aware in an hour that the shadows had moved. At the end of the drawing the shadows had gone. On a clear day there were so many shadows, but then some days there would be smoke on the other side.

PJ: When you were dealing with multiple images like this making up a single work, it must give you the opportunity to represent a single portion of time with each image?

DH: Well, it's many things, each picture would have its own vanishing point, so you would be looking at ninety-six vanishing points, or sixty vanishing points, which you're not used to. Also there's a very practical point about painting this way because if it was one huge canvas, you'd have to work it all out beforehand, and keep moving ladders about in order to paint it. You couldn't invent it as you went along. I added the second row (of canvases) from the bottom after I'd been painting it for two weeks. You can add this way. I had it on a grid so I could move it up and down. I could paint the sky when I was standing on the floor, where your arm can work with greater ease than it would be swaying about on a ladder. Right at the end, I could make marks and move to the back of the studio to see what impression that one mark had made, and so on.

P:J In that respect, the work relates very directly to the photo-collage technique of adding – I remember you said in Cologne that you could go on adding those Polaroids until you ran out of physical space.

DH: Yes, I'm now going to paint the third Grand Canyon just from my head.

PJ: The last time we were at Salts Mill, we looked at the Yorkshire paintings. They were to do with an experience of travelling through landscape.

DH: Travelling, yes. You travel through here with your eyes. There it was the body, about driving, here it is about remaining physically still, but moving within your head.

PJ: In that respect, that Yorkshire work related back to *Pearblossom*, didn't it?

DH: Yes, moving, driving through a landscape. Here, standing in front of the paintings, your eyes have to move in every direction, just as they do in the Grand Canyon. You have to look in every direction in that great space. Even in the nineteenth century someone observed that there is no perspective in the

Grand Canyon. There's no focus point. You simply have to look everywhere: up, down, around. We do that everywhere, really; unfortunately cameras think we always look in one place.

Thomas Moran, the nineteenth-century painter of the Grand Canyon, went with a camera crew and photographed the points from which he would make pictures. But, of course, a nineteenth-century painter couldn't escape perspective. He saw with perspective. He died in the 1920s, hating what he then saw in art, which was Cubism. Well, the irony is that without cubism I wouldn't have been able to paint them like this, or even make the photographs I did. I'm well aware that nobody has painted a scene as wide as this. We take it in, but the camera can't. Once it's moved to another scene, you've lost it. So Thomas Moran was stuck with his perspective. Most people are.

PJ: Were you conscious of those Moran pictures being iconographic?

DH: No, not particularly. Actually they are a bit made up: he dramatized it. One or two early pictures of the Grand Canyon are interesting, but then it was not easy to photograph. It's unphotographable really, certainly the experience of it is unphotographable. It's a spatial experience, and photography is not about space.

PJ: Photography brought you back to painting in a sense. When you do your painting of the Canyon from your mind's eye, how do you think it will emerge?

DH: Well, if I knew, I wouldn't bother doing it! I can't predict that at all.

PJ: You did tell me that there were places, for instance, in the John Ford Monument Valley, that attracted you very much, and in fact you described one mesa so vividly to me that afterwards I was convinced you had shown me a painting!

DH: I'm trying to do the Monument Valley. It's very hard to work out how it can be done, but I will do it.

PJ: But these Grand Canyon paintings will help you into that valley. The next thing would be to take a mirror into the canyon! (*David laughs.*)

David decided to stay in London during June, using his studio at Pembroke Gardens for the first time in years in a really serious way. For now he was embarking on a series of intimate portraits using the Victorian optical device, the camera lucida *(these formed the basis for a show at the Annely Juda Gallery, London, in July 1999). The* lucida *is basically a small prism on a stick, which attaches to the artist's drawing board and projects an image vertically on to the paper. The portraits which he began using this device were as penetrating as any I had seen. He would begin*

Mrs Charles Badham,
née Margaret Campbell,
1816 by Ingres

with a subject by asking them to remain absolutely still for the first two minutes, expression (if any) locked in place. As he started to draw me, it reminded me of what it must have been like to have a photograph taken, in Victorian times, allowing a lengthy exposure because of the slowness of the film emulsion. After the first couple of minutes he would discard the camera lucida *and continue, so to speak, freehand. Each portrait would take around ninety minutes.*

PJ: Can you tell me a bit about Ingres and his *camera lucida*?

DH: I saw the Ingres show at the National Portrait Gallery and realized what was happening. Optical devices go back to Durer and Holbein, a long way. It enables you to catch an expression that would be harder to achieve otherwise. After an hour of sitting, people's expressions collapse.

PJ: What made you think that Ingres was using some kind of optical device?

DH: It's the precision of detail within the face, particularly the relationship of the eyes to the nose and mouth. You can see that he just used it to measure, really, and then he scrutinized the face. I have the impression that Ingres wasn't naturally sociable and didn't get to know people that easily. In this sense *camera lucida* was a valuable tool for him.

PJ: The art establishment didn't want to know about your opinions when you first voiced them, did they?

DH: No, I don't know what they were looking at. It seems more obvious to me the closer I studied the Ingres drawings. When I first suggested my theory to art historians they were horrified, as if by even mentioning this it somehow diminished Ingres' work. If you paint a face, and you paint it in fifty sittings, what is the face going to look like? There's a freshness to Van Dyck's faces. There's liveliness to great portraits. It means that they have to be done reasonably quickly. People can't have been there for hours and hours. It would reveal itself in the face. A really good portraitist has to be interested in the individuality of faces. Ingres was a superb portrait artist, just superb. Did you see the exhibition?

PJ: I did indeed. It was a revelation.

DH: I scrutinized the catalogue. For instance, I was looking at his drawings of the Villa Medici, which he would then put in the background of another painting. These are made with the camera obscura probably. When he was drawing this Scottish lady, he would have taken a great deal of time over the head, and the body would have been drawn quite quickly. You can see the line. Then she's sitting in a chair in his studio, and because she's supposed to be in Rome, he adds the Villa

Medici which is actually just copied from his previous drawing, a tiny drawing. You can see this drawing quite clearly in Ingres' views of Rome.

PJ: When you turn to the small *camera lucida*, you use it only for a few minutes, don't you?

DH: Yes, you cannot peer at a face through it. It's too small. It's a measure. Ingres would have known exactly which points to measure. You can then do in a minute a drawing which would take you a good half-hour to do by eye. By then your subject would have become bored and things would have changed. It's not easy to use. I bought one years ago but then gave up with it. But looking at Ingres taught me how to use it. He was marvellously observant about faces. I was told he would ask the sitters for lunch and observe how they looked, how they used their hands, how they talked, and so on. Then he would spend the next morning on the face with subtle lighting, and then he'd come back after lunch and draw the clothes, which are probably done rather quickly, using a *lucida*. With the face, he's not gazing at it all the while through the *lucida*, he's probing around, but he would have undoubtedly have marked reference points at the outset.

PJ: The *lucida* you use throws an image four or five inches across, something like that?

DH: It's not very big. It depends how far it is from the paper.

PJ: Where do you think all this is leading you, David?

DH: You know it was Ingres' great rival, Delaroche, who exclaimed on seeing a daguerreotype, 'from today painting is dead'. Perhaps he meant that chemicals were to replace the hand. It was, of course, a prophetic statement, and one which has entered the common language to be accepted up till now as a self-evident truth. But it's not a truth for all time! It is perfectly clear to me that the period of chemical photography is over. The camera is yielding itself up to the hand, those hands which now operate computers. We have entered the post-photographic age. For an artist, this has to be the most exciting time of all.

Paul Joyce, London, 2nd June 1999. This is one of a series of drawings which Hockney worked on in London in May and June of 1999, in which he made use of the *camera lucida*. These drawings were shown at the Annely Juda Gallery, London in June 1999.

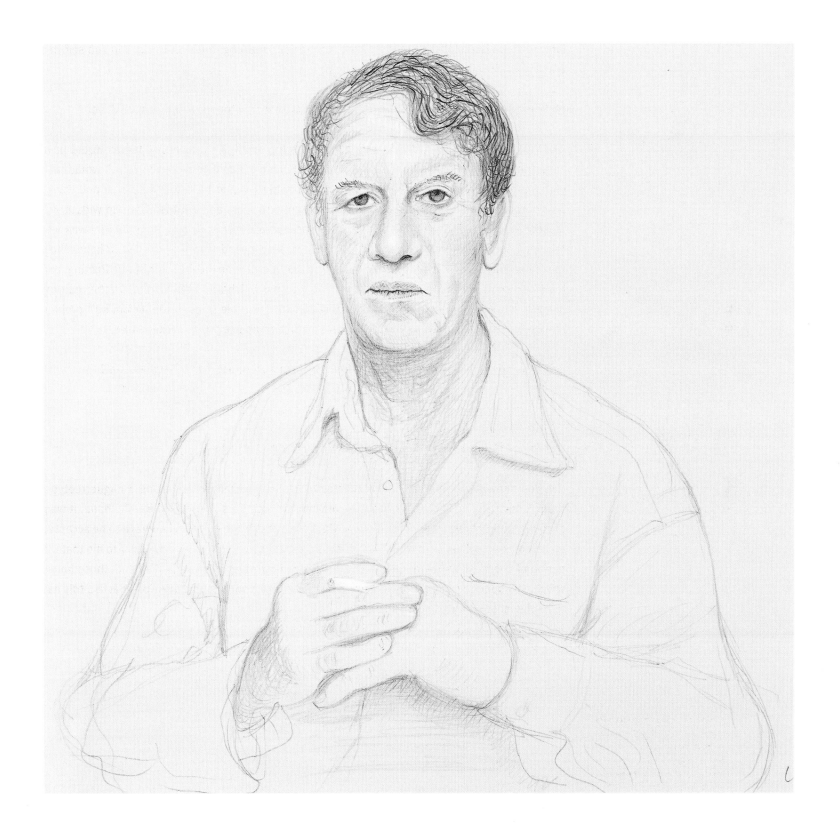

Index

260

Picture acknowledgements

The author and publishers are grateful for permission to reproduce the following illustrations:

Pages 3, 6, 13, 14, 15, 16, 17, 18, 22, 26, 30, 44-45, 52, 56, 59, 62-63, 66, 73, 74, 85, 88-89, 92-93, 94, 99, 102, 105, 108-9, 112, 113, 114, 115, 116-17, 118, 119, 122-23, 125, 127, 131, 132, 138-39, 144-45, 147 (x 2), 148, 149, 155 (x 2), 156, 157, 160-61, 164-65, 166, 172-73, 176, 177, 179 (x 2), 180-81, 182, 184, 186-87, 188, 189 (x 2), 190-91, 192, 196-97, 198, 199, 200, 201, 207, 208, 209, 212, 213, 220, 221, 222-23, 226, 228-29, 232, 233, 234-35, 236-37, 240, 241, 244, 245, 249, 250, 253, 259 all by courtesy of David Hockney/© David Hockney.

Page 19 Metropolitan Museum of Art (gift of Spencer Bickerton, 1938); page 20 Dumfries Museum, Scotland; page 21 Bridgeman Art Library, London (Stavros Niarchos Collection); pages 33 and 215 Tate Gallery, London; page 36 Sydney L Moss Gallery, London; page 38 The Metropolitan Museum of Art, New York (Whittelsey Fund, 1972); pages 39, 87, 110 and 170 Musée Picasso, Paris/DACS; page 40 National Gallery, London; page 48 J P Kernot; page 49 Popperfoto; page 58 Bridgeman Art Library, London; pages 60 and 61 from *Citizens in War – and After* by Stephen Spender, George G Harrap & Co. Ltd, 1945; page 65 The August Sander Archive and Sander Gallery Inc., New York; pages 70, 76, 77 and 79 National Gallery, London; pages 81 and 97 (x 2) Henri Cartier-Bresson/Magnum Photos; page 84 Nick Ut/Associated Press; page 90 The Royal Photographic Society, Bath; page 107 Galleria Nazionale delle Marche Urbino/Bridgeman Art Library, London; page 126 Christie's Images Ltd, 1999; pages 128 and 129 source unknown; page 135 Robert Capa/Magnum Photos; page 151 Arundel Manuscript, British Museum, London (reproduced by Courtesy of the Trustees of the British Museum); page 167 *David Hockney by David Hockney*, Thames & Hudson, 1976 (cover photograph by Peter Schlesinger 1975); page 169 John Heartfield; page 203 Museum of Fine Arts, Boston (bequest of Anna Perkins Rogers); pages 206 and 256 National Gallery of Art, Washington; page 211 Sygma; page 216 Musée D'Orsay, Paris; page 217 courtesy of Lucian Freud © Lucian Freud; page 218 David H Koch/Bridgeman Art Library, London.

The photographs on pages 11, 13, 28, 29 (x 3), 54, 55, 57, 68, 69, 72, 75 (x 2), 82, 83, 95, 98, 101, 120, 121, (140), 142 (x 2), 143, 146 (x 3), 154, 158, 175, 178 (x 2), 195, 204, 205, 214, 238, 240 (x 3) are by Paul Joyce/ © Paul Joyce.

Every effort has been made to trace the copyright holders but if any have been inadvertently overlooked the publishers will be pleased to make the necessary arrangement at the first opportunity.